Type: the secret history of letters

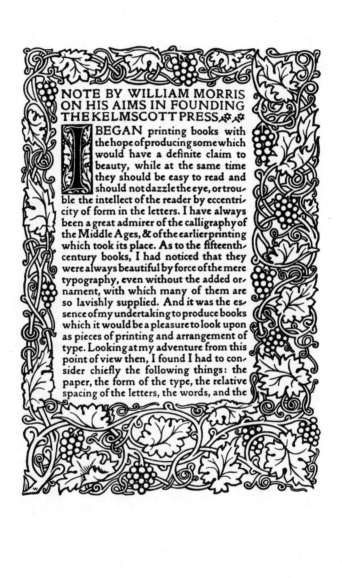

NOTE BY WILLIAM MORRIS
ON HIS AIMS IN FOUNDING
THE KELMSCOTT PRESS.

I BEGAN printing books with the hope of producing some which would have a definite claim to beauty, while at the same time they should be easy to read and should not dazzle the eye, or trouble the intellect of the reader by eccentricity of form in the letters. I have always been a great admirer of the calligraphy of the Middle Ages, & of the earlier printing which took its place. As to the fifteenth-century books, I had noticed that they were always beautiful by force of the mere typography, even without the added ornament, with which many of them are so lavishly supplied. And it was the essence of my undertaking to produce books which it would be a pleasure to look upon as pieces of printing and arrangement of type. Looking at my adventure from this point of view then, I found I had to consider chiefly the following things: the paper, the form of the type, the relative spacing of the letters, the words, and the

Simon Loxley

Type: the secret history of letters

I.B. TAURIS
LONDON · NEW YORK

New paperback edition
published in 2006 by I.B. Tauris & Co. Ltd
6 Salem Road, London W2 4BU
175 Fifth Avenue, New York NY 10010
www.ibtauris.com

In the United States of America and in Canada
distributed by Palgrave Macmillan, a division of St
Martin's Press, 175 Fifth Avenue, New York NY 10010

Published in hardback in 2004 by I.B. Tauris & Co. Ltd

ISBN 1 84511 028 5
EAN 978 1 84511 028 4

A full CIP record for this book is available from
the British Library
A full CIP record for this book is available
from the Library of Congress
Library of Congress catalog card: available

Printed and bound in India by
Replika Press Pvt. Ltd
Set in Monotype
Bembo and
Futura
Bold

Contents

Sine qua non

The Beach Boys once wrote a song called 'You Need A Mess Of Help To Stand Alone', and the truth of that title was borne home to me nearly every day while writing this book, an impossible task without the help, time and advice of lots of people. My apologies if I've missed anyone. For specific chapters:

1: The Statsbibliotheek Haarlem, Marijke van Hoorn at the Teylers Museum, Gerard van Thienen, Lotte Hellinga, Bob Taylor; 3: Justin Howes; 4: Sinéad Byrne at Birmingham Museums and Art Gallery; Detour: Duncan Avery and Richard Cooper at the Type Museum, Theo Rehak (<www. daleguild.com>); 6: Patricia Cost, Theo Rehak, Sharon Moncur at AtypI, Thomas Phinney at Adobe, Dennis Bryans; 7: Sophie Wilson, at the Cheltenham Art Gallery and Museum; Detour: David Bolton, at the Alembic Press (<alembicprs@aol.com>); 9: Shirley Thompson and Rachel Bairsto at the Ditchling Museum; 10: Shelley Gruendler, Warren Platt at the New York Public Library; 11: Ruari McLean; 12: Shirley Thompson and Rachel Bairsto at the Ditchling Museum, Lida Lopes Cardozo; 13: Peter Lofting at Apple, Bruno Steinert at Linotype, Hermann Zapf; Detour: Lida Lopes Cardozo, Sarah Charlesworth and Graham Beck at the Cardozo Kindersley Workshop; 15: Stephen Walford and the Transport Research Laboratory, Giles Chapman, Lida Lopes Cardozo, Sarah Charlesworth and Graham Beck at the Cardozo Kindersley Workshop; 17: Wim Crouwel, Sue Nottingham, Margaret Mayo, Anne Irving; 18: Julian Balme; Detour: Christian Küsters (<www. acmefonts. net>), Dirk Wachowiak, Robert Green; 20: Joe Graham at Fontworks.

Thanks also to Mick Walsh for sowing the seed of the original idea, and to Christine Lalla for taking pictures including the author photo.

Especial thanks for all their help to Nigel Roche and his team at St Bride Printing Library, in particular Denise Roughan and Lyn Arlotte; the library and its staff are truly one of London's hidden treasures.

And finally thanks to John Miles; in the corner of rural England that we both inhabit, where to buy a pint

of milk or a newspaper requires a car journey, to find such a fund of typographical experience, recollections, advice and opinions within walking distance made me feel that the fates were surely smiling on my enterprise. I hope you'll think so too.

This book is dedicated to Sarah, who will always be my type.

The naked letter: *the anatomy of type*

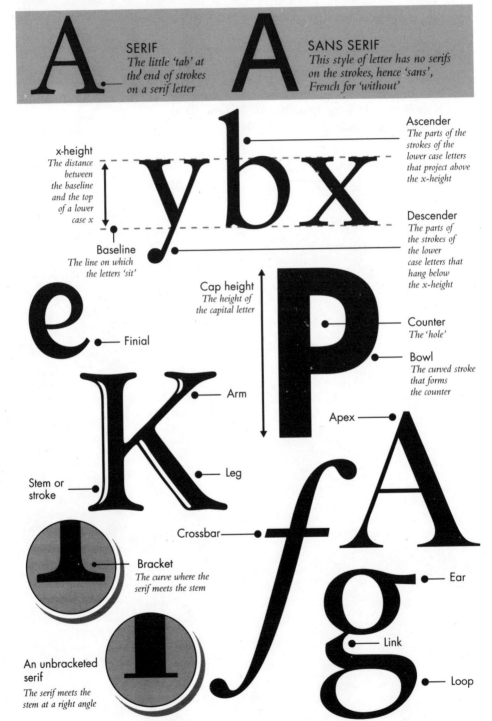

SERIF
The little 'tab' at the end of strokes on a serif letter

SANS SERIF
This style of letter has no serifs on the strokes, hence 'sans', French for 'without'

Ascender
The parts of the strokes of the lower case letters that project above the x-height

x-height
The distance between the baseline and the top of a lower case x

Descender
The parts of the strokes of the lower case letters that hang below the x-height

Baseline
The line on which the letters 'sit'

Cap height
The height of the capital letter

Counter
The 'hole'

Finial

Bowl
The curved stroke that forms the counter

Arm

Apex

Leg

Stem or stroke

Crossbar

Bracket
The curve where the serif meets the stem

Ear

Link

An unbracketed serif
The serif meets the stem at a right angle

Loop

Introduction

The New York City sky glowed red as the column of
smoke rose into the darkened heavens; by the morning
there would be a piece missing from the familiar skyline
of buildings. It was the night of 10 January 1908. On the
street, one man stood immobile among the onlookers,
watching his livelihood going up in flames. Frederic
Goudy and his wife Bertha had only recently moved
their printing business to the city. The workload had
been growing steadily, and the couple had taken their
first night off in weeks. A frantic phone call disturbed
their repose; the Parker Building in midtown Manhat-
tan, home of the Goudys' Village Press, was on fire. As
Goudy watched helplessly, amid the roar of the inferno
and the cries of the firefighters could be heard the in-
termittent crashes of the two printing presses, falling
stage by stage from the sixth floor through the collap-
sing internal structure of the building. The business was
uninsured; apart from a few copies of the book they
were currently printing, all that was saved were some
of Goudy's Village Type matrices, stored in a safe in the
superintendent's office. Staring at the torrents of water
streaming down the gutter, Goudy felt as if his whole
life was disappearing with it.

Yet within ten years he was to be an internationally
renowned designer, the first American type star. Typeface
design, not printing, was the art that would make his
name, and his fame and success were to become such
that leading lights in the world of type would soon
start wishing that Goudy himself had been among the
company assets lost on that New York winter night.

Today, Frederic Goudy's lettering, in Britain at least, is
linked more to water than fire – water, that is, brewed
with some hops and malt. Frequently the lettering used
to spell out the names of public houses, it was chosen
for its rare combination of qualities – tradition and
warmth – and proliferated through corporate make-
overs and takeovers. But few passing beneath the signs,
their minds focused on that first drink of the evening,
would be aware of the dramas in the life of the man who

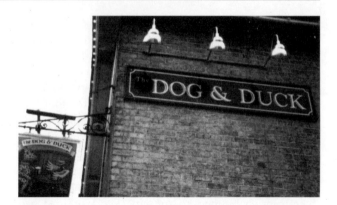

1 Make mine a pint ... the work of Frederic Goudy, greeting customers at a bar near you.

originally drew the letters, for Goudy's career, tirelessly self-promoted in a profession well stocked with shrinking violets, was laid low by fire not once, but twice.

And why should they be aware? What is intrinsically interesting about a typeface? Why do we need so many different styles? Times, Century, Garamond, Arial, New York, Geneva, News Gothic, Univers, Franklin, Old English, Goudy ... and the list keeps getting longer every year. Who cares what the style is? What the words are saying is what's important, surely, so couldn't we get along quite happily with just, say, Helvetica? It's clear, highly readable, does the job, delivers the message. One of typography's most lucid and influential commentators, the American émigrée Beatrice Warde, even confessed to being uninterested in type as such: 'Typography must be clear and good in order to communicate – but that's as far as it goes ... To me it is not so important *how* the idea is communicated, provided it successfully gets across from one mind to another.'[1] The message was the thing; the delivery, as Beatrice saw it, of *truth*. But one person's urgent truth is another's irritating piece of trivia. How do you persuade someone to read your version? One answer is the typeface.

Who cares about type? Although initially they may take some convincing, any organization with an eye to a profit. The high-profile company experiencing a slump in sales and attempting to revamp its image, or reposition itself in the marketplace, overlooks typography at its peril.

British high street giant Marks & Spencer was thrown into comparative crisis at the end of the twentieth century by drab interior styling, a refusal to countenance elec-

1 John Dreyfus, 'Beatrice Warde, the First Lady of Typography', *The Penrose Annual*, vol. 63, New York, 1970.

tronic customer payments, and the fact that every other clothing retailer was now selling underwear – always the company's core business. It has attempted to remedy the situation by giving its stores a fresher, more contemporary feel, through choice of colour and materials, and of course different typography – a not-quite-serif, not-exactly-sans-serif face that looks contemporary yet won't make older customers shy away. Oh, and you can pay with a credit card too.

It seems to be working. As it has for Burberry, famous for its black, red and beige check fabric, raincoats, umbrellas and scarves, and for being the choice of rich American and Japanese visitors, and middle-aged Mayfair. When the company decided to go for a younger, trendier clientele, it not only ran ad campaigns featuring youthful, sulky models in startling juxtapositions, but also redesigned the lettering of the company logo, going for an elegant, modern serif – classic, yet of today too, exactly the way Burberry now wishes to be perceived.

Because there is fashion in typefaces, just as there is in clothes. What is a type style but a suit of clothes for the letters of the alphabet? You can send your words out into the world looking as though they are in touch with modern trends, or stuck in a 1980s timewarp of big-haired power dressing; wearing an old tweed jacket with leather patches on the elbows, or as a total fashion victim.

As far back as 1936, John Allen Murphy, writing in the American printing trade journal *The Inland Printer*, was trying to analyse the demand for new faces:

2 Marks & Spencer's type makeover: a vital part of the rescue operation.

> There is no question but that type is subject to the same law of change that influences design in innumerable other fields. What the true motivating power behind this law is, no one knows. Probably the factor of change is due to a certain restlessness in people. They become bored with what they are accustomed to seeing, and vaguely crave something different. The public rarely *says* what it wants. In fact, it does not know. The manufacturer must sense this strange unexpressed desire of the people for a change, and design merchandise that he believes fashion will accept.
>
> The same sort of thing is going on in the type world. As in merchandise, the pendulum of favour swings away from certain types. New favourites come in …

Murphy was writing of the need for type manufacturers to gauge changing trends and unspoken desires. Today, the style changes are more likely to be wrought by art directors in influential positions, or by a type designer striking it lucky with a face that gets a wide take-up. But the trends are still there. The turn-around is simply faster than in Murphy's day. As Joe Graham of type company Fontworks says: 'We've seen quite a few vogues for different styles over the last few years – grunge faces, then stencils were popular for a while, and ultra lights. There also seems to be an interest at the moment in rounded faces, like rounded versions of Helvetica. The Tate Gallery, for example, has gone for a rounded face in its logo and type style.'[2]

In the 1980s, the so-called designer decade, the concept of 'style', as reflected in the clothes you wore, the interior of your home or the restaurant or wine bar you frequented was usually supported on the printed page, on labelling or on the street-front fascia by lettering composed of a serif typeface, narrow characters with a strong contrast between the thick and thin strokes.

To the world at large this said 'contemporary style', and looked the height of sophistication. Today there's a different typographical approach, but the same basic message: 'This is for someone who is in touch with what's happening NOW, who has sophisticated tastes that are untrammelled by a nostalgia for what's gone before.'

All that has changed is the style of typeface. The sans serif now holds sway, either one of the timeless designs of the 1920s or 1950s, or one of the myriad created in the last ten years. And the style of presentation has changed too; where in the 1980s the size of the lettering that carried the main information – the headline or the copy line – would have been large, now it is small. Previously, the lettering would probably have been condensed, squeezed to make it narrower, and the individual letters closely set. Now the letters may well be more widely spaced, and if there is any stress on their shapes, they are more likely to be expanded, stretched to make them broader.

2 Grunge fonts use battered, distressed, distorted and informal letters – style is more important here than crystal clarity. Ultra lights have strokes with the uniform thickness of a thin line.

Who cares about type? Well, you do. Since the advent of the personal computer, everyone can be their own typographer in a way that was impossible before – typesetting, once an expensive, closed-shop service, the

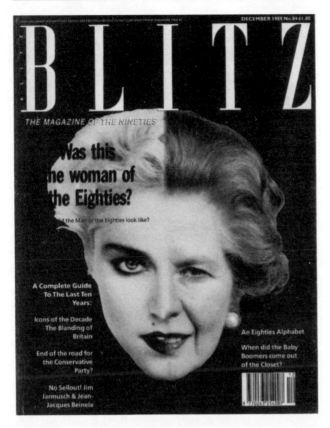

3 Late 1980s typographic chic, serifed, condensed, typified by the masthead of now defunct style magazine *Blitz*.

guarded preserve of trained professionals, has become available to anyone with space on their work surface for a computer.

And you have a choice of which font you want to set your work in.[3] Do you have a favourite? Do you use different ones for different purposes? A museum fundraiser confided to me that she always uses Times Roman for letters in which she is seeking donations. She felt the typeface suggested visual and financial impoverishment, with no available resources to spend on a more considered design approach. No doubt the designer of Times, the venerable Stanley Morison, would have been spinning in his grave at this assessment.

Who cares about type? Sometimes a whole nation: type style was a debate that raged in Germany throughout much of the nineteenth century, reaching a peak with the rise to power of Adolf Hitler in the 1930s. Indeed, a case could be made for a nation expressing its national

3 When referring to pre-digital type technology, I have used the traditional English spelling, 'fount', and thereafter the now completely dominant American form, 'font'. Originally a 'fount' referred to a complete set of characters in one design, and in just one size, but is used here in the modern wider sense synonymous with 'typeface' – a single alphabet design irrespective of size.

character through typography. The Swiss? Clean lines, controlled, well ordered. The French? Stylish, quirky, inhabiting their own very individualistic universe. The Americans, while boasting highly creative individuals, managed to make type big business as well. And Britain? What else but the home of the eccentric typophile, the oddball and the loner?

Who cares about type? The characters who populate the stories that follow. In the process they kick-started the two great technological and social revolutions that have shaped Western society in the last six hundred years. But revolution, although it was sometimes the fruit of their obsession, was rarely their objective. Many found their passion while aiming for something else entirely. Type was something they stumbled across while trying to reach some other goal. The phenomenon of the trained designer as typographer is a relatively recent one; in the past the type designer often began by following an entirely different calling. Theirs was no creative ivory tower. They brought to their designs all the inescapable human baggage of ambition, jealousy, desire, treachery and love. And it is this baggage, informing and some-times twisting the course of their endeavours, which makes their stories as fascinating as the letter shapes they brought into being.

1 | The adventure and the art: the obscure origins of a revolution

'Have you ever seen a scribe at work?' I asked. Indeed they had, and sighed, ready to be disappointed.

'And have you any notion of how long it takes a scribe to write ten pages? Two hours? Ten?'

'Something in between, perhaps.'

'What would you say if I told you I can make one hundred pages in an hour?'

'I would not believe you,' laughed von Seckingen.

'I would think you had supped too much from your own cellar,' scoffed Smalriem.

'We have heard you are quick-fingered, Johann, but no hand could write that fast,' they mocked together.

'Yes, yes, but suppose,' I went on, 'the hand were that of a machine. You have seen a wine-press? Well, imagine a wine-press being used to make words. Imagine a line of metal squeezing out letters on paper. Imagine the method that stamped this mirror' – here I brandished one of the mirrors made for the Aachen pilgrimage – 'being used to stamp books.' (Blake Morrison, *The Justification of Johann Gutenberg*, 2000)

The story of type begins in the mid-fifteenth century. Many of the people and designs that we will meet in the following pages drew inspiration or used letter forms from earlier sources. The capital letters carved on the Trajan Column in Rome in AD 114, or the lower case letters, the Carolingian minuscules, developed in the reign of the Emperor Charlemagne at the start of the ninth century, are the two salient examples. They belong to the world of lettering and calligraphy, but are not in themselves, by definition, also type – lettering for mass production. When people refer to the birth of printing in Europe, what they actually mean is the birth of type. Movable type – individual letters that could be arranged, edited, printed from, then dismantled and reassembled to print again in a new configuration – this was the real breakthrough, the spark that fired the printing revolution that was to sweep through Europe during the rest of the

century, its output greedily consumed by an information-hungry population.

Printing itself had existed in China since at least the start of the second millennium, possibly as early as the middle of the first. But the sheets were probably rubbed down on a reversed image in a single unit, made from hand-carved wooden blocks. Movable type is known to have been used in China, and later in Korea, made of porcelain, wood or cast in bronze; all this before its European introduction. But its development and widespread use were conceivably too daunting and impractical for Far Eastern languages, with their thousands of ideograms. The mere twenty-six characters of the Latin alphabet presented a far more manageable proposition.

But what exactly did *movable* type mean? Today we are used to arranging, manipulating and printing from letters on a computer screen. But until the 1950s 'type' meant each letter having a physical existence as an individual piece of metal, comprising of the face – a reversed image of the letter, which was the surface that would receive the ink and form an impression on the paper – and the shank, a rectangular body of metal, of varying width according to the letter it was carrying, but of a uniform length, usually just slightly longer than the width of a thumb, for maximum ease in picking it up and minimum wastage of materials. The shank had to be exactly the same length as all its counterparts, so that the printing surface of the letters was at an even height – the height-to-paper – when the type was placed on the bed of the printing press.

4 Gutenberg's breakthrough – a piece of movable type (actual length 23 mm). The little nick on the side allowed the compositor to tell, by touch alone, which side was up. The reversed image of a capital B forms the upper surface.

The type was created by first cutting a punch. This was sculpted out of steel, with the letter reversed. The punch was then struck with a mallet to form an impression in a softer metal, copper, crucially always to the same depth. This piece of copper became the matrix, a mould for the letter. When the matrix was fitted into a type mould and filled with molten metal – a mixture of lead, tin and antimony – a piece of type, a relief reversed-image character, shank and all – was produced, and could be replicated in whatever quantities were required.

Until the invention of typesetting machines in the late nineteenth century, the individual pieces of type were picked by hand out of a tray and placed, in the

required order, in a hand-held composing stick. This was a right-angled holder in which the type could be held until transferred to a work surface and locked up tight in a chase, a metal frame. It could then be moved to the bed of the printing press.

Regardless of any possible knowledge of artefacts from the Far East, it would be an insult to the intelligence of our medieval ancestors to imagine that the concept of simple printing hadn't occurred to more than one mind; a hand or fingerprint, the mark of a dog's muddy paw, would be sufficient to sow the seeds of the idea. But what to do with it? Two vital factors needed to be in place for the printing revolution to succeed, and by the middle of the fifteenth century they were.

There are European examples of printed items which at least *bear* dates earlier than that of the generally accepted arrival of movable type, although exactly what method was used to create them is still open to speculation.[1] But up to this point such books as existed were handwritten. Initially this work had been done by monks. As long as the demand was restricted to monastic libraries or private collections, this didn't represent a problem. If you could read them and afford them, a dozen books could constitute a library.

In the late 1980s the course of my work as a freelance designer took me into many different offices. I started noticing over and again the same cartoon taped to the walls of design departments. In some instances it looked like a fourth-generation photocopy, as though the thing had been passed around London like a chain letter. The cartoon showed two monks, one standing, the second seated at a table in front of him, halfway through creating a magnificent illuminated manuscript. The seated monk had turned around, a look of intense annoyance on his face, and the caption read: 'Deadline? No one told me about any ****ing deadline.'

Of course, beyond the comic shock of the blaspheming monk, the reason for the cartoon's popularity among hard-pressed art directors is obvious. But maybe the cartoonist was closer to the truth than he imagined. The number of universities in western Europe in the fifteenth century was increasing; education was spreading. The English king Henry VI, a saintly nonentity who ended

1 Block books, printed by xylography – from complete wooden blocks rather than movable type – were usually just single sheets, with an illustration as a religious aid for the illiterate, or brief textual works, such as Aelius Donatus' Latin grammar, which was short enough to be economically printed in this way. Although the majority of surviving examples were previously considered to pre-date movable type, current thought tends to regard them as running concurrently, from no earlier than the 1460s. There are existing woodblock prints dated 1418 and 1423, although the former may be a later copy of an original version.

as a pawn in a civil war that cost him his throne and his life, nevertheless left lasting monuments as the founder of Eton College and King's College, Cambridge.

To be able to read and write was seen increasingly as an essential asset for advancement, and not an accomplishment limited just to scholars. In the prologue to Geoffrey Chaucer's *Canterbury Tales*, written in about 1387, we find among the descriptions of his motley band of pilgrims several references to literacy, the love of reading, or to professions that would have required the ability to read and write. The Squire, alongside his skills in riding and warfare, can also write and draw, and at the start of 'The Prioress's Tale' she tells us of a small school where the children learn '... to rede, As smale children doon in hire childhede'.

With the growth of educational establishments, perhaps the unfortunate monks were indeed being presented with deadlines they were no longer able to meet.[2] Secular scribes joined the fray; in university towns, the most important of which at this time was Paris, the copyists became numerous enough to form their own professional guilds. A growing market was waiting to receive information and learning, but these new consumers were students and their funds were limited.

The crucial parallel development was the growth of paper manufacture. Up until this time, the material used by the scribes was vellum. Made from the skins of calves, vellum was expensive, whereas paper was now becoming affordable. And, as has been observed, it's easier to make paper than to produce calves. So all that was needed now was a means of duplicating the required information, more cheaply and much, much faster.

It has been a matter of furious dispute as to who exactly should receive the credit for the invention of movable type, but the laurels are now generally allowed to rest on the brow of Johann Gutenberg (or Gensfleisch zur Laden – the name Gutenberg was taken from his family house). He is the least shadowy figure in a small, ill-lit cluster of otherwise dubious claimants. There is no book or printed work in existence which bears his name, and no portrait was done of him in his lifetime. His exact date of birth is uncertain, but he was born in Mainz in Germany in the late 1390s, or possibly at the start of the fifteenth century. Any evidence is purely

2 It has been estimated that a written Bible represented four years' work.

circumstantial, but there is enough of it to make him by far and away the strongest and most feasible contender. To him, also, falls the credit for the first major printed work in the Western world, the 42-line Bible, published about 1455.

What little we know of Gutenberg's life comes mainly from legal records. He initiated or was drawn into legal conflict on a fairly frequent basis, and for this historians must be profoundly grateful. Mainz has taken a pounding over the centuries; pillaged and burnt during a conflict between two rival archbishops in October 1462, it also experienced the ravages of the Thirty Years War in the seventeenth century[3] and of French Revolutionary mobs at the end of the eighteenth. So it's possible that other material that could throw more light on Gutenberg's life and work has been lost along the way.

We know that his father was connected to the episcopal mint, and Johann himself gained experience in working with metal, a knowledge that proved invaluable in his later undertaking. He is first recorded in 1420, in connection with the settlement of his father's will, which meant that he was legally of age, at least fifteen. In 1430 he is listed in a decree issued by the council of Mainz allowing certain exiled citizens to return, although there is no record that he did. In 1434 he was involved in the arrest of a Strasburg city official for non-payment of money owed, and a couple of years later in a breach-of-promise suit.

In 1439 he is back in the courts, and here is where the story becomes interesting. Gutenberg had set up a business partnership, he and his colleagues working together initially on two projects: polishing gemstones and making mirrors for pilgrims. These latter were useful for glimpsing holy relics from the midst of a large crowd, but there was more; catch the reflection of the relic in the glass, then carefully cover it, and the healing powers of the devotional object would be held until required, or so ran the belief. Then simply uncover the mirror and direct it to where the blessing was needed.

The Aachen pilgrimage was the marketing opportunity for these items, but the small cooperative got the date wrong. The pilgrimage was to be in 1440, not, as they thought, in 1439 – a good instance of the need for some printed pre-publicity. Now short of work and

3 The Thirty Years War (1618–48) started as a religious conflict and widened into a general struggle for power, involving France, Spain, the Netherlands, Denmark, Sweden and the states of the Holy Roman Empire, and was fought mainly on German soil.

with another year to wait to recoup their outgoings, Gutenberg reluctantly let the partners in on his third project, what would be mysteriously referred to in the court documents as 'the adventure and the art'. Chestmaker Konrad Saspach built a press for the purpose, and Hans Dünne, a goldsmith, was commissioned to engrave 'forms' (an early term for type). Unfortunately one of Gutenberg's partners, Andreas Dritzehn, died of plague, and his two brothers were keen to take over his interests in the businesses, not least the mysterious third project. Even before Dritzehn's death, Gutenberg had given orders to melt down 'forms' so that no one would see them. He now instructed his servant, Lorenz Beildeck, to go to Dritzehn's brother Claus and ask him to take apart something that was lying in a press in the work premises. The object was in four pieces which could be dismantled by removing two screws. The pieces were then to be laid out separately on the press so that no one would know what they were. But when Claus arrived at the workshop, the mysterious object was nowhere to be found. The Dritzehns took legal action over their stake in the business, but they retired defeated; the terms of the partnership stipulated that relatives of a deceased member would receive just 100 guilders compensation.

Gutenberg was trying to keep the number of people who knew about the third project as small as possible. Even in the court case it is never revealed exactly what the nature of the business is. Maybe this was because, to use the terminology of the computer industry, it was about to 'ship'. Albert Kapr, in his definitive 1996 biography *Gutenberg: the Man and His Invention*, states his belief that printing was born in Strasburg. He dates the fragment of the *Weltgericht*, a poem about the Last Judgment found in 1892 in the binding of an account book for Mainz University, at between 1440 and 1444.[4] The typeface is recognizable as Gutenberg's but the variance in height-to-paper of some of the letters, resulting, in places, in weak impressions, suggests earlier, unperfected technology. He dates a twenty-seven-line *Donatus* – a Latin grammar also later found in the bindings of Strasburg books – even earlier, probably about 1440, the year after the Strasburg trial.

Gutenberg drops from view from 1444 until 1448 – the missing years – when he resurfaces back in Mainz.

4 Early printed fragments are usually discovered as parts of book bindings. They were probably printer's waste, but the fact that they were printed on parchment would still make them valuable material for binders. When the bindings later disintegrate, and the volumes are re-bound, the prints come to light.

We owe much of subsequent documentation to the fact that his venture was an expensive one, and he had to seek loans to finance it. In that year he borrowed 150 Rhenish guilders, and a year later another 800 from a lawyer called Johann Fust. In 1455 he was involved in yet another legal action, this time against Fust, who in the interim had become Gutenberg's business partner and financier. Fust had foreclosed on his loans, and took over Gutenberg's operation.

Also in 1455, the future Pope Pius II wrote of a meeting held the previous year in which a man had either been showing or talking about his work on a Bible. In 1458 Gutenberg defaulted on some old Strasburg debts; 1465 found him granted a pension by the prince-archbishop of Mainz, and finally, in February 1468, we have the record of a beneficiary to his will, Dr Konrad Humery, who had presumably also lent Gutenberg money, and received as posthumous conpensation some print-related equipment and material.

It is irresistible to cast Fust as the villain of the piece, the man who robbed Gutenberg of the fruits of his genius at the point when more than fifteen years of perseverance were about to pay off. To his credit, he brought into the enterprise Peter Schoeffer, a punch-cutter par excellence, who probably raised Gutenberg's production to a higher aesthetic plane than it would otherwise have achieved. With Gutenberg out of the picture, Fust and Schoeffer went on to produce further books: the Mainz Psalters, *The Rationale of Durandus*, and another Bible in 1462.

Gutenberg's enduring monument is his Bible, known as the 42-line Bible, from the number of lines of text on the page. It ran to over 1,200 pages, and was finished in about 1455. For some it remains one of the most beautiful books ever made, both aesthetically and technically.

His typeface was an imitation of the monastic script, a blackletter. The decorations were put in by hand afterwards. In the use of this lettering it has been argued that he was simply going to every possible length to make his printed Bible as close in appearance to a handwritten one as he could, to make his new product acceptable to his potential market. The Bible had to be a commercial success, if only so that Gutenberg could pay back his creditors. This was no vanity publishing, undertaken purely for aesthetic motives or solely for the glory of

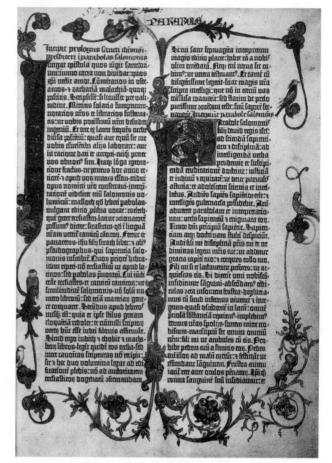

5 The opening page, Proverbs, of the second volume of Gutenberg's 42-line Bible. The decorations were put in by hand. 'For regularity of setting, uniform silky blackness of impression, harmony of layout … it is magisterial in a way to which we can rarely aspire under modern conditions' (Albert Kapr).

God. It has been remarked that 'extreme conservatism as to the presentation of reading matter has always been the outstanding characteristic of the reading public'.[5] In other words, if it looks strange and unfamiliar, the reader won't go near it.

But equally we have no evidence that Gutenberg was intrinsically interested in letter forms anyway. Why should he be? With enough on his plate perfecting his new production process – and for his Bible to succeed it had to look as good as he could possibly make it – why redefine the whole visual appearance of a book's pages? Far safer for the success of the enterprise to reproduce an existing and accepted style.

The most intriguing aspect of Gutenberg's type, and the thorniest problem for scholars, is the variations between different instances of the same letter. Was this to

5 S. H. Steinberg, *Five Hundred Years of Printing*, London, 1955.

simulate the variance in handwritten characters, to make the pages look as similar as possible to those produced by the process that printing was intended to replace? Or were they just earlier versions, initially rejected, then pressed back into service as time or finances became crucial? A recent theory has proposed that movable type, as we understand it, with castings from matrices, arrived only later, in the 1470s, when type began to be traded.[6] Did Gutenberg in fact use combinations of punches to create his characters, pressing configurations of single character-stroke punches into damp sand, a known casting medium, as an impermanent mould to make the type? Clearly, if this were the case, each character composite would be slightly different, sometimes noticeably so. The theory is fascinating, yet begs the question as to whether experienced workers in metal would not have hit on the matrix idea almost immediately. It certainly offers an ingenious answer to the question of the variance in the type, and serves to underline how much, over five hundred years later, remains intelligent speculation. It's another mystery, and one that may never be satisfactorily resolved.

Along with the crucial development of oil-based printer's ink, Gutenberg's breakthrough brought with it the facility to edit copy, to print a proof, correct it easily, and then print the run. His invention can lay strong claim to being the most significant of the second millennium. Its most immediate major effect was to make possible the Reformation; before, the Church largely controlled the dissemination of knowledge and the reading of the Bible. The ideas and writings of Erasmus, and later the pamphlets of Martin Luther, could not have achieved the influence or effect they did without the printing press. Whether this was a good or bad thing depends on your point of view, but the unstoppable spread of ideas through printed material was an essential step on the road to democracy.

Nearly all major inventions or scientific breakthroughs have claimants and counter-claimants to the distinction of having been the inventor or discoverer – the circulation of blood, DNA, the telephone, television, photography, cinema. Someone has their ideas taken and exploited by someone else; sometimes they make an

6 Gutenberg's blackletter, lovingly re-created by New Jersey's Dale Guild Type Foundry for modern-day letterpress enthusiasts. The variance in Gutenberg's original letter forms means that the present project, called B42, remains in a constant state of flux; 'It may never be a finished, "done" thing,' say its makers.

6 Paul Needham and Blaise Agüera y Arcas, in a lecture to the Grolier Club in New York in January 2001.

early unsatisfactory version and the person who makes a better, subsequent model scoops all the credit. The invention of movable type is no exception. Various claimants have had their champions, and the nineteenth century was to witness a ferocious debate over the contributions, and even the very existence, of the most significant, Laurens Coster.

But first let's look at the also-rans. Step into the spotlight, Pamphilo Castaldi. In 1866 the British literary magazine *The Bookworm* ran a short article about the imminent erection in the Italian town of Feltre of a statue to Castaldi, the inventor of movable printing type. Apparently Castaldi, after studying law, opened a 'school of literature' for learning the proper usage of the Italian language. One of his students was 'John Faust of Mentz'. In 1442 Faust was supposed to have shown Castaldi some of Gutenberg's efforts at printing from wood blocks. Castaldi then, it is alleged, invented movable type himself, inspired by glass letters made in Venice. He knew how the scribes used these to print the large first letter on the page, and hit on the idea of employing this method for the rest of the text as well. Not realizing the momentousness of his idea, he was careless enough to mention it to Faust, who promptly headed back to Mainz to communicate the brainwave to Gutenberg and Schoeffer. A Castaldi festival was held in 1866, including musical works specially written in his honour.

The Bookworm took this account from an Italian historian, Stefano Ticozzi, and while regarding it with caution reminded us that 'great discoveries are seldom attributed to the real inventors'. It was probably no co-incidence that 1866 was also the year in which Venetia, the province in which Feltre is located, was freed from Austrian control to join the recently unified state of Italy. The fêting of Castaldi was doubtless an attempt to foster a new sense of national identity with the creation of a local, but also Italian, hero.

Make room, then, Castaldi, for Jean Brito. The Abbot of Cambrai, Jean Le Robert, recorded in his diary in 1446 and 1451 that he had bought in Bruges and Valenciennes copies of a book called the *Doctrinale of Alexander Gallus*. In 1898 the archivist of Bruges, Louis Gilliodts-van Severen, put forward the claim of Jean Brito, one of Bruges' first printers, but also, Gilliodts asserted, the

printer of the abbot's *Doctrinale* and therefore the inventor of movable type. His argument is open to question, to say the least. Brito had claimed in a later credit line, a colophon,[7] that he had 'discovered, without being taught by anybody, his marvellous art'. The existence in the National Library in Paris of a *Doctrinale* printed at a later date by Brito seemed to Gilliodts confirmation that Brito had printed the abbot's copies too. Interestingly, though, Gilliodts also believed that Gutenberg's letters were not cast but engraved, which links tangentially with the latest theories.

Step forward next, perhaps the most intriguing case of all, Procope Waldfoghel, an itinerant goldsmith who arrived in Avignon in France in the early 1440s, announcing a method of mechanical writing, using letters of tin, iron, brass and lead. He was lent money by one Davin de Caderousse in return for instruction in this new craft. In July 1444 a student called Manaud Vital was promised two steel alphabets, two iron forms, a steel instrument called a *vitis*, forty-eight tin forms and 'other forms appertaining to the art of writing'. Waldfoghel had been in Lucerne, and may conceivably have met Gutenberg's earlier Strasburg contacts, the Dritzehns, who are known to have gone there too. Did he learn enough of what Gutenberg had been doing in Strasburg to make him decide to set up his own operation in Avignon, selling instruction in the new craft? A further connection has been suggested with Hans Dünne, Gutenberg's goldsmith accomplice. Was Waldfoghel an assistant of Dünne's? Once again, it's a tantalizing episode that seems fated to remain for ever the subject of supposition – Waldfoghel and his partner, the locksmith Girard Ferrose, left Avignon in May 1446 to escape their creditors, and disappeared into the mists of history. No examples of their printed work have ever been found.

This highly valuable art was discovered first of all in Germany, at Mainz on the Rhine. And it is a great honour to the German nation that such ingenious men are found among them. And it took place about the year of our Lord 1440, and from this time until the year 1450, the art, and what is connected with it, was being investigated. And in the year of our Lord 1450 it was a golden year, and they began to print, and the first book they

7 The colophon was a statement at the end of the book which carried the kind of information that would be found on the imprint page of a modern book – the one following the title page that gives the date of printing and who the printer is. The medieval version was sometimes also used as a piece of self-promotion by the printer.

printed was the Bible, in Latin; it was printed in a large
letter, resembling the letter with which at present mis-
sals are printed. Although the art (as has been said) was
discovered at Mainz, in the manner as it is now gener-
ally used, *yet the first prefiguration was found in Holland, in
the Donatuses, which were printed there before that time.* And
from these the beginning of the said art was taken, and
it was invented in a manner much more masterly and
subtle than this, and became more and more ingenious.
One named Omnibonus wrote in a preface to the book
called Quintilianus, and in some other books too, that a
Walloon from France, named Nicolas Jenson, discovered
first of all this masterly art, but that is untrue, for there
are those still alive, who testify that books were printed
at Venice before Nicolas Jenson came there and began to
cut and make letters. But the first inventor of printing
was a citizen of Mainz, born at Strasbourg, and named
Junker Johan Gutenberg. From Mainz the art was intro-
duced first of all into Cologne, then into Strasbourg and
afterwards into Venice. The origin and progress of the art
was told me verbally by the honourable master Ulrich
Zell, of Hanau, still printer at Cologne, anno 1499 by
whom the said art came to Cologne.[8]

The above extract, an interview with a printer on the
origins of his craft contained in a history of the city of
Cologne, was, despite the ambiguity of its information,
one of two sources cited as evidence by the promot-
ers of, after Gutenberg, the best-supported claimant to
the invention of printing with movable type – Laurens
Janszoon Coster, from the Dutch town of Haarlem. The
second document was a pedigree, a family tree, which
Gerrit Thomaszoon, a Haarlem sheriff, churchwarden
and innkeeper, had drawn up before his death in either
1563 or 1564. One of the entries referred to the second
wife of one of his ancestors as being 'the daughter of
Louris Janssoens Coster who brought the first print into
the world Anno 1446'.

The story of Coster was taken up by the historian
Hadrianus Junius (Adriaen de Jonghe), who wrote the
first account, and fostered the claim that movable type
had been invented, not in Germany, but in the Neth-
erlands. Junius was born in Hoorn in 1511, and in 1540
received a degree as a doctor of medicine. The years 1542

8 *The Cologne Chronicle*,
published by Johann Koelhoff the
Younger, 1499. Emphasis added.

to 1548 saw him in England, employed by the Duke of Norfolk as his physician. After the duke's death he wrote a celebratory poem on the marriage of Mary I of England to Philip II of Spain, in the hope of financial reward from the royal couple. Disappointed in this expectation, Junius returned to the Netherlands, and from 1559 until his death in 1575 lived (apart from a short period in Denmark) in Haarlem. He eventually became physician to the Prince of Orange, and was considered – after Erasmus – the most learned Dutchman of his time. In 1565 the prince commissioned Junius to write a history of the Netherlands.

In the resulting work, *Batavia*, Junius dealt with the Coster story. Laurens Coster, a Haarlem chandler and innkeeper, took a walk one day with his grandchildren in the Haarlemmerhout, a wood in the southern part of the town. He cut some letters out of the bark of a beech tree, and later, using ink, printed impressions of the letters for the amusement of his grandchildren.

Realizing the possibilities of this, Coster improved the ink and started printing, changing the letters to lead and tin ones in the course of his first work, the *Speculum Humanae Salvationis* (The Mirror of Human Salvation). Coster's business flourished, to the extent that he began to employ more workmen. But while the Coster family were at church on Christmas Eve 1441, one of these employees, Johann, broke into the printing office, stole all the type and fled to Germany – to Mainz, where the following year a printing office was set up, and copies of the *Doctrinale of Alexander Gallus* were immediately produced.

Junius claimed that the story had been reliably told to him by another member of Coster's workshop,[9] who had, much to his subsequent revulsion, shared a bed on many occasions with the nocturnal thief. As further proof, wine pots could still be viewed which were made from the melted-down metal of Coster's types.

In 1628 another writer, Petrus Scriverius, recounted the Coster story; the legend now found ready acceptance in the Netherlands. The young Dutch republic, in the final stages of its eighty-year struggle for freedom from Spanish domination, and growing rapidly in wealth and influence, was hungry for national heroes, and Coster was enthusiatically taken up. Scriverius's book even featured a

9 Only barely plausible, as the informant would have had to have been about a hundred years old at the time Junius interviewed him.

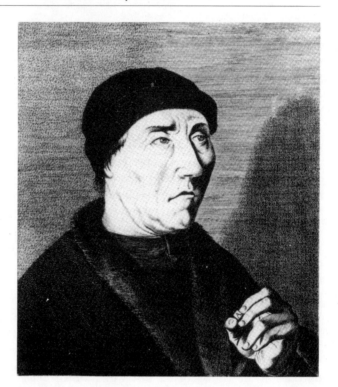

7 'And all he left was this letter A … ' Legend presents Laurens Coster as the victim of a malign Santa Claus, having all his toys taken away on Christmas Eve. This is the first portrait of Coster, from Scriverius's seventeenth-century retelling of the story.

convincingly unheroic, jowly portrait of Coster, holding a piece of type bearing the letter A. He wears a disappointed and slightly aggrieved expression, as well he might, having had all the tools of his trade carried off by a trusted assistant. The Haarlem painter Jan de Bray's 1663 portrait of prosperous printer Abraham Castelyn and his wife shows Castelyn seated at ease among his books and a giant globe of the world, with a bust of Coster emerging from the shadows in the background.

The problem with Scriverius's retelling, and that of Jacobus Koning in the early nineteenth century, was that the facts didn't quite tally. Later versions have the central character as Laurens or Lowerijs Janszoen, not Coster at all, and put his death as early as 1439. During his walk in the woods he cuts the letters, wraps them in paper and falls asleep. It rains, Coster (or Janszoen) wakes, and sees that the soaked wooden letters have made an image on the paper wrapper. The mysterious thief Johann, previously held to be either Johann Fust or even Gutenberg himself, becomes Gutenberg's brother Friele.

However, by now Haarlem had taken Coster com-

pletely to its heart. An 1823 'Costerfest' was followed by an even bigger event in 1856, when the 1722 statue of Coster, portraying him in laurel-festooned Roman garb, was moved from its position in the Grote Markt, the central market square next to the cathedral, and back to its original site in the Prinsenhof, a smaller adjacent square. It made way for a considerably larger memorial in bronze, with Coster wearing more historically accurate clothing but still holding up the letter A. The plinth of the statue bore the unequivocal tribute: 'Inventor of the art of printing with movable letters cast in metal'. Along with the statue, a memorial tablet was unveiled in the church, all of this amid enormous celebrations.

Nevertheless, there were doubters. In 1867 A. J. Enschedé, of the Haarlem type founders and printers Johann Enschedé, published documents from the archives containing evidence that Coster was still alive in 1447 and selling candles. In 1871 Antonius van der Linde published *The Haarlem Legend of the Invention of Printing by Laurens Janszoon Coster, Critically Examined*. Van der Linde was himself a Haarlemer, and a prolific writer on theology, philosophy and his great passion, chess. He tore into the supporters of the Coster claims, scornfully questioning the reliability of earlier sources, particularly Junius, whom he accused of talking up the Coster legend to please his adopted home town. *Batavia* contained recountings of factually ludicrous folklore and, van der Linde asserted, the Coster story was just one more example.

Van der Linde believed that the Coster camp had made themselves completely ridiculous by compounding two distinct people, Laurens Jaszoon, who died in 1439, and Laurens Janszoon Coster, who first appeared in town records in 1436, and was last registered having paid a ferry toll to leave in 1483. All that connected these two people was the fact that they had both been innkeepers at some point in their careers.

Of the 'Costeriana', the blanket term given to all early unnamed and mostly undated Dutch printed material, van der Linde declared that there was no evidence that it pre-dated Gutenberg's Bible (an assertion with which most modern scholars would agree), or that it was printed with movable type, being more probably the product of xylography – printing from carved wooden blocks. The man whose statue now stood in the square in Haarlem

had nothing whatsoever to do with printing, and he and the memorial tablet in the cathedral should be removed as a national embarrassment. Van der Linde concluded with the pronouncement of a death sentence on Coster: 'He expresses our ridiculous self-adoration, and it is a *national* interest to destroy him.'

The book caused an uproar; van der Linde was labelled a psychopath, the 'Coster-murderer'. But much of what he said would chime with contemporary thinking, and the idea of the type spirited away on Christmas Eve, charming as it is, does suggest an attempt to shore up the argument by discrediting a rival claim with an accusation of industrial espionage.

The English translator of van der Linde's book, Jan Hendrik Hessels, was also from Haarlem, and held an MA from Cambridge University. His introduction was reserved in tone. Despite Dr van der Linde's apparent wholesale demolition of the claims of the Coster supporters, Hessels drew the reader's attention to

the existence of a comparatively large number of works – block books and incunabula[10] – which are of an incontestably early, and Dutch origin, and which cannot, even at present, be ascribed to any known printer, but of which it is certain that they belong to the printer who produced the four editions of the *Speculum Humanae Salvationis*, the book referred to by Junius.

A greater part of these works – which we might still call, for the sake of convenience, Costeriana – consists of different typographical editions of *Donatus*, the very book in which, according to the famous passage in *The Cologne Chronicle* on the invention of printing 'the first prefiguration was found and which was printed in Holland before that time'.

We find, moreover, among these Costeriana a goodly number of different editions of Alexander Gallus' *Doctrinale*, a little school-book, of which it seems that copies, *gette en molle*,[11] were sold at Bruges and Valenciennes in 1446 and 1451, and which is also mentioned by Junius as being the first book printed at Mainz with the type stolen from Coster.

10 The term incunabula is taken from a seventeenth-century phrase coined by Bernard von Mallinckrodt. Contributing to a bicentennial piece celebrating Gutenberg's invention, he referred to the period up to the start of the sixteenth century as '*prima typographiae incunabula*', when typography was in its infancy, its 'swaddling clothes'.

11 One interpretation of this is 'cast in a mould' (*The British Colonial Printer and Stationer*, 12 May 1898, and elsewhere), but its precise meaning remains elusive.

In 1887 Hessels went on the offensive. In *Haarlem, the Birth-place of Printing, Not Mainz*, he launched into a criticism of van der Linde's research techniques, then, instead

of trying to mount a new defence for Coster, took the battle into enemy territory by questioning the validity of Gutenberg's claim. Of Ulrich Zell's statement in *The Cologne Chronicle*, the first part, about printing having been invented in Germany, had, he asserted, been directly copied from an earlier book, *The Nuremberg Chronicle* of 1493. Dismissing the hypothesis that because Zell had been a pupil of Peter Schoeffer he might wish to detract from Gutenberg's glory by mentioning an earlier source, Hessels asks why then refer to Holland at all, if there was no truth in what he was saying?

Likewise the 1455 lawsuit between Fust and Gutenberg does not show the latter making any claims to having invented a printing method; Fust and Schoeffer's colophon to their 1457 Psalter refers to an *adinventione*, which Hessels believed implied a new development of an existing method rather than a claim to invention. This, argued Hessels, they would surely have included to forestall any counter-claims by Gutenberg. He stressed that any such claim was in fact non-existent; Gutenberg's own colophon to his 1460 *Catholicon*[12] again omits any reference to invention. Hessels argued that it is only after Gutenberg's death that we have any evidence of him being credited with the invention, and that these assertions can be traced to former employees, or to the monastery of which Gutenberg became a lay member. Any idea that Gutenberg was the inventor of movable type, he concluded, was actually circulated by Gutenberg himself.

To bolster Coster's claim, he stated that the term *gette en molle* had never, at least since the 1470s, been applied to xylographic works, so it was not unreasonable to suppose that the books that the Abbot of Cambrai mentions in his diaries, the *Doctrinales*, were indeed typographic works, and that furthermore no xylographic *Doctrinales* were known to exist. *Someone* had printed the Costeriana, which he dated no later than 1446; even if the date on Thomaszoon's pedigree has been tampered with, why would Thomaszoon make such a statement about Coster if it was not held by some to be the truth? Why open himself to ridicule with a patent lie? The Laurens Janszoon who was buried in 1439 was an unconnected irrelevance. Reinterpreting the burial documents, Hessels asserted that his relations clearly could not meet all the

12 It is now believed to be questionable that it was in fact printed by Gutenberg, but he may well have been involved in a supervisory capacity.

expenses; he was not a man of means, and therefore not the earlier Laurens Janszoon of the legend. The only part Hessels couldn't square with his theories was the statement that Coster had grandchildren, which made him too old to fit the documentary dates.

Laurens Coster is the typographical equivalent of the Loch Ness Monster; if you like theories that upset an established notion, he holds an irresistible attraction, an attraction that collapses the instant a logical analysis of the evidence is applied. But the announcement of any new sighting by a reliable witness immediately, against any better judgement, sets hopes rising again. Albert Kapr accepts Coster as possibly 'a not insignificant producer of block books'. And Otto Fuhrmann, in his 1940 book *Gutenberg and the Strasbourg Documents of 1439*, seems by his description to draw an indistinct figure to the very edge of our pool of light: 'Where, when, and by whom the early Dutch prints were made, we do not know. They might have been simultaneous to Gutenberg, possibly earlier. They were a singular attempt by one man; nobody carried on after him. Whether Gutenberg ever saw one of these, presumably older, Dutch prints and was influenced by it to experiment along similar lines, we have no means of ascertaining.'

Fuhrmann's speculation is that the Dutch printer was a man of lesser education than Gutenberg, and went for the lower end of the projected market for printed work: schoolbooks and pamphlets. Ulrich Zell's statement in *The Cologne Chronicle* indicates that *something* was going on in the Netherlands prior to Gutenberg, and it would be nice to think that Coster may have been involved. But subsequent opinion, and absence of any new credible evidence, has given van der Linde's standpoint the ascendancy. As the inventor of movable type, Coster stands entirely discredited – 'Only Dutch schoolchildren believe in Coster: no scholar does.'[13]

But whatever the truth of the theories and counter-theories, Coster still commands a high visual presence in Haarlem. If he's a fake, then he's the most successful one in the history of human communication. As well as the statue in the Prinsenhof, what is said to have been Coster's house on the north side of the Grote Markt carries a memorial niche, Coster again holding his favourite letter. And there too stands the giant 1856 statue,

13 Gerard van Thienen, Curator of Incunabula at the Royal Library in Amsterdam, e-mail to the author, 2002.

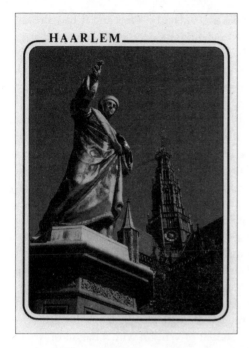

8 Typographical tourism: Coster's statue is still a prominent Haarlem attraction, featured here on a contemporary postcard. If he's a fake, then he's a real fake.

its metal now oxidized to a glorious Statue of Liberty green, Laurens Janszoon Coster still unrepentantly holding aloft his letter A for all the world to see.

In the end it doesn't really matter who got there first. What is important is that printing with type arrived in Europe and flourished. Gutenberg unquestionably gave us a typeface, in addition to presumably working out a formula for the alloy to make metal type – 80 per cent lead, 15 per cent antimony and 5 per cent tin – and for printing ink. His typeface was a blackletter, also known as textura – upright characters, angles and straight edges instead of curved strokes, condensed and with short ascenders and descenders, designed with the aim of getting as many words on a page as possible. But as the intellectual tides of European thought swept south, blackletter would almost immediately meet with strong typographical competition.

It survived as a text face in northern Europe for nearly five hundred years; in Sweden until the late nineteenth century, and in Germany until the Second World War. In England the first printed books, by William Caxton, used blackletter, but his foreman Wynkyn de Worde, 'the father of Fleet Street', was using roman type (the

lettering style we use today) by 1520, and it had already been present in England for a decade. Shakespeare's plays were first printed in roman type.

In England blackletter took the form of that curved, convoluted and spiky lettering which has proved strangely tenacious in its grip on the public consciousness. As it exists today, usually called Old English, its use is almost totally vernacular. Safe to say, beyond the mastheads of newspapers, it is never employed by trained designers except ironically. But any establishment that calls itself 'Ye Olde Tea Shoppe' almost inevitably uses Old English on its frontage. Its use on shop signage still remains extremely popular in northern France; this seems to add some substance to Paul Renner's argument in the 1920s that it was in that region that blackletter originated, and that it was therefore not in essence a German typeface (see Chapter 11).

The associations of Old English are cosy, evoking an idealized medieval England where the local tavern would serve a haunch of venison with a flagon of mead, while a wandering minstrel in tights strummed a lute. But elsewhere in Europe other versions of blackletter would ultimately take on associations that would be far more sinister, as the 'house' type style of Hitler's Third Reich.

As revolutions in type aesthetics go, there has probably never been one as dramatic in purely visual terms as the adoption, from the sixteenth century onwards, of roman lettering at the expense of blackletter. Although printing was a northern European development, it occurred in the middle of the period of European history that we now designate the Renaissance, the centre of which was northern Italy. The Renaissance ('Rebirth') is seen as a cultural and intellectual reawakening that drew its inspiration from the values and artistic styles of classical antiquity; a period of scientific enquiry, geographical exploration and the emergence of the philosophy of humanism, which valued the personal worth of the individual rather than total submission to religious belief.

The Renaissance saw a dramatic change in painting – the use of perspective, proportion and the illusion of space and depth, instead of the flat decorative styles that had been prevalent. And there was a corresponding

development in the fledgling art form of typography. Gutenberg's blackletter enjoyed only a couple of decades of dominance before it came under threat. The outside world was soon to take an interest in developments in Mainz; Nicolas Jenson (1420–80), in his role as Master of the Mint at Tours in France, was sent in 1458 by Charles VII to find out more about printing. By 1470 he was in Venice, where he cut the first roman typeface, based not on handwritten manuscripts, as Gutenberg's had been, but designed according to typographic principles, with a consistent size and width for each character, and an evenness which meant that each character could work visually with any other combination of characters. It was to be a model for typeface design through to the modern age.

Jenson had designed a roman typeface in response to the great revival of interest in the Italian city states in the writing of classical authors such as Cicero and Virgil. The handwritten style they had used, the roman, was becoming the preferred form. They were known as the Humanists, and this term was also used to describe the typefaces they inspired.

Venice was also the birthplace of the first italic type-face. The publisher and printer Aldus Manutius (1450–1515), seeing the potential market for cheap, pocket-sized books, was inspired, with the help of his punch-cutter, Francesco Griffo, to develop a space-saving typeface.

As a typographical revolution the rise of the roman face would have been a relatively slow-moving one, but a revolution it was none the less. Perhaps the popularity of the roman style spread as it became synonymous with change and new ideas, an early instance of a style of lettering having a cultural significance, a meaning beyond that of the actual words it is forming. To use an anachronistic expression, it became *cool*.

2 | Dynasty: in which William Caslon makes Britain the type centre of the world

Joseph Jackson rubbed his aching jaw resentfully. All he'd done was to show Mr Caslon his first attempt at cutting a punch, hoping the master would be pleased at his initiative. What he'd got for his trouble was a blow to the face and a threat of jail if he ever tried such a thing again.

Maybe he had been wrong to make that hole in the wall so he could watch how the master and the young master cut the punches. But if they always locked themselves away to do it, how was he to find out? Wasn't that what apprentices were supposed to do, learn the trade?

Well, those Caslons might rule the roost for now, but it wouldn't stay that way for ever. Other people could make their fortune in this typecasting business too. And maybe one of them could be Joseph Jackson.

Walking around London is an exhausting but rewarding activity, the opportunity to study in detail a thousand things that would go unnoticed when travelling by bus or car. Allow yourself the time, and an impression of the layers of history impacted on each other gradually emerges – the modern city on top of the Victorian city, the Victorian superimposed on the Georgian, all the way down to Anglo-Saxon Lundenwic and Roman Londinium, descending farther still to the lost underground rivers snaking their way around the capital, leaving their traces above the surface in street names and undulations in ground levels.

I decided to plot my own historical walk through one of my favourite areas of London, the City, and see what traces were left of the man who single-handedly created the type industry in Britain in the early eighteenth century, William Caslon. He founded not only type but a type-founding dynasty, for there were four William Caslons, numbered for easy reference, not to mention the Henry Caslons I and II and a couple of Elizabeths. Like any good family from a TV soap, they fought with their business rivals and with each other,

and the female members were as capable as the men; the Elizabeths took over the running of the foundry in the 1790s, nearly eighty years before the Married Women's Property Act gave women in Britain control over their own finances.

The man who started it all, William I, was born near Halesowen in Shropshire. His exact date of birth is open to dispute; it was usually given as 1692, but in his exhaustive study of the life of Caslon, *William Caslon: Master of Letters*, the author Johnson Ball cites baptismal records as evidence for putting the date at 1693, claiming that the inscription on Caslon's tomb as to his age at death is wrong.

But whatever the correct date, Caslon's story really begins a quarter of a century later in London, where he was apprenticed to a gun engraver in Vine Street, near the Tower. My journey began there too, although the territory had already been staked out for a historical tour; a notice told me that it was on the route of a 'Wall Walk' tracing the course of the old London city wall. This had long been outgrown by Caslon's time, but he would have still seen fragments of it around Vine Street during his time working there. Today Vine Street is an undistinguished back road, mostly delivery entrances and rear views of office buildings. No sign of Georgian London meets the eye, but even so, it's a place of significance. While working there, Caslon first won approval for his fine engraving of decorations on gun stocks and barrels. He also designed and created bookbinders' tools for applying the ornamentation to the covers. This involved the cutting of letters and ornaments into either brass punches for hot pressing on leather, or into steel ones for cold work. It was this aspect of his craft which was noted independently by two people, both printers. One was William Bowyer, the other John Watts, whose premises would give employment in the 1720s to the young Benjamin Franklin.

Printing and typography in England at this period were undergoing a prolonged creative low. A 1586 decree had prohibited printing outside London, with the exception of one press each at the universities of Oxford and Cambridge. This remained in force until 1695. The two universities were each allowed a type foundry, but a 1637 Star Chamber decree limited type production in England

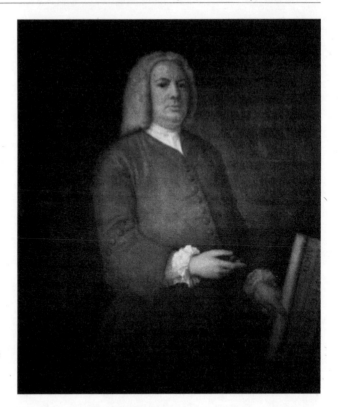

9 For mine is the kingdom: William Caslon I, master of all he surveyed, who revived the debased art of English type founding, and reversed the flow of imported type. He was painted by Francis Kyte in 1740, with Chiswell Street type specimen in hand.

to just four additional producers. During this period of political and religious strife, printing was regarded purely as a means of propaganda, to be rigorously controlled. Those given the right to print were by no means the best of their profession.

By the early eighteenth century, most type was still brought in from Holland, or indifferently cast from Dutch matrices, and printing quality was poor. We can only assume that the same idea independently entered the heads of both Bowyer and Watts. Could someone who was capable of such fine engraving work transfer that skill to cutting punches, and thereby bring about the production of better-quality type? The generally accepted story, as told by Talbot Baines Reed in *A History of the Old English Letter Foundries*, and recounted elsewhere since, is that Bowyer took Caslon along to the foundry of Thomas James, at this time located in the chapel of the church of St Bartholomew-the-Great. This was the second stop on my walk. The church, extensively but attractively restored at the end of the nineteenth century, is

still there in a quiet side street off Aldersgate, overlooked in the distance by the towers of the Barbican.

Caslon was shown the punch-cutters at work. Did he think he could do this sort of work? asked Bowyer. Give me a day to think it over, replied Caslon, and after due consideration he decided that he could. Bowyer and Watts, along with Bowyer's stepdaughter's husband, James Bettenham, advanced Caslon the money to set himself up in his new venture, in a garret in Helmet Row, off Old Street.

It's a romantic tale, says Professor Ball, but one that doesn't stand up to examination. Punch-cutting was a closely guarded skill. Would James have been likely to have allowed a complete stranger to take a look at these secret arts, with a view to setting up in opposition? Caslon himself reacted extremely violently to an attempt to discover and imitate his methods of punch-cutting, so Ball clearly has a point. He thinks it more likely that Caslon was asked whether he thought he could *cast* type; his work for bookbinders made it clear he could already cut punches with unparalleled skill.

Whatever the truth of events, in 1720 Caslon launched his new business. Helmet Row forms part of two Caslon centres in London. It still has some Georgian buildings, and it is perhaps not too fanciful to imagine that the face of Caslon may sometimes have gazed from one of the top-floor windows as he took a break from his work.

Helmet Row runs alongside the churchyard of St Luke's, an appealing but architecturally odd building, the steeple resembling an obelisk with a cross on the top. The church, which lost its roof in the late fifties, and lay closed as a danger to life and limb for decades, was at the time of writing covered in scaffolding and swathed in plastic. A Lotto grant has finally turned the long-abandoned shell into a music education centre for the London Symphony Orchestra. I had walked past the church scores of times in the previous decade without realizing its typographical significance. Seeing the builders' wooden perimeter boards blocking off the church and its surrounding area, I concluded that I had come at the wrong time to view the final resting place of Caslon, which I knew to be in the grounds of the church, or in the church itself.

I had paid only fleeting attention to the tomb enclosed

in dingy white railings that was the solitary feature in the neglected and weed-infested front courtyard. The inscriptions in the stone could be read only with difficulty, lichen-covered and pitted as they were by two centuries of metropolitan air. It was only on second inspection that I realized with something of a shock that I had found the object of my search, the family tomb not only of William Caslon I, but of his son William Caslon II as well. It felt like the moment in *The Lord of the Rings* when the dwarf lord Balin's tomb is found in the abandoned mines of Moria. The creators of the British type business were here, lying forgotten in this blighted spot as the traffic roared by.

The road flanking the other side of the churchyard at the Old Street end is now called St Luke's Close. But until recently it formed part of Ironmonger Row, where Caslon moved his premises in 1727. It was at these two addresses that Caslon's fortune and reputation were made. There was once a Caslon Street immediately to the east of Ironmonger Row, rechristened in his honour in the 1930s. Bethnal Green, to whose rural charms William I was to retire, had a Caslon Place. Both are now gone, obliterated by modern developments.

Although William I was to become celebrated for his roman alphabets, his first notable successes were in cutting Eastern founts. The Society for Promoting Christian Knowledge needed to print a New Testament and Psalter for poor Christians living in the Middle East, and approached Caslon to cut an Arabic fount. This he did, but he also cut the letters of his own name in what he called Pica Roman,[1] and put it at the bottom of the specimen of the Arabic fount. When this was seen, it provoked demands for the face, so he went ahead and cut a whole alphabet plus an italic version. This was the commercial breakthrough. Business boomed, and by 1730 he could be said to have single-handedly stemmed the flow of foreign type into Britain, and indeed to have reversed the traffic, as his own productions were exported to Europe. He became the sole supplier of founts to the King's printers.

Caslon also cut Armenian, Coptic, Etruscan Ethiopic and Old English faces – his 1734 specimen contained thirty-eight founts, thirty-five of them cut by Caslon, and informed prospective customers: 'The above were

1 Pica referred to the size of the type, just as later, with Two Lines English Egyptian, Egyptian was the name of the typeface and Two Lines English was the size, equivalent to about 28pt. Before the point system used today there was a kind of pounds, shillings and pence of type sizes: Non-pareil was about 6.5pt, Brevier about 8pt, Long Brevier a little less than 10pt, Small Pica about 10.5pt. Pica was 12pt, and English about 13.5pt. Great Primer was about 17pt, Double Pica about 20pt and Three Line Pica 36pt.

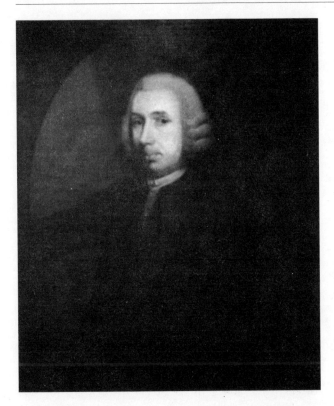

10 Carrying on the family business: William Caslon II, by an unknown artist. With his father, he was an exponent of the school of two-fisted punch-cutting.

all cast in the foundry of Mr W Caslon, a person who, though not bred to the art of letterfoundry has, by dint of genius, arrived at an excellency in it unknown hitherto in England, and which even surpasses anything of the kind done in Holland or elsewhere.'

Caslon clearly subscribed to the dictum 'If you've got it, flaunt it'. In 1737 the foundry moved to new premises in Chiswell Street, near to what is now Liverpool Street Station. A short walk west from the station across Moorgate brings you there, to this second Caslon business centre. It too retains some Georgian architecture, although not on either of the sites the Caslon foundry occupied at different stages in its history; both were demolished by German bombs in 1940 and 1941. But from the surviving eighteenth-century structures we can get a good idea of what they must have looked like. On one of these sites, a stone-clad monstrosity of a 1980s office building carries a London County Council blue plaque commemorating the site of the Caslon foundry from 1737 to 1909.

The north end of the street directly opposite, Moor Lane, was actually named Type Street by one of Caslon's later competitors, Edmund Fry, when he moved his business there in 1788. But sadly the name is gone now, as is everything else from that period. It is another street devoted to goods entrances. Chiswell Street still has the old Whitbread Brewery buildings, no longer operational, now renamed 'The Brewery – the unique venue in the City'. William I's daughter Mary married one of the Whitbread partners, and William himself was apparently partial to a bit of home-brewing.

In 1739 Caslon bought half of Robert Mitchell's foundry, and by the end of the 1740s the company was called William Caslon and Son; William I had been joined by William II (1720–78). All punch-cutting was done in secret; the Caslons would lock themselves in to perform these duties, away from prying eyes. But one of their apprentices, Joseph Jackson, was keen to extend his skills, and drilled a spyhole so he could see just what his masters were up to. He was able to glean enough information to produce a punch of his own. Proudly but unwisely showing it to William I, he received a blow for his pains, and a threat of jail. To Caslon this was tantamount to stealing trade secrets; now Jackson had the basic knowledge, he could pose a future economic threat to the company.

This wasn't a groundless fear. Jackson's mother bought her son punch-cutting tools so that he could hone his forbidden skills outside working hours. In 1757, following agitation by the foundry workers for higher pay, Jackson and Thomas Cottrell were sacked as ringleaders. Both were to set themselves up in the type-founding business as rivals to the Caslons.

William I died in 1766, and William II in 1778. The running of the foundry now passed to William II's wife Elizabeth (1730–95), with her son William III (1754–1833) only joining her as an active partner some time later: 'Mrs Caslon … had for many years habituated herself to the arrangements of the foundry; so that when the entire care devolved upon her, she manifested power of mind beyond expectation from a female not then in very early life.'[2]

The forty-eight-year-old Mrs Caslon's power of mind stood her in good stead, for William III was not

2 Obituary, *The Freemason's Magazine and Cabinet of Universal Literature*, March 1796.

11 A woman's work: the first Elizabeth Caslon, who confounded contemporary preconceptions of women in business by successfully running the foundry after the death of her husband, William II.

to be an enduring partner. The foundry's success had by now spread globally; in 1776 the American Declaration of Independence was set in Caslon type, and later the United States Constitution. Caslon's type was championed by Benjamin Franklin, presumably because John Baskerville, Franklin's good friend and in his own mind at least Caslon's great rival, was now dead (see Chapter 4). In Britain type-founding was now a cut-throat business, with some competitors just around the corner in much of what is now the Barbican area of London. As well as Jackson and Cottrell there was Edmund Fry, and in Scotland Andrew Wilson.

In the 1785 specimen book, William III claimed that the Caslons' 'uncommon Genius transferred the Letter Foundry Business from HOLLAND to ENGLAND', and raged against his competitors who 'promise (in order to induce Attention and Encouragement) that they will use

their utmost Endeavours to IMITATE the Productions of this Foundry'.

In 1792, following a disagreement with his mother, William III split the foundry into two, selling out to Elizabeth and buying the business of the recently deceased Jackson. He moved his new acquisition to Finsbury Square, just down the road from Chiswell Street. But by 1794 he was bankrupt, and restarted the foundry back at Jackson's former location near Fleet Street. Elizabeth was meanwhile joined by a second Elizabeth Caslon, the widow of her youngest son Henry. They continued together until the first Elizabeth died in 1795, when the company was bought at auction by her namesake. *Her* son, Henry Caslon II, took over on her death. The company became Caslon, Son and Livermore in the 1820s, and later H.W. Caslon. It continued until 1937, when it was bought by Stephenson, Blake and Co.

On the other branch of the tree, William III was joined in 1803 by his son William IV (1780–1869), and their company became W. Caslon and Son, and on William III's retirement in 1807, William Caslon Junior. William IV sold the foundry in 1819 to Blake, Garnett and Co., who removed it to Sheffield in Yorkshire.[3] He now devoted himself to a scheme to illuminate London with coal gas, receiving the medal of the Society of Arts for his work, but no financial benefits, having failed to patent any of his innovations. He became blind in 1842, but lived another twenty-seven years. He invented a writing aid for the blind, and was described in a contemporary tribute as 'an example of cheerful old age'. But shortly before his death he understandably professed to being 'tired of being so long in the dark'.[4] He died in 1869.

William I's typographic achievement was qualitative and economic rather than a question of design; the Pica Roman was based closely on an existing Dutch type. But it was Caslon's skill as an engraver which lifted English type into a new division, a Champions League in which it could compete with the best that Europe had to offer. Caslon survives as a popular face into the present day, and can be classified as a Dutch Old Style. Old Style faces have less contrast between the thick and thin strokes, and the Dutch phase, the last, had a larger x-height than previous incarnations. So many versions of Caslon have been produced in the nineteenth and

3 Blake, Garnett and Co. later became Stephenson Blake, so the 1937 purchase finally reunited the two branches. The Caslon name was retained by forming a new company called H.W. Caslon Ltd at Stephenson Blake's headquarters in London's Aldersgate Street, and their Sheffield foundry was renamed the Caslon Letter Foundry. Stephenson Blake's company pedigree, which they traced back to the first English printer, William Caxton, included, as a result of various purchases and metamorphoses, nearly all the major eighteenth-century London foundries – Jackson and Cottrell, Robert Thorne, Fry's and William Thorowgood. Stephenson Blake's archives now form part of the collection of the Type Museum (see Detour 1). The name H.W. Caslon now exists in cyberspace as <www.hwcaslon.com>, a website selling digital re-creations of original Caslon faces.

4 Obituary, *The Printer's Register*, December 1869.

twentieth centuries that they have moved away consider-
ably from the original. A consistent distinguishing feature
is the obliquely cropped apex of the upper case A, and
the italic is *very* italic, condensed and sloping – it usually
needs a little letterspacing to make it easier on the eye.
In some versions, including the ITC Founder's Caslon,
which is a digital reconstruction of the eighteenth-
century originals, the upper case italic A, V and W seem
to slope even more than the lower case. The upper case
roman Q in Founder's Caslon has a very long tail, but
this has been modified and reduced on versions produced
in the following centuries. Curiously, a version of New
Caslon Italic on offer in the 1980s used the design of
the original upper case italic J as an alternate F.

Johnson Ball points out that subsequent versions of
Caslon tend to look anaemic compared to the originals.
We have to take into account the ink spread that would
have occurred on the lower-quality paper of Caslon's
day, dampened to help the impression as the type was
driven into the surface.

In terms of innovative type design, the prize actu-
ally went to the least assuming William Caslon – the
fourth. Under his auspices the foundry offered for sale
the first commercially available sans serif, although it
appears unlikely that they realized the ground-breaking
nature of what they were doing, or even considered it
of particular value. The 1816 Caslon specimen featured
a face called Two Lines English Egyptian.[5]

Egypt had come into vogue at the end of the eight-
eenth century. Napoleon had invaded the country in
1798, taking more than 150 scholars and artists to record
and interpret what he found there. Horatio Nelson won
a victory against the French fleet at the Battle of the
Nile in the same year, and steady French military losses
compelled them to sign the Treaty of Alexandria in 1801.
By its terms all Egyptian antiquities acquired by the
French expedition had to be forfeited. One of the many
items thereby making its way to the British Museum
in London was a find of enormous archaeological value
– the Rosetta Stone.

French engineers constructing defences at el-Rashid
near the Egyptian coast had discovered a fragment of a
massive stone slab on which was inscribed an Egyptian
royal decree from 196 BC. What was dramatic about

AEM
gpm

12 Caslon: not so much a new
design, drawing as it did on
existing Dutch examples, but
a qualitative leap for English
type, Caslon's punch-cutting
skills raising the bar for would-
be competitors.

Why

Caslon italic. The W appears to
slope even more than the other
characters.

5 The term 'Egyptian' was
confusingly applied to both sans
serifs and slab serifs, the early
nineteenth-century advertising
faces with strokes and squared-off
serifs of the same or similar
thickness (see Chapter 5).

13 Soft sell: the unobtrusive arrival of the first commercially available sans serif, Two Lines English Egyptian, buried among more ornate neighbours. Its first known appearance was in about 1816, but there are no known examples of its use before the 1830s.

CANON ITALIC OPEN.

CUMBERLAND.

CANON ORNAMENTED.

TYPOGRAPHY.

TWO LINES ENGLISH EGYPTIAN.

W CASLON JUNR LETTERFOUNDER

TWO LINES ENGLISH OPEN.

SALISBURY SQUARE.

the stone was that the inscription was in three forms: Greek, which European scholars could read, Demotic, the everyday language of literate Egyptians, and hiero-glyphics, the written language of the Pharaohs. Working on the premise that it was the same message repeated three times, it now became possible to begin interpreting the hieroglyphics, a hitherto impossible task.

The Greek characters were inscribed in a simple one-stroke cut which could be termed sans serif, purely because there were no serifs. The simplicity of sans serif was therefore seen as being in spiritual affinity with the stylish simplicity of Egyptian artefacts. Some artists and architects were already using sans serif lettering by this point, its ancient Greek precedents giving it a desirable classical pedigree.

> Why was [Two Lines English Egyptian] made? If it appears in a typefounder's specimen, a type is at least nominally offered for sale, but there is no known example of the contemporary use of this one. Its appear-ance, set between lines of bold inline roman and italic titling capitals, is oddly inconspicuous, and one is led to the suspicion that it may well have been made by the founder, willingly or not, to the specification of a client to whom – from having seen it in other locations – this new 'Egyptian' letter was already familiar and acceptable. But as for the identity of this hypothetical client, and the use for which it was intended we are wholly in the dark.[6]

All very mysterious. The foundry, always with a business eye alert to new trends and developments, undoubtedly saw sans serifs being used for advertising or inscriptions, and arguably tried to cover that particular base by cut-ting their own face. Perhaps a lack of confidence in the face's potential meant its arrival went unheralded. It was

6 James Mosley, *The Nymph and the Grot*, London, 1999.

offered for sale by Stephenson Blake throughout most of the nineteenth century, but none of the few known examples of its use pre-dates the 1830s. It is probably safe to say that the face wasn't an overnight success.

But in 2000 Two Lines English Egyptian made a significant reappearance. When Dulwich Picture Gallery in south London reopened following refurbishment and the building of an extension, lettering modelled on Two Lines English Egyptian was used for the exterior gallery name and directional signage. Although sans serif lettering comes as a surprise for a gallery of this age, England's oldest public gallery with a collection of almost entirely pre-nineteenth-century pictures, it was actually a harmonious and adventurous choice. The connection was Sir John Soane, the architect of the original gallery buildings.

The gallery's collection had an unusual birth, assembled in the 1790s as a national collection for Stanislaus Poniatowski, the King of Poland. But by the time the pictures were assembled, neither Poniatowski nor Poland was there to receive them. The country had disappeared from the map of Europe, partitioned for the third and final time by its voracious neighbours, and Poniatowski had been forced to abdicate.

The inheritor of the pictures left a bequest to Dulwich College to build a permanent gallery for them, with a wish for the architect to be his friend Sir John Soane. The gallery was opened to the public in 1817.

Soane had rebuilt the Bank of England, and was later, after falling out with both his sons, to leave his house in Lincoln's Inn Fields in London as a gift to the nation. It's possibly the capital's finest little-known attraction, a bizarre and beautiful place with a labyrinthine interior that is home to Hogarth's *The Rake's Progress* series, and all the collectings and unconsidered trifles of Soane's magpie mind. In the upstairs rooms can be seen some of his architectural drawings, and the hand-drawn lettering Soane used on them is sans serif, which he had been favouring since the 1780s. Given that he was an early exponent of the style, it was a fitting tribute to Soane to use Caslon's pioneering and contemporaneous design to grace the twenty-first-century rebirth of one of his most unusual and startling buildings.[7]

7 The founders of the collection are buried in a mausoleum within the gallery, bathed in an eerie golden light which filters through coloured glass in the small windows high in the roof, a classic Soane treatment.

3 | Garamuddle: when is a sixteenth-century typeface not a sixteenth-century typeface?

Looking at the pre-nineteenth-century typefaces that are still in widespread use today is a little like visiting a modern re-creation of an Anglo-Saxon village. If you ignore the aircraft passing overhead you can easily imagine yourself back in the first millennium. But however absorbed the inhabitants seem in their daily tasks, you know that at the end of the day they will take off their coarsely woven garments, slip into some Lycra and head home, probably picking up a takeaway and video en route. However convincing it all looks, in reality it's an elaborate fake.

And that's just how it is in the world of type. You may think you're working with actual letter forms drawn in the sixteenth century, but they're actually a twentieth-century re-creation based on the originals, or what were thought to be the originals. It can get confusing. Plantin was based on a face cut by the French type designer Robert Granjon (working 1545–88); the printer Christopher Plantin himself never used the original source type. Janson, designed in 1937, is named after a Dutchman, Anton Janson, who had nothing to do with the face at all; the design was inspired by the work of the Hungarian Nicholas Kis (1650–1702). The various versions of Baskerville are all twentieth-century work; the earliest one was not even based directly on Baskerville's type, but on what came to be known later as Fry's Baskerville, a piece of eighteenth-century intellectual piracy.

In 1924 George Jones designed a face for the Linotype company which he called Granjon, but the design he used as inspiration turned out to be the work of Robert Granjon's fellow countryman and contemporary Claude Garamond (c. 1500–61). And the typefaces that bear Garamond's name – well, as the saying goes, fasten your seat belts, it's going to be a bumpy ride …

Garamond had long been regarded as one of the type designers par excellence of the century that followed Gutenberg's invention of movable type. Using Aldus Manutius's roman type as his inspiration, Garamond

had cut his first letters for a 1530 edition of Erasmus. It was so well regarded that the French king François I commissioned Garamond to design an exclusive face, the Grecs du Roi. Although Garamond's typefaces were very popular during his lifetime and much copied, as with many of the early type designers the work didn't bring him much financial reward. When he died, his widow was forced to sell his punches, and his typefaces were scattered throughout Europe. Garamond the typeface gradually dropped out of sight, to disappear for nearly two centuries.

In the nineteenth century the French National Printing Office, looking for a typeface to call its own, took a liking to the one that had been used by the seventeenth-century Royal Printing Office, operating under the supervision of Cardinal Richelieu.[1] Richelieu called his type the Caractères de l'Université, and used it to print, among other things, his own written works. The nineteenth-century office pronounced the face to be the work of Claude Garamond, and the Garamond revival began.

But it was only after the First World War that the bandwagon really picked up momentum. Suddenly every type foundry started producing its own version of Garamond. American Type Founders (ATF) were first, then in 1921 Frederic Goudy (see Chapter 8) offered his interpretation, Garamont. Monotype in England brought out theirs in 1924, and Linotype replied with Granjon. There were yet more versions on the market by the onset of the Second World War, most notably Stempel Garamond by the German foundry of that name.

Back at ATF, the company that had started the rush, Henry Lewis Bullen,[2] librarian of the company's formidable archive, had nagging doubts about his company's product. One day, as recalled by his assistant Paul Beaujon, he declared: 'You know, this is definitely not a sixteenth century type … I have never found a sixteenth century book which contains this face. Anyone who discovers where this thing comes from will make a great reputation.'[3]

Beaujon wrote an article about the Garamond faces for *The Fleuron*, an English typographical journal (see Chapter 10). The pages had been proofed and the presses were ready to roll when Beaujon, visiting the North

AET
agm

14 Garamond: revivals of what was believed to be the work of Claude Garamond proved to be a misattribution.

1 Armand Jean Duplessis, Cardinal Richelieu (1585–1642), chief minister to Louis XIII, and effectively ruler of France for the last two decades of his life.

2 The Australian Henry Lewis Bullen (1857–1938) was publicity manager of American Type Founders and assembled their formidable typographical reference library, both to preserve the resources of the small American foundries driven into extinction by the creation of ATF, but also to provide invaluable research material for the company's own type revivals. Following ATF's financial problems in the 1930s the library was sold. Most is now in Columbia University, New York.

3 *The Monotype Recorder*, June 1970.

Library of the British Museum to check some dates, happened to glance at one of the items in the Bagford Collection of title pages. And there was the source type for all the twentieth-century Garamonds.

Except that this typeface wasn't by Garamond at all. It was the work of another Frenchman, Jean Jannon (1580–1658), a seventeenth-century printer and punch-cutter. As a printer he was unremarkable, but as a designer and punch-cutter he was unparalleled, cutting the smallest type ever seen, an italic and roman of a size less than what would now be 5pt. Frequently in trouble with the authorities for his Protestant beliefs, Jannon had eventually found work at the Calvinist Academy at Sedan, in northern France.

Cardinal Richelieu's early years of office under Louis XIII were spent in a power struggle with the Huguenots, the French Protestants. An effective way of hastening their eventual submission was to remove their means of spreading information, and the government paid the academy a visit. Among the items confiscated in the raid was Jannon's type. However, although Richelieu took exception to Jannon's religious affiliations, he liked his typography so much that his faces became the house style for the Royal Printing Office.

Following a swift trip to the Mazarine Library in Paris to compare impressions with their Jannon specimen book, Beaujon's original feature was pulled in favour of a new one revealing the true source of the 'Garamond' faces. It was hailed as a masterly piece of research, and the Monotype Corporation in England offered him the job of editing their in-house magazine. But the twist was that Beaujon, like the Garamond typefaces, was not at all what he appeared to be.[4]

4 | The maverick tendency: the type and strange afterlife of John Baskerville

The catacombs of Christ Church, normally a silent chamber of the dead, were, on this spring morning in 1893, filled with the living. It was an august gathering, including not only the Mayor of Birmingham, Lawley Parker, but Canon Wilcox the vicar, a coroner, a doctor, a surveyor, and Talbot Baines Reed, the type historian whose collection would later form the basis of London's St Bride Library. Under the low ceiling of the vault, their tall hats scraped the roof. Two men in workman's clothes stood ready, chisels and hammers in hand.

'Usually, we would never allow such an undertaking,' the canon was explaining in a low voice to the reporter from the *Birmingham Daily Argus*. 'It's only because this vault, which belonged to Mr Barker, our churchwarden back in the twenties, has no record of anyone actually having been interred within it. Therefore, the Church authorities have allowed the unprecedented step of opening it to see what, if anything, is inside.'

The assembly watched in silence as the men set to work. Their efforts soon removed the outer brickwork, only to reveal another wall.

'This looks unpromising,' whispered the canon. 'There can hardly be room for a casket behind that, surely.'

Taking up his tools once more, one of the workmen deftly knocked out two bricks from this second layer, and inserted his hand cautiously through the opening. 'There's a coffin in there, all right,' he informed the expectant dignitaries behind him. He resumed his efforts, and more bricks fell away. Baines Reed leaned forward excitedly. 'It's made of lead,' he exclaimed, 'and there appears to be something on the front.'

The glow from the wall light in the vault was subdued, but bright enough for the onlookers to see, soldered on to the head of the casket, reversed-image letters – metal type. They spelled out two words: John Baskerville.

'Gentlemen,' said Baines Reed, 'I think we've found our man.'

John Baskerville was a type designer by reason of personal

15 John Baskerville, painted by James Millar, the date unknown but probably towards the end of his life. Printing and type, his personal obsession for nearly a quarter of a century, left him disillusioned; 'this Business of Printing; which I am heartily tired of, & repent I er [ever] attempted', he wrote as early as 1762.

interest and obsession; it was not his profession or, despite his best efforts, a source of income. Indeed, the printing of his designs, for Baskerville an inseparable part of the process, became a considerable drain on his finances. He was a superb example of an eighteenth-century Renaissance man, capable of turning his mind to a wide variety of subjects, and arriving at original and practical solutions. In this way he is reminiscent of Benjamin Franklin, most renowned as a co-author and signatory of the Declaration of Independence, but a multi-faceted personality: printer, scientist, philosopher and one-time deputy postmaster general for the American colonies. It is perhaps unsurprising in the comparatively small world of eighteenth-century intellectual life that the two should have met, but Franklin was also to become a staunch supporter of Baskerville at a time when his own countrymen were largely antagonistic towards his work.

The only known portrait of Baskerville made during his lifetime shows a determined figure well kitted out in gold brocade, looking slightly disapproving of the business of having his portrait painted. But there is the

ghost of a smile playing around his mouth, below a pair of lively eyes. You get the feeling he is about to burst out laughing any moment at the absurdity of it all.

Baskerville was born in January 1706, or possibly late December 1705, in the parish of Wolverley in Worcestershire, in the English Midlands. His family were financially comfortable, but there is little concrete information about his life until 1728, when his name appears on a mortgage indenture on a Wolverley property, possibly to raise money to set him up in business. It has been claimed that in his late teens he worked as a footman. This would at first seem unlikely given his family's status, but Baskerville is supposed to have once declared that he had worked his way up from being a servant, so it may contain an element of truth.[1] Hidden away on the back of a pillar on the top floor of Birmingham Central Library is a small, engraved black slate sign:

> Grave Stones
> Cut in any of the Hands
> John Baskervill
> WRITING–MASTER

(The final e at the end of his name arrived later.) It seems likely that he at least designed, but possibly also cut, gravestones. If the money in 1728 was for business purposes, it would have been to start Baskerville as a teacher, a writing master. The slate sign is a beautiful piece of letter cutting, each line of text executed in a different style, as befitting its purpose as an advertisement: an ornate script, lower case roman, black letter and italic capitals. So his later move into type design wasn't an illogical one – he already had a solid background and experience in creating fine letter forms.

After his father's death in 1738 Baskerville began what was to be a profitable career as a japanner. Japanning was the application of a black varnish to metal household objects such as snuff boxes, buttons, candlesticks and picture frames, the resulting effect supposedly like fine mahogany or tortoiseshell. In the early years of the eighteenth century Birmingham had undergone a commercial revolution, and there was a great demand for such goods. No known example of Baskerville's work in this field survives, but the business made him wealthy,

1 John Dreyfus, in his article 'Baskerville's Books' in *Book Collector*, 1959, cites the Swede Bengt Ferrner, who mentions this fact in his account of his visit to the Baskervilles.

although not enough to retire. He continued japanning until a couple of years before his death.

By 1748, he had prospered to the extent that he was able to move into his newly built house, Easy Hill, the site of which is now in the centre of Birmingham. On the land lease he is described as a 'boxmaker'. As a clear indication of Baskerville's maverick tendencies, he was almost immediately joined there by his mistress Sarah Eaves. Sarah was already married with five children, but her husband had deserted her in 1745; only on his death in 1764 were she and Baskerville able to marry.

Baskerville's domestic set-up doubtless invoked moral disapproval, and although Sarah was a regular churchgoer, Baskerville seems to have become increasingly truculent towards organized religion and its ministers. It was said of him: 'He had wit, but it was always at the expense of religion and decency, particularly if in company with the clergy.'[2] His friend William Hutton was later to make a sympathetic appraisal of Baskerville's character in his *History of Birmingham*, written in 1835: 'If he exhibited a peevish temper, we may consider that good nature and intensive thinking are not always found together.'

Baskerville started printing in about 1751. What is striking about his work, always peripheral to his main occupation, was that Baskerville set about trying to improve the entire process, from the presses he used to the paper and the ink – and, of course, the nature of the characters he was printing. Technically printing had altered little since Gutenberg's day, but Baskerville was about to push it on to a new level. William Caslon's founts were the dominant force in English typography in this period, but Baskerville considered that their effect was frequently ruined by bad printing. It seemed essential to him that a type foundry should have its own printing press.

Probably unsurprisingly for someone used to analysing the quality and nature of black in the japanning trade, Baskerville was determined to produce ink that was blacker than that currently available. Once he had perfected his formula, his ink was left to stand for about three years before he used it. He also experimented with paper technology, reasoning that the quality of the printed letter could not improve if the quality of the paper did not. Using a closely guarded method of hot-pressing the paper between copper plates or cylinders to

2 The Reverend Mark Noble, an uncomplimentary commentator on both Baskerville and Sarah, in his *A Biographical History of England* (1806).

achieve an unprecedented smoothness, he then created a gloss surface, possibly after the sheets were printed, using a varnishing technique borrowed from japanning. This was a breakthrough, but one that was unfortunately to prove a key factor in his subsequent lack of commercial success in this new field.

In 1758 Baskerville met Benjamin Franklin, who had come to England with an introduction to Matthew Boulton. Boulton was a successful Birmingham manufacturer of silverware and ran a mint. He was also a founder member of the Lunar Society of Birmingham, a group of scientists that included in its ranks James Watt and Joseph Priestley.[3] Having himself worked in the printing trade both in England and the American colonies, Franklin was probably just as interested in meeting Baskerville, who had in 1757 produced his first book, the works of the Roman author and poet Virgil, printed by him and using his own type. This was seen as a sound commercial choice, as Virgil was experiencing a current upsurge in popularity.

The book was a creative triumph, not only for its production qualities, but also for its type and layout – although this was not unprecedented, Baskerville designed his title pages using wide letterspacing, and they have an elegance that contemporary productions lacked. Again untypically for the time, he relied on almost pure type for his effects, with very little ornamentation. Baskerville may have been spurred into type production by seeing the specimens issued by the Birmingham type founder William Anderton in 1753, and he may also have met Samuel Caslon, brother of William, at around the same time. Of his own type, Baskerville said he had 'endeavoured to produce a Sett of Types according to what I conceived to be their true proportion'.[4]

In other areas he was just as meticulous. Of a print run of two hundred books he would discard about fifty as failing to pass his quality control standards, and he would use his type only once, to avoid any subsequent damage or deterioration to the characters. Although possibly self-educated, he was a meticulous proofreader. (Later Baskerville productions, on which he relinquished the editorial chores to others, failed to maintain this standard.) A 1757 letter from his London bookseller, Robert Dodsley, finds the writer apologizing

3 James Watt (1736–1819) – not the inventor of the steam engine, but he improved it and made it commercially viable. Joseph Priestley (1733–1804) carried out ground-breaking work on gases, and discovered oxygen.

4 Preface to Baskerville's edition of John Milton's *Paradise Lost*, 1758.

AEM
fgh

16 Baskerville: 'the means of blinding the nation', a shock to contemporary eyes. The thin strokes have become thinner, the serifs finer.

for having advertised the Virgil as appearing at a certain date, a publication schedule now impossible owing to Baskerville's lengthy proof-correcting. When the Virgil finally appeared, Benjamin Franklin himself bought six copies, along with a selection of japanned goods.

However, Baskerville's work was collecting a growing force of detractors. Said one critic: 'We told him that the exceeding sharpness of his letter, and the glossy whiteness of his paper, both beyond anything we had been used to, would certainly offend.'[5] The paper seemed to cause the most irritation; it was too white, too shiny. But some found his type 'too sharp', as well. Baskerville's face is now described as Transitional; in contrast to Caslon's Old Style lettering there was greater differentiation between the thick strokes and the thin strokes, and this was the root of the trouble.

Franklin was valiantly and at times impishly fighting Baskerville's corner, and we have a marvellous example of his support in a letter of 1760. It was sent from Franklin's house in Craven Street, near what is now Charing Cross Station in London:

Let me give you a pleasant instance of the prejudice some have entertained against your work. Soon after I returned, discoursing with a gentleman concerning the artists of Birmingham, he said you would be a means of blinding all the readers in the nation; for the strokes of your letters, being too thin and narrow, hurt the eye, and he could never read a line of them without pain. 'I thought,' said I, 'you were going to complain of the gloss of the paper, which some object to.' 'No, no,' said he, 'I have heard that mentioned, but it is not that; it is in the form and cut of the letters themselves; they have not that height and thickness of the stroke, which make the common printing so much the more comfortable to the eye.' ... Yesterday he called to visit me, when, mischievously bent to try his judgement, I stepped into my closet, tore off the top of Mr. Caslon's specimen, and produced it to him as yours, brought with me from Birmingham; saying, I had been examining it, since he spoke to me, and could not for my life perceive the disproportion he mentioned, desiring him to point it out to me. He readily undertook it, and went over the several founts, showing me everywhere what he thought

5 F. E. Pardoe, *John Baskerville of Birmingham: letter founder and printer*, London, 1975, citing Edward Rowe Mores, *A Dissertation upon English Typographical Founders and Foundries*.

instances of that disproportion; and declared that he could not then read the specimen, without feeling very strongly the pain he had mentioned to me. I spared him that time the confusion of being told, that these were the types he had been reading all his life, with so much ease to his eyes; the types his adored Newton is printed with, on which he has pored not a little; nay, the very types his own book is printed with (for he is himself an author,) and yet never discovered this painful disproportion in them, till he thought they were yours.[6]

Baskerville must have been justifiably amused on reading this, yet may be excused a growing feeling that they were all out to get him. He clearly appreciated the letter, though, and used it as advertising copy for his 1763 edition of the Bible.

He must have chuckled at the unconscious criticism of Caslon; Baskerville comes across as an eighteenth-century Brian Wilson to Caslon's Beatles, driven to creative heights by a sense of rivalry of which only he was aware. In a letter to Robert Dodsley giving impressions of some of his punches, he adds the nervous postscript: 'Pray put it in no-one's power to let Mr Caslon see them.' In the Preface to his edition of *Paradise Lost*, Baskerville praises Caslon in a way that reveals his obsession with him, and his belief that he had bettered him at his own game:

> Mr Caslon is an Artist, to whom the Republic of Learning has great obligations; his ingenuity has left a fairer copy for my emulation, than any other master. In his great Variety of Characters I intend not to follow him; the Roman and Italic are all I have hitherto attempted; if in these he has left room for improvement, it is probably more owing to that variety which divided his attention than to any other cause. I honour his merit, and only wish to derive some small share of Reputation from an Art which proves accidentally to have been the object of our mutual pursuit.

Whatever opinion Baskerville had of his own work, the public just weren't buying in great enough numbers. He had to borrow money to produce his Bible, and a letter of 1762 to the Member of Parliament Horace Walpole lays bare his financial woes and sense of grievance; although

6 *Letters of the famous 18th Century printer John Baskerville of Birmingham together with a bibliography of works printed by him at Birmingham*, ed. Leonard Jay, Birmingham, 1932.

he has lowered his prices as much as he can, booksellers will not give him orders. He professes himself 'heartily tired' of the printing business, in which he wishes he'd never got involved: 'It is surely a particular hardship that I should not get Bread in my own Country (and it is too late to go abroad) after having acquired the Reputation of excelling in the Most useful Art known to Mankind, while everyone who excels as a Players [*sic*], Fidler, Dancer, &c. not only lives in Affluence, but has it in their power to save a fortune.'[7]

Baskerville goes on to say that he is trying to sell his complete business to a European court, though this would be a national disgrace; a friend who had been given 'a handsome premium for a quack Medicine' by Parliament had suggested he approach them for finance himself. Baskerville is feeling sorry for himself, but his lamentations have a familiar ring to them – the creative mind that has to leave Britain or seek foreign investment for proper recognition of their abilities. A 1767 letter to the ever loyal Franklin found Baskerville offering his business to the Court of France. The French were interested, but the nation's coffers, they regretted, had been left too impoverished by the recent Seven Years War (1756–63), in which France had lost most of its North American possessions to Britain. There is a suggestion that Louis XV may have offered Baskerville an apartment in the Louvre if he would move to Paris and print, but if this is true, the offer was not taken up.

Baskerville seems to have got so sick of it all by the end of the 1760s that he let one of his foremen, Robert Martin, take over the printing. He was stung into re-entering the fray in 1772, when a local printer, Nicholas Boden, made it known he was printing a Bible; Baskerville responded with his second version of the good book, and seems to have become interested in the business again. Franklin wrote to him in 1773, informing him that he would distribute Baskerville's specimens among American printers, and telling him of some matrices from another foundry which were up for sale. 'You speak of enlarging your foundry,' says Franklin, and adds, 'There seems to be among them some tolerable Hebrews and Greeks, and some good blacks. I suppose you know them. Shall I buy them for you?' The eventual purchaser was Caslon.[8]

7 Ibid. Himself a printer, mostly for pleasure rather than profit, the output of Walpole's Strawberry Hill Press is highly regarded today. He was a customer of Caslon.

8 Ibid., 'blacks' were Old English-style lettering.

In 1773 Baskerville once again sought to persuade the French court to buy 'my whole apparatus of Letter-founding and printing'. He died two years later with the said apparatus still unsold, and one must suppose with one of the great passions of his life having left him with a bitter taste. Sarah, revealed by an early account to be a highly capable individual herself, and clearly familiar with Baskerville's paper-making processes, went on to produce a Baskerville type specimen in 1777, and in 1779 sold the type to the French dramatist Pierre-Augustin Caron de Beaumarchais, author of *The Barber of Seville* and *The Marriage of Figaro*; purchasing on behalf of the Literary and Typographical Society in France, Beaumarchais wanted to print the complete works of Voltaire using Baskerville's founts.

Later, after Sarah's own death, the punches made their way to Paris, from which new type was cast; in the turbulent years of the French Revolution it was used to print the *Gazette Nationale*, the official journal of the French Republic. So Baskerville's typographic innovations, which had fallen so flat in Britain, found a new lease of life across the English Channel, helping to fuel a political, social and intellectual revolution.

Although his type brought him little honour or profit in his own country, by the 1760s some English type founders had taken note and, perceiving that a change in typographic style was on the horizon, produced their own versions. The most notable of these was what came to be known as Fry's Baskerville, first offered in 1766 by Isaac Moore, a partner in the Fry and Pine type foundry. What was later cited as the last use of Baskerville before its revival in the twentieth century was an 1827 reprinting of *The Treatyse of Fysshinge with an Angle*, purportedly with 'the types of John Baskerville', but actually Fry's Baskerville. The newspaper owner and publisher John Bell branched out into type founding in 1788, and the face that bears his name, as revived by Monotype on the centenary of his death in 1931, owes more to Baskerville than it does to Caslon.

However, although dead, the irrepressible Baskerville was still to make his presence known for a number of years. Towards the end of his life he had become interested in windmills, and had one built in the grounds of Easy Hill. His will specified that he was to be buried

in a vault in this 'conical building', upright. His epitaph was a last swipe at the Church:

Stranger —
Beneath this Cone in unconsecrated ground
A friend to the liberties of mankind, directed his body
to be inhum'd.
May the example contribute to emancipate thy mind
From the idle fears of superstition
And the wicked arts of Priesthood.

But that wasn't the end of the story. Easy Hill was wrecked in the Birmingham Riots of 1791,[9] and the mill was demolished, although the body was left undisturbed. That is until 1820, when Birmingham's ever increasing industrial growth took a hand. The owner of the land cut a canal through it, and built a wharf. Baskerville's lead coffin was unearthed and opened. The body was in a good state of preservation. The skin on the face was dry; the eyes were gone but the eyebrows, eyelashes, lips and teeth remained. The body gave off 'an exceedingly offensive and oppressive effluvia, strongly resembling decayed cheese'.[10] The coffin was hastily closed, and supposedly given to Baskerville's surviving relations for reburial. However, this didn't happen. The coffin was left in a warehouse on the property for eight years, where for a payment of sixpence anyone who wanted to have a look at the body might do so.

In 1829, Baskerville's remains were moved to a plumber and glazier's shop. Once again the coffin was opened, and a local artist, Thomas Underwood, made a sketch. Underwood recounted how the 'effluvium' made people ill, and how a surgeon, who had taken a piece from the shroud and put it in his coat pocket, was dead within a matter of days. Underwood himself, he gratefully assured us, suffered only loss of appetite for a week.

Eventually Baskerville was reputed to have been re-buried next to Cradley Chapel, a property belonging to a branch of the Baskerville family. However, the story was more complex. Marston the plumber, on whom the responsibility for finding a resting place for the corpse seems to have devolved, had trouble finding a berth for it because of Baskerville's uncompromising attitude to religion during his lifetime. A bookseller called Mr Knott

9 Joseph Priestley spoke out in favour of the French Revolution, and in doing so started a riot. His own house was burnt down in the ensuing commotion.
10 From J. A. Langford, *Disinterment of Mr Baskerville*, Birmingham, 1821.

17 The disinterment of John Baskerville: Thomas Underwood's hasty drawing following a reopening of the coffin in 1829. The 'effluvium' noted in 1821 still lingered, supposedly causing illness and death.' ... the sketch shows correctly what I saw of the remains of the man who was an artist in every sense of the word, and will ever deservedly be famous as one of the worthies of our town, who spread its fame the wide world over,' wrote Underwood.

told Marston that with the proper permission the coffin could be placed in his family vault in Christ Church[11] in Birmingham. Marston's friend, Mr Barker, was by chance churchwarden of Christ Church; permission was refused, but Barker let Marston know where the key to the vault was kept, and turned a blind eye. Marston sneaked the coffin in on a hand cart. A notice was later put in the press to the effect that the body had been buried on some erstwhile property of the Baskervilles near Dudley, and consequently for many years there was confusion about the site of final interment.

In 1893, following a lecture on Baskerville by Talbot Baines Reed, it was decided to solve the mystery of his resting place. The result was the strange scene enacted in the catacombs of Christ Church. Despite some protests as to the propriety of the proceedings, the remains of John Baskerville were once again brought to light.[12]

11 Christ Church was demolished in 1897. Its site was in what is now Victoria Square in Birmingham.

12 This wasn't the end of Baskerville's movements, however. Following the demolition of Christ Church in 1897, he was reinterred in Warstone Lane cemetery, a former sandpit just north of Birmingham's jewellery quarter. A catacomb had been built into the side of one of the pits, and here Baskerville was finally laid to rest. Vandalism in the 1970s resulted in all the catacomb entrances being sealed up, with Baskerville's memorial tablet from Christ Church also inside. Sarah negotiated the social minefield more successfully than her husband, and has a memorial

Baskerville's type is categorized as Transitional. In simple terms this means that there is a greater contrast in thickness between the thick strokes and the thin ones than there was in Old Style. In the later 'Modern' faces the contrast became even more pronounced. Caslon was Old Style, Baskerville was Transitional, and there lay the problem for contemporary readers. So many versions of Caslon have been produced in the twentieth century, some even making it more of a Transitional face, that it is hard now to make an accurate comparison. But the Old Face or Old Style versions are more uniform in their stroke weight than Baskerville, which has quite fine thin strokes, and pointed serifs. It looked very alien to the eighteenth-century eye, especially enhanced by the new clarity that Baskerville had brought to the printing. But it's an elegant face, wider than those of his contemporaries. And when it was set it looked even; there was no wavering up and down:

> He was not an inventor but a perfecter… He concentrated upon spacing. He achieved amplitude not merely by handsome measurement but by letting in the light. He married paper and type in what was called a 'kissing impression'. Look at the title page of his Virgil. It seems no more than a series of lines of capitals centred over one another, as by a combination of logical arrangement and formula. But this is artifice at a height: the art of concealing the care and sense of balance which has taken infinite pains to obtain the right interlinear spacing and letter-spacing, the right gradations of size.[13]

In his lifetime, Baskerville ended up as the archetypal prophet without honour in his own country. However, Birmingham has since put matters right. The site of Easy Hill is now an elevated piazza containing the city war memorial. Baskerville House, a monolithic 1930s municipal building with classical pillars, is closed at the time of writing and awaiting redevelopment. In between these two structures is a delightful sculpture: six stone representations of punches, each carrying on the top a reversed letter in metal. Together they spell 'Virgil'. It is deserved recognition; Baskerville made breakthroughs on several fronts, and the changes he brought to type design were to be a catalyst for developments in the years to follow. But it was Italy that was to pick up the baton.

in the churchyard of St Philip's in the city centre

13 Francis Meynell, *English Printed Books*, London, 1946..

Detour | Meltdown: a stroll around a fallen giant

What was ATF worth? ... the auctioneer sold ATF for a grand total of $77,863. Subtract the type, and the total is $66,213. Subtract $35,580 for the [matrices] and patterns, and the remainder is only $30,633. Subtract another $3,321 for various lots of scrap metal, and we're down to $27,312. And that includes all machines and tools of every possible sort, all the furniture, cabinets, and shelving, and the type specimen books. Indeed, take away the metal ATF had accumulated, and the plant itself didn't fetch enough to hire a single employee for a year. (Gregory Jackson Walters, *The Auction of the Century*, 1993)

The early 1990s spelt the end for the two twentieth-century giants of the metal type business; on one side of the Atlantic, American Type Founders in New Jersey, on the other the Monotype Corporation, based in Surrey in the English Home Counties. ATF's demise was summary and brutal, its heritage only partially saved by enthusiasts from inside and outside the company. But as a result of timely intervention, Monotype's archives were rescued from a similar fate and taken into care, a state from which it is hoped they will slowly emerge to play a valuable role in the new century.

ATF's problems began with the purchase in 1970 of Lanston Monotype, the original American arm of Monotype. Lanston's equipment turned out to be woefully inadequate, and replacements had to be leased from British Monotype. The three-quarters of a million dollars this cost the company severely damaged its financial footing, and it was bought by White Consolidated Industries, the descendant of the White Sewing Machine Company. WCI (nicknamed 'Wrecking Crew Industries' by disenchanted ATF staff) laid off employees and sold ATF on again in 1986 to a Los Angeles firm, Kingsley Imprinting, who oversaw the death throes of the company that had once been synonymous with American type. There had been moves to digitize the ATF faces for the new technology, but it was too little too late, and the company was suddenly put up for auction in August 1993.

The sale was held at ATF's headquarters in Elizabeth, New Jersey, an immense building now only partially occupied by the type company. Among the lots on offer were more than a hundred old casting machines, setting and engraving equipment, plus drawers and drawers of type, matrices and patterns. The bidders included historians, collectors and metal type enthusiasts, members of the new ATF, the American Typecasting Fellowship. But there was also a large representation of scrap dealers, who ended up getting a considerable amount of American type heritage.[1]

In Britain, Monotype had gone into receivership two years before the ATF auction. The last two decades had been ones of slow decline, in tandem with the disappearance of metal type, and the arrival of film and then digital setting spelt a final end to the ailing company, although the Monotype name continued, in a smaller way, with digital type sales, at least until the mid-nineties, when it was bought by Agfa.[2]

Driving along Clapham Road in south London in 2001, my eye had been caught by brown signs pointing to the Type Museum. I had never heard of it, but directory enquiries gave me a number, and I called to find the opening times. The speaker informed me that they were not in fact yet open to the public, but if I wished to have a look round, then he would be happy to give me a guided tour.

Tucked away in a backstreet not far from the Oval cricket ground, the building that housed the Type Museum had been, before the First World War, a horse and dog hospital, chiefly to service the hansom cabs of turn-of-the-century London. Bizarrely it had also been a home for two elephants owned by the *Daily Mirror* newspaper. Some of the upper flooring was still cobbled, a suitably durable surface for large hoofed beasts.

But today the building represents, among other things, the final resting place of the original Monotype Corporation, the company that had dominated the world of typography in Britain, and commanded a global market for a large slice of the twentieth century. Like a mighty ocean-going liner, believed to be lost at sea and then found run aground in some secluded cove, here it all was – the name plaque from Monotype's second London headquarters, commemorating its replacement of the

1 Theo Rehak of the Dale Guild Type Foundry in New Jersey attended the auction, and speaks emotively of the fragments of type history he rescued, and of the legacy of Morris Fuller Benton, ATF's prolific designer (see Chapter 6): 'In 1993, at the company's demise, I succeeded in saving some portion of the "essence" of what ATF was. Especially with the matrices, I have always felt his presence when using the very tools and devices he and his father designed and built.' E-mail to the author, 2002.

2 Agfa Monotype still supplies digital fonts.

original building destroyed in the Blitz in 1941, the 1740 portrait of William Caslon I by Francis Kyte, which used to hang in the company offices, showing him clutching a copy of his type specimen 'by William Caslon, Letter founder in Chiswell Street, London'. There was also a portrait of William Caslon II, and a wall-mounted glass case contained some original Caslon punches, personally cut by the masters. There was an example of Tolbert Lanston's original typesetting machine, and a keyboard and caster from 1897. And stacked in towering piles on the floor, drawers and drawers of steel punches, patterns and matrices.

The Type Museum was the brainchild of its founder, typographer, designer and printer Susan Shaw. Foreseeing that a huge storehouse of typographical history was about to become scrap, she set up the museum charity trust in 1992, and, with the help of a £50,000 grant from the National Heritage Memorial Fund, acquired the whole Monotype archive: about 6 million artefacts, eighty machines and all the company records. The patterns, punches and matrices, 23,000 drawers of them, represented not just the Latin alphabet, but virtually every major world alphabet, including Hebrew, Arabic, Cyrillic, Hindi, Greek, Armenian, plus the Moon alphabet (an alternative to Braille), and thousands of numbers, symbols and special characters, tiny metal reproductions of company logos – Coca-Cola, Volkswagen, Shell, Boots the Chemist …

In 1995, this vast haul, 390 tons of it, was moved to its present London location. The collection swelled with the acquisition of the Stephenson Blake archives, guardians of the Caslon heritage, and the stock and equipment of Britain's last commercial manufacturer of wood lettering, DeLittle of York.

Duncan Avery, the owner of the voice on the telephone, showed me in. He had been a former Monotype employee: 'Not a typographer; I was on the engineering side,' he explained. 'My first ever job as an apprentice with Monotype was making metal feet for Bren gun tripods.'[3]

The process of hot-metal composition begins in familiar territory, keying in the copy, although the keyboard Mr Avery showed me was a colossus compared to modern slimline affairs. Weighty, free standing, it had seven sets of keys, for roman upper and lower case, italic upper and

3 A Second World War-era machine gun, made in Enfield in north London.

18 Monotype monster: a seven-alphabet keyboard for hot-metal setting. The operator was unable to see the results of their typing until it came out of the caster in the form of metal type.

4. There were more complex operations involved. To justify setting, first of all the key buttons had to be lifted up and a frame containing rows of metal bars was placed underneath. These bars would be the corresponding set for the typeface you wished to use, and adjusted the instructions coming from the keys. A further typeface-related piece would be fitted – the stop bars, which made allowances for different character widths, to aid justified setting. The line length, the measure, was set with a sliding marker, like those on manual typewriters. Each time a key was struck, a small drum (a different one had to be fitted for each type size) would rotate. Each time the space bar was hit, a small metal arm moved up the side of the drum. Its surface covered with tiny numbers, the drum was actually a calculator, working out the word spacing for each line of text.

As the operator typed, a bell would ring when the end of the measure had nearly been reached and the metal arm would point to two numbers on the drum. This would give an indication as to the width of the word spacing. If you wanted it tighter, you could perhaps add another word, or part of a word and a hyphen. When you were satisfied, your two numbers on the drum would

lower case, bold upper and lower, and small capitals. But once the key had been struck, all familiarity in the process ended. In the simplest terms, the keystroke punched holes into a roll of paper which, when the keying-in was completed, was fitted on to the caster.[4]

This was an even weightier piece of equipment, standing waist high. Mr Avery stared reflectively but fondly at this piece of engineering, as at a complex, occasionally exasperating but much-loved friend. 'There are thousands of working parts in here,' he said, and I had no doubt he had been personally acquainted with all of them during his career. 'But the basic principle on which they work is compressed air.'

As the paper roll turned, air surging through the holes punched into it would move some of these working parts. Each pair of holes represented a character, and related to vertical and horizontal coordinates on the matrix case, which held the moulds for the characters. Compressed air passing through the holes would move the required character matrix into position to be filled with molten metal to create the type, which would be shunted out in correct sequence from the innards of the caster.

The Monotype method, as the name suggests, cast individual pieces of type, while the Linotype machines produced a 'line o' type', a metal slug for each line. Corrections were therefore easier with Monotype, so although most newspapers used Linotype, *The Times* always used Monotype for the stock market prices. All the numbers were of identical width, and if the share prices altered at the last minute, it was relatively easy to lift a number out and insert another.

It struck me that, as a keyboard operator, it was imposs-ible to see whether you'd made a mistake until the type was cast. I remarked on this to Mr Avery, recalling the comment of one such operator: 'On the keyboard, all we produced was a paper roll with holes in it. Not like today where you can see on a screen exactly what you're doing. We had to hold the image in our heads, line by line, as we tried to match the design.'[5]

Mr Avery agreed with this, but added:

A skilled typist generally knows the moment they've hit a wrong key. Monotype used to run a training course for keyboard operators free of charge for any com-pany who bought the machines. There was a pass rate of something like four mistakes per thousand strokes, which was deemed an acceptable level of error. This particular keyboard doesn't have a kill key,[6] but if you realized you'd made a mistake, you could always patch the holes that had been made on the paper roll.

Being myself of the one-finger school of typing, this information came as something of a surprise, but in fact most skilled tasks are carried out with a subliminal level of understanding, beyond the sensory input of the eyes and ears. David Beckham probably knows the instant he's struck a free kick whether it's going to go where he intended.

My guide then imparted an even more startling piece of information. The Type Museum was still making the necessary equipment for casting metal type. These build-ings were not just the repository for a fascinating but obsolete technology, but a working museum for one that was, against all preconceived notions, still alive. But who wants metal type nowadays?

The customers fall into two basic groups. In the UK, America and Europe, the demand is aesthetic, for small presses who want the distinctive look that metal type gives, who feel that in the end there is no substitute for that kind of quality. The second group, Mr Avery explained, were those still using it as an economic im-perative:

India, Bangladesh, Ethiopia – in some countries in the developing world there is a considerable capital invest-ment tied up in hot metal. They may want to change

then be entered using special red buttons on the keyboard. The holes made by the red keys were the first information received by the caster, and would move a metal wedge, typeface-related in size, to define the area into which molten metal would flow to create the word spaces.

5. *Car* magazine, thirtieth anniversary supplement, Septem-ber 1992.

6. The kill key, if struck after a wrongly hit key, would interrupt the hole-punching process on the paper roll.

59

over to digital technology, but can't afford to. Metal setting may be more labour intensive, but in these countries labour costs are cheaper. So the system works. There are also parts of the world where the supply of electricity is uncertain; not much help for computers, but I've seen casting machines in Africa powered by some improvised arrangements of pulleys and heated by paraffin!

Another bonus, of course, is that the lead used to cast the type is a recyclable resource. When you've finished with it you can just melt it down and use it again. We supply replacement matrices for ones that have got lost or damaged. We even had to create an entirely new character for metal the other month, the euro symbol. Tricky, but we got there in the end!

The person responsible for this undertaking was also in the building. Parminder Kumar Rajput had come to Britain in 1965 from Kenya and got a job with Monotype. The professional structure at Monotype was strictly delineated – if you made matrices, that's where you stayed. You didn't have a go at machining components as well, nor probably would you want to. However, Kumar had a more enquiring mind: 'If they needed someone to change jobs, everyone else would always refuse, but I'd say yes. And I got on well with the foreman, so he let me try other things as well.'

Kumar eventually familiarized himself with the whole process, from the making of patterns[7] to cutting punches and making matrices. He stayed with Monotype until the end, and then joined the Type Museum, bringing with him a unique and invaluable store of knowledge of the whole matrix production process. I found him using an automatic punch-cutting machine, creating a character for an Esperanto alphabet, using a pattern he had created by grafting an inverted half-moon accent on to an existing character.

What of the future for the Type Museum? The first phase of the development project is to create an archival store for the contents of the 23,000 drawers so that they can be kept in ideal conditions and be readily accessible. This will then liberate the floor space for the development of the museum – introducing displays illustrating the development of type and working dem-

7. The designer's drawing of a character was enlarged to 10 inches (254 mm), and then traced round with a pantograph. The other end of the pantograph would be a stylus cutting the shape of the character into a piece of wax-covered glass. The wax outside the character area would be removed, the glass and character wax would then be coated with silver nitrate and dipped in an electrostatic bath for twelve hours to grow a thin film of copper on its surface. The copper was then backed up with lead to add strength, and the pattern was complete – a metal image of the character in relief. The pattern could then be used in conjunction with a punch-cutter. The size of type required could be set, and the cutter's guide would follow the edges of the pattern. This movement would be transferred to a metal cutter, which would sculpt the character image to the size required on the surface of the punch.

19 The art of punch-cutting, still alive and kicking, as practised by Parminder Kumar Rajput at the Type Museum.

onstrations of metal and wooden type manufacture and their printing techniques, in which the public will be able to participate.

There will be educational opportunities for primary and secondary school pupils, study visits for students, courses for designers and the general public, and a lecture theatre and meeting room available for local groups. At the time of writing, though, the museum is still in the fund-raising stage. The first part of its development, the creation of the archive store, still needs £675,000 to make it a reality.

5 | 'Hideous Italians': thicks, thins, and the rise of advertising type

Although John Baskerville experienced little take-up of his ideas in Britain during his lifetime, his efforts had not gone unnoticed elsewhere. More than a decade before his death, his work had made an impression on a young Italian, Giambattista Bodoni (1740–1813), who took the developments Baskerville introduced into his type design – the contrast between the thick and thin strokes which had so offended some of his fellow countrymen – a step farther, and so brought about the type style that would come to be characterized as 'Modern'.

Bodoni was born in Turin in 1740. His father was a printer, and this was to be Bodoni's trade as well. From the age of eighteen he worked for eight years as a compositor at the Propaganda Fide, the Church printing house in Rome. Inspired by Baskerville's productions, he decided to head for England and find work there. But he was fated not to arrive; he contracted malaria, and returned to the parental home in Saluzzo to recover. His father was still running his printing business in the town, and Bodoni, while helping out with the family concern, began to cut his first typeface. His reputation as a printer grew, and he was given the task of setting up a printing house for the Duke of Parma. This he ran for forty-five years, building its reputation to a level of European pre-eminence.

His type layouts featured generous white space, letter-spacing and sparing use of ornament, much in the style that Baskerville had favoured. Bodoni's type, although seen as the first example of a Modern face, drew on the 'Romains du Roi', the type designed exclusively for the French king Louis XIV's printing, which boasted flat, unbracketed serifs. Although use of the type outside of the royal printing house was forbidden by law, subtly modified versions were produced by other type founders, most notably Pierre Simon Fournier and Pierre-François Didot. Fournier's work in particular influenced Bodoni, and he developed the flat serif into a virtual hairline, with the thin strokes of the characters of a comparable thickness.

Since the latter half of the twentieth century, Bodoni, and the subsequent Modern-style faces it has inspired, have been regarded as cool, elegant and sophisticated. The Modern face is the 'classic fashion' typeface; books or magazine features on, for example, Christian Dior or Coco Chanel invariably use it for headlines and titling. It is surprising, therefore, to realize the depths of loathing it inspired in the century or so after its creation. This is Emery Walker, of the Doves Press (see Chapter 7), on the subject:

> Bodoni admired Baskerville and he carried the exaggeration of the thin and thick strokes of the letters still further, until Baskerville's type by the side of the Italian looks serious and dignified. Bodoni's influence on type design was very great, but from the point of view of beauty, entirely bad. At the end of the century it had driven the reasonable types of Caslon out of the market,

20 Giambattista Bodoni, whose typeface typified the Modern style. William Morris was later to consider his influence responsible for 'sweltering ugliness', but the twentieth century associated the style with extreme elegance.

and for the next fifty years a style derived from his letters was dominant, ending in what [William] Morris called 'sweltering ugliness'.[1]

Francis Meynell, writing in 1946, is more guarded, but describes Bodoni as having 'almost parodied' Baskerville. It's difficult to say whether the anecdote he cites is in approval or the opposite:

> Paul Valéry tells us that Stendhal once visited Bodoni at Parma, and found him at a moment of typographical triumph. He had just finished the arrangement of a title-page. The word OEUVRES was centred above the word DE, and that was centred above BOILEAU–DESPRÉAUX. 'Look, sir,' cried Bodoni, in a fervour of self-appreciation, '"Boileau–Despréaux" in a single line of capitals! I have searched six months, sir, before I was able to find this arrangement!'[2]

Bodoni died in 1813; his widow, Paola Margherita, finished the book he was working on at the time of his death, the *Manuale Tipografico*, which was finally published in 1818. He was a rare example of an early type designer who actually made some money out of his work; at the height of his success he was even receiving 300 francs a year from no less than Napoleon Bonaparte. However, what is now perceived as a general decline in printing standards in the nineteenth century took its toll on the fine strokes of the Modern face, which explains in part the reaction against them. It was only in the twentieth century that Bodoni experienced a revival. Morris Fuller Benton designed the American Type Founders version, but his redrawing took into account the printing realities of the time, with a consequent strengthening of the characters. Monotype also revived it, but the most faithful version was considered to be that of the German foundry Bauer, designed by Heinrich Jost (1889–1948).

Although the Modern face did achieve some popularity in Britain, there the new thrust in type innovation was pushing in an entirely opposite direction – towards thick, not thin, serifs. These were characterized by Clarendons, with thick, bracketed serifs, and the unbracketed, but equally weighty, Egyptian, later to be known as the slab serif. The catalyst for type development in Britain in the first half of the nineteenth century would not be

AEM
abx

21 Bodoni: the thin strokes are now very thin, the serifs flat, unbracketed.

1 From Emery Walker's Cambridge Sandars lecture.
2 Francis Meynell, *English Printed Books*, London, 1946.

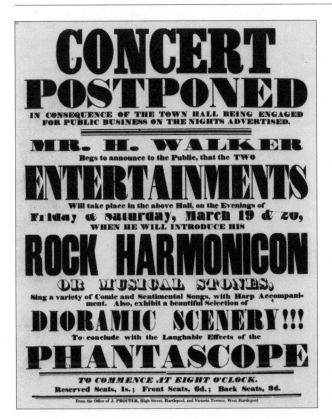

22 A typical nineteenth-century riot of display letters, like Bodoni, the victims of a late-nineteenth-century backlash. 'Who can exaggerate the horrors of those letters?' wrote a commentator in 1895.

continuous text reading, but short, impactful advertising copy.

The origins of the slab serif – heavy, monoline (having a uniform stroke width), with thick square-ended serifs – are uncertain, but it was probably developed by sign-writers around the beginning of the nineteenth century. Rather than relying on existing typefaces, they experimented with creating heavier letter forms that better suited their requirements for short, bold copy. Clearly, for this kind of unleisurely reading on the move, fine, contrasted types such as Baskerville or Bodoni lacked impact, and it's not difficult to see how a slab serif would be easier to paint than a thin bracketed one. Thus the display face, the headline, was born.

Type founders eventually responded to this demand by producing their own slab serif faces. The London foundry of Vincent Figgins offered an 'Antique', as they chose to name it, in their 1817 specimen. Also in London, the death of type founder Robert Thorne in 1820 resulted

in his business being bought by William Thorowgood (or Thorogood), whose 1820 specimen also featured slab serifs (presumably in preparation by Thorne at the time of his death). He called them 'Egyptians' – doubly confusing, as this was the name that William Caslon IV's foundry had given to their solitary, pioneering sans serif face (see page 37).

Throughout the 1820s and 1830s the production of display faces snowballed: 'fat faces', Bodoni's concepts taken to their ultimate conclusion, with extremely heavy thick strokes and very fine thin strokes, ornamented faces with decorations within the stroke areas, and 'open' styles, containing a white cut-out area within the letter form. The latter styles clearly worked better on a heavy face, and slab serifs were ideal. Taken to an extreme, the slab serif developed to the point where it was thicker by far than the other strokes in the character, in the style we now dub 'Wild West'.

The popularity of slabs was waning by the middle of the century, and they were superseded by increasingly complex, largely 'grotesque' faces (as sans serifs were now generally known) – ornamented, outlined, with three-dimensional, 'perspective', shadow effects. These are the faces, usually used in a typographical riot, that typify the Victorian advertising handbill, the auction notice and the theatre poster. Because of their size, all these display types would have been cut in wood, not cast in metal. Their strength and energy are such that their use today inescapably conjures up a 'period' feel. And the period they represent was one of growing commercial vigour.

Britain had been first into the Industrial Revolution in the early nineteenth century; a rapidly increasing output of mass-produced goods needed aggressive advertisement. A French visitor to London in 1850 was astounded by the pervasive and inventive advertising sites used in the West End:

In Piccadilly, St James's Street, everywhere in fact where the crowd was densest, one met men transformed into walking advertisements. One wore a scarlet boot as a headdress, was wrapped in a garment entirely composed of cardboard, and carried a flag bearing a bootmaker's name and address. There were others in all sorts of gro-tesque accoutrements. When the goods advertised need

long explanation, the man is concealed in a closed–up sentry-box. They wall him in between four boards, clap a little roof on top, and he rotates slowly to allow the passer-by to read what is written on the placards …

Publicity invades even the asphalt pavement. It relies on the frequent rain and the habit people have here of looking down as they walk. When the weather is fine, dust dulls the surface and nothing much is visible. But as soon as a shower has washed it clean the characters appear, letters blossom under your feet, and you find yourself walking on gigantic posters.[3]

The end of the century found slabs joining Modern faces in the doghouse of aesthetic opinion: 'Who can exaggerate the horrors of those letters? Sometimes one sees a facsimile playbill or ticket of, say 1812. There seems no redeeming feature in the job-letter. Flat, squat, flat-serifed romans; enormously thick antiques, the serifs as heavy as the body-marks; hideous "Italians" – romans with the thick and thin lines carefully reversed …'[4]

Strong stuff indeed. But as with most things that fall from grace, a revival eventually comes. A new wave of slab serifs arrived in the late twenties and early thirties, and the slab enjoyed a vogue in post-war Britain as a particularly British type style, notably in Charles Hasler's lettering for the Festival of Britain in 1951.

3 Francis Wey, *Les Anglais Chez Eux,* extract taken from *The Story of Advertising,* James Playsted Wood, New York, 1958.

4 R. Coupland Harding, *The Inland Printer,* August 1895.

6 | American spring: creating the modern age

'And by the way, Harry, talking about silly marriages, what is this humbug your father tells me about Dartmoor wanting to marry an American? Ain't English girls good enough for him?'

'It is rather fashionable to marry Americans just now, Uncle George.'

'I'll back English women against the world, Harry,' said Lord Fermor, striking the table with his fist.

'The betting is on the Americans.'…

…'They are pork-packers, I suppose?'

'I hope so, Uncle George, for Dartmoor's sake. I am told that pork-packing is the most lucrative profession in America, after politics.'

'Is she pretty?'

'She behaves as if she was beautiful. Most American women do. It is the secret of their charm.' (Oscar Wilde, *The Picture of Dorian Gray*, 1890)

Following the end of the war between the states in 1865, America had embarked on a phenomenal expansion. At that point there were no states between Kansas in the Midwest and California and Oregon on the West Coast. But the 1869 east–west railway link created a unified market that came to be dominated increasingly by large companies. By 1890 one-third of the world's railway track was in the United States. Between 1860 and 1890 the population doubled, fed by a second wave of immigration from central and eastern Europe, swelling the northern cities. For refugees from poverty and persecution in Europe, America was seen as a land of opportunity where a person could flourish purely by virtue of their own talents and industry. And for millions it proved to be true.

Wilde's aristocrats' remarks reveal how newly wealthy and self-confident Americans were colonizing the social world of European old money. Europe liked to consider itself culturally pre-eminent, regarding America as a land of rough frontiersmen and millionaires self-

made by ungentlemanly trades. But the United States was now beginning to look uncomfortably threatening. The writing of Henry James – himself an American who became a European – frequently explored the culture clash of American innocence and idealism and European cynicism. But America was fast abandoning its introspection.

The Spanish–American War of 1898 was an engineered opportunity to kick a declining European imperial nation out of the New World, and to establish a new island-based American Empire. Although the Monroe Doctrine of 1823 had declared that European wars were of no concern to the United States, the entry of America into the First World War was a consequence of the belief, largely promulgated by the President, Woodrow Wilson, that the nation should exert a greater moral influence in the world as a champion of freedom and democracy. The conflict left many of the European dynasties toppled and the victors exhausted, both financially and in terms of depleted population. After half a century of quietly building its wealth and power the United States was now in a position to make the twentieth century the American century.

The two giants of American typographical design during this period are truly a study in contrasts. One, Morris Fuller Benton, was college educated, joining his father's business and toiling diligently for that company for his entire working life. He sought and achieved anonymity to the extent that now, over half a century after his death, the man himself has become little more than a shadow behind the towering monument of his design output.

The other, whom we will look at in Chapter 8, was Frederic Goudy, self-taught and beginning his working life pursuing completely different occupations. The course of his career was often difficult. He was self-employed and also ran his own private presses. His detractors branded him a shameless self-publicist, but his outspokenness and promotion of his name and opinions were to a large extent the defensive reaction of an talented autodidact who felt himself an outsider in the professional circles in which he moved.

What the two shared was the creative energy and business drive of the rapidly expanding and developing

nation in which they lived. Their output was prodigious. Calculations as to the number of typefaces they produced vary, but a conservative figure would put the combined total at over 350 faces, a truly staggering amount. Between them they created the modern American type industry, and turned it into a global business.

Just as many everyday products and brands date from late-nineteenth-century America – Coca-Cola, Kodak, Kellogg's breakfast cereals – some of the most durable of Benton's faces are the typographical equivalent of cornflakes: unostentatious and dependable. It is not fanciful to see them as a reflection of the solid Midwestern background of their creator.

Morris Fuller Benton's story actually begins with his father, Linn Boyd Benton (1844–1932). Benton senior was born in Little Fall, New York, but spent his childhood farther to the north and west, in Milwaukee and La Crosse, Wisconsin. 'His own father had been the editor and part-owner of the *Milwaukee Daily News*, and by the age of eleven Boyd had learned to set type. In 1873, however, he was working as a bookkeeper at the Northwestern Type Foundry in Milwaukee; the company went bankrupt that year, and Benton and a partner bought the type and equipment. Benton later remarked that, given what he now knew about type founding it would have made better financial sense to have thrown his new acquisitions into the lake there and then. But his foundry, Benton, Waldo and Company, was still in existence nearly twenty years later, when it became one of those amalgamated in 1892 to form American Type Founders – ATF.

Benton was a skilful punch-cutter, and had also developed a system of self-spacing type. However, his greatest contribution came after the introduction of Otto Merganthaler's Linotype machine in 1886. Up to this point type had been set by hand, a laborious process which involved manually picking each individual character out of a tray. It was a procedure that was crying out to be replaced by a method of fast, automatic type composition. On both sides of the Atlantic there had been a huge growth in newspapers, magazines and books, fed by an equally expanding advertising industry. In 1886 the *New York Tribune* installed Merganthaler's first Linotype casting machine (it literally produced a 'line o' type' in

a metal strip). This new process was called 'hot metal' as opposed to hand, or 'cold', composition.

Merganthaler had an immediate problem. He couldn't produce matrices fast enough to supply the machines. Failure was staring him in the face until Benton came along with his automatic punch-cutter (see footnote, page 74). Linotype was saved, and hot-metal setting was now a viable innovation.

Ironically, the punch-cutter hastened the end for the kind of small foundry in which Benton was a partner. At this time most big American cities had at least one type foundry, which would produce pre-cast metal type to supply the local print companies. The Linotype machine, and its soon-to-arrive competitor from Washington, DC, Tolbert Lanston's Monotype machine, meant big trouble for these small concerns. With hot-metal setting, you cast your own type, using matrices, and melted it down for reuse afterwards. Furthermore, matrices took a lot longer to become worn or damaged than lead type. Faced with a crisis, twenty-three of America's leading type founders merged in 1892 to form ATF, thus reducing operating costs. Taken on as technical adviser, Benton set up a design department that was to ensure that ATF constituted a powerful force in the world of American type for over thirty years.

One of the first typefaces to be produced with the automatic punch-cutter was Cheltenham. It had been designed by the architect Bertram Grosvenor Goodhue (1869–1924), whose commissions included the Church of St Thomas in New York and some of the buildings at the US Military Academy at West Point. Cheltenham was originally designed for the Cheltenham Press in New York in 1896, possibly the first typeface to be designed with maximum legibility in mind; short descenders, less important than ascenders for readability, allowed room for wider line spacing. The design was acquired by ATF in 1902. Cheltenham has been described as the typeface designers love to hate, but it proved a staple of American graphics and advertising until well into the 1970s.

Linn Boyd Benton's contribution was largely on the technical side, although with *Century* magazine's editor, Theodore L. De Vinne, he designed the first version of the magazine's eponymous typeface. His other great offering to the world of type was his son, Morris Fuller

23 The power and the glory: an American Type Founders' 'Bon Voyage' lunch, given in December 1923 in honour of Henry Lewis Bullen prior to his trip to Europe. Among the fulsome tributes, Frederic Warde described Bullen as 'a lighthouse for typographically shipwrecked mariners'.

Morris Fuller Benton: the contrast in personality and presence between him and his father is apparent even in this group portrait.

Benton (1872–1948). With Morris's arrival at ATF the modern type business effectively began.

An only child, Morris suffered from poor health, and to this his later reserved, reticent personality is undoubtedly attributable. Like his father he learned at an early age to set type, and worked a printing press in the family home. It was perhaps inevitable that he would join Boyd at ATF after graduating from Cornell University in 1896.

As well as the two Bentons, ATF was blessed with Robert W. Nelson as president, and Henry Lewis Bullen as publicity manager. ATF was essentially a conglomeration of competitors, but Nelson turned it into an effective unit, and Bullen skilfully marketed the company's products with sales offices around the country and the production of specimen books. ATF introduced the concept of type families, a sound marketing move, offering not just a roman and italic version of any given face, but bold and bold italic, and further weights too. Once a customer had bought one weight, it was a logical step to buy more in the same family.

An ever-hungry market for the type family was the advertising agencies. They were nothing new in America – J. Walter Thompson founded his company in 1864 – but the first three decades of the twentieth century saw a massive growth in advertising revenue, and the agencies, constantly seeking new typefaces to add distinctiveness and novelty to their campaigns, appreciated the versatility of a multi-weighted face to emphasize different parts of the advertising copy.

The 1923 ATF specimen book, a doorstop of a manual, was a work of art in itself, featuring numerous examples of the faces in action, often in colour fold-outs. Sixty thousand copies were produced. The introduction trumpeted the company's innovation:

In what position, may we ask, would the printing industry be today without the great type families, known to fame as Cheltenham, Century, Bodoni, Cloister Oldstyle, Goudy Oldstyle, Caslons, Garamond, Copperplate Gothics, and others? Are there anywhere any other type families? Would not your typography be barren in appearance and much less profitable to the advertisers if these great type designs had not been developed?

The younger Benton's first task at ATF was to go through the type lists of the twenty-three companies that had merged, removing any duplicates and sometimes merging disparate faces into one family. They also needed conversion to the newly adopted pica point measuring system. This intensive work sharpened Benton's technical skills and his awareness of type design. In 1898 he adapted drawings for Roycroft, his first recorded type design,[1] and after this his output grew at a blistering pace.

In 1900 he took his father's Century and created Century Expanded and Italic. The ten-year period from 1902 saw the development of the Franklin Gothic family. In 1904 he began turning Cheltenham into a family, in 1904 Cloister Black, and in 1907 Clearface and the ATF revival of Bodoni; 1908 saw the arrival of News Gothic. By 1910 he had designed Century Bold and Bold Italic and Hobo, adding Copperplate Gothic in 1912 and Souvenir in 1914. The years 1915 to 1917 produced ATF's Garamond and Baskerville revivals, and around the same time Goudy Bold and Century Schoolbook. In the 1920s he designed classic Art Deco display faces like Broadway, Modernique and Parisian, and in 1931 the slab serif Stymie. And that's just a selection of the better-known and more enduring faces.

Morris Benton remained a low-key figure; he worked for ATF until his retirement, seeing the calling of the type designer as traditionally anonymous. The 1923 specimen book lists him among the department heads, but he merits no mention in the introductory article about the design department, also a claimed ATF innovation, and

Linn Boyd Benton, relaxing with a post-prandial cigar; looking over his shoulder is Bruce Rogers. One of the most respected designers of the period, Rogers's letter of recommendation clinched the AFT job for Beatrice Warde.

Beatrice Warde: long days in the ATF library, armed only with a duster, enabled her to build up a prodigious mental store of typographical knowledge (see Chapter 10).

1 Roycroft was originally called Buddy – some accounts have it that Benton designed it in collaboration with a colleague, Lewis Buddy.

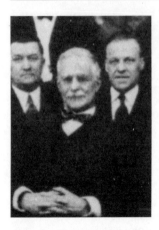

Henry Lewis Bullen: these were his golden years. The thirties would see ATF revived only after bankruptcy, and his great creation, the library, dispersed. Both he and Nelson would be dead by the end of the decade.

Robert W. Nelson, ATF's gifted president, who could lay claim to have invented the concept of the type family.

2 Richard L. Hopkins, *The Story Behind the Engraved Matrix*, New Jersey, 1994.

3 Patricia A. Cost, 'Linn Boyd Benton, Morris Fuller Benton and Typemaking at ATF', *Printing History*, vol. XVI, no. 1/2, 1994.

one that had, they said, increased the demand for printing by making typefaces work more effectively. In July 1935 Morris ventured out of the shadows to become the cover star of that month's *Printing* magazine, photographed demonstrating the Benton Hardness Tester, a device to calibrate the durability of ATF's cast type. Typically, it was the back of his head that he presented to the camera.

John Allen Murphy, interviewing him for *The Inland Printer* in March 1936, called him 'one of the most difficult men to interview I have ever talked to – and I have interviewed thousands in my time. Try to pin some honour on him, or give him credit for some achievement, and he will modestly sidestep with the remark that "Lady Luck helped me a lot there!"'

William Gregan, one of Morris's former colleagues at ATF, once observed, 'Mr. Benton never spoke two words to me, when none would do.'[2] The perpetual presence of his father at the company may well have given Morris a sense of being in a subordinate position, the eternal junior partner. Boyd, larger both physically and in personality, outspoken and outgoing, was a dominating and sometimes a smothering force in his son's life. Morris's first wife was even the daughter of Boyd's patent lawyer, and once he and Ethel had a family they shared a home for some years with Benton senior – first in a rented house, and then from 1908 in the 'White Elephant', a vast property in Plainfield, New Jersey.

The two men continued to go into work together even when Boyd was well beyond the normal retirement age. Morris's younger daughter Caroline attributed the stomach ulcers that her father developed in the 1920s to the daily stress of having to deal with Boyd's increasingly difficult personality. Outwardly still the sociable character of his youth, Benton senior was becoming ever more irascible and demanding, both at home and at work. As Caroline observed: 'That's the trouble when you work 'til you're 88, you know, somebody has to help you. And you know who did it.'[3]

After the early death of Ethel in 1920, Morris remarried – Katrina was twenty years his junior. By 1930 they were both back living with Boyd, whose own wife had died that year. Benton senior finally retired on 1 July 1932. The life force was now disconnected from its source – two weeks later he was dead of a cerebral haemorrhage.

Morris received little public recognition from the print industry during his lifetime. In September 1930 *The Inland Printer*, announcing in its news pages the launch of two new Goudy faces, Goudy Text and Lombardic Capitals, described Goudy as an 'internationally famous designer', and even ran an affectionate caricature of him by the British cartoonist Cyril Lowe. By contrast, in June of the same year, we find Henry Lewis Bullen of ATF bagging himself kudos while simultaneously making a play for our sympathy: 'One of my efforts in behalf of the industry for which I shall probably get no credit was the introduction of the classical revivals: Garamond, Caslon, Cloister and Bodoni, all of which have been tremendous sellers and have dominated and improved the commercial typography of the United States.'[4]

Bodoni was certainly hogging the top position of the magazine's 'Typographic Scoreboard' at this period, but, significantly, Benton gets no mention. In such a large company, there were always more strident voices and more assertive opinions than his.

Of Morris Benton's typefaces, the three most signifi-cant are arguably Century, Franklin Gothic and News Gothic; significant in that for a designer they are the most versatile, the most usable. What these three have in common is their almost total lack of quirks; there are no distinguishing features or any particular characters that can aid identification of the face. You tend to rec-ognize them on a page through their overall appearance, a tribute to the sheer good draughtsmanship involved in creating them.

Franklin Gothic and News Gothic are both sans serifs. Acclaim for sans serif faces rests with the European de-signs: Futura, Gill Sans, Univers and Helvetica are the big names. It was in Europe that the serif versus sans serif debate raged, and where typefaces were linked to wider design styles and philosophies. Yet Benton was quietly designing practical sans serif text faces nearly twenty years earlier. Both Franklin and News Gothic are non-geometric forms; the o and other round parts are oval rather than circular, and in this they reflect the nineteenth-century grotesques which would have been the model Benton had to draw upon. Unlike Edward Johnston, whose London Underground lettering was the next important development in sans serif (see Chapter 9),

Frederic Warde: a riddle wrapped in an enigma of his own devising. Husband to Beatrice, his search for perfection in his work contrasted starkly with the disarray of his own life (see Chapter 10).

4 J. Horace McFarland, 'With good sense again dictating type use, what will be next in type design?', *The Inland Printer*, June 1930.

Benton didn't rethink the whole form of the letters. But what he did was create two really practical text faces that also work extremely well at larger, headline size.

Franklin is clearly a child of the heavy nineteenth-century advertising sans serif, but with News Gothic Benton pushed the sans serif in a new direction, creating a cool, sleek face in a lighter weight than had previously been seen in a sans serif. It may not have quirks, but it's stylish and looks great letterspaced at large sizes.

Benton senior's Century, later to become Century Old Style, is an unfussy and reliable serif text face, but it was Morris's Century Schoolbook that really gave the Century family its character. Commissioned by the educational publishers Ginn and Co., who wanted a face that had maximum readability for children, Benton made intensive use of existing studies of legibility before producing his design. The art director of a London magazine company I worked for, in the days before the font-changing capacity of digital setting, used to have Century Schoolbook as his 'when in doubt' face. For rush jobs, when the pressure was on and there was no time for finely considered design decisions, he knew that Century Schoolbook would do its job, and crucially not provoke anyone on the editorial side to start questioning

AB
fms

25 Franklin Gothic: a well-designed descendant of the nineteenth-century grotesques.

24 Morris Fuller Benton: one of type's greatest low profiles. His more outgoing and increasingly problematic father accompanied him to work until his retirement at the age of eighty-eight.

its selection. It could slip happily into place, and look at home wherever it was put.

Yet that description does it a disservice. It's solid and dependable, and its serifs and thin strokes aren't going to look weak even at small sizes. But once again Benton's excellent drawing makes for an attractive, well-proportioned face at whatever size it is used. A later, condensed version called Century Nova sticks in my mind as a favourite classic 1980s display face.

Of Benton's other notable faces, Stymie was a slab serif that never achieved the level of recognition of Mono-type's Rockwell, or indeed the slab serifs coming out of Germany during the 1920s and 1930s, such as Beton, City and Memphis. It was reputedly facetiously named, intended as it was to be a spoiler, to 'stymie' the release of similar designs. Linotype's importation of the German face Memphis into the United States effectively stymied Stymie – like Rockwell, it's an anonymous, unappealing face.

His other durable face was fifty years ahead of its time. Designed in 1914, Souvenir was offered to the trade in the early 1920s. It appears in the 1923 specimen book, but curiously, given ATF's belief in the type family, it came in one weight only, with no italic. This apparent lack of confidence in the design was reflected by market response, and Souvenir died an unlamented death. However, in 1967 a company called Photo-Lettering revived it for one of its accounts, and two years later the face achieved high profile when a redrawn version, known as Eastern Souvenir, was created for the new identity for Eastern Airlines. Souvenir is a face that is intractably rooted in style to a particular era, although one a half-century after its creation. It is a quintessential late 1960s and 1970s typeface, informal, with full rounded character shapes and rounded serifs, a laid-back Cheltenham.

Whether Benton was an impossible interviewee or not, John Allen Murphy managed to extract enough material for a three-part Benton feature for *The Inland Printer*. He gave Benton both the credit for the concept of the type family and 'the credit for having taken the designing of type out of the cloister and the artist's studio, where it was the product of inspired genius, but where the Muse did not punch a time clock, and of making it the product of organised, systematic research, operating

ABM
fnw

26 Century Schoolbook: sound, sensible, unfussy, just good craftsmanship; Benton took legibility studies into account when creating this text face originally intended for children's books.

AGM
fgw

27 News Gothic: Benton anticipated Johnston's creative redemption of the sans serif by eight years with this light, elegant face.

under the direction of an executive committee … He is an executive as well as a designer, a business man as well as an artist'.

This is not an entirely appealing image – the corporate hand tightening its grip on the province of the lone artist/designer – but Murphy saw this as the third stage of Benton's career. He had streamlined the proliferation of faces that had resulted from the mergers that created ATF, then had been the artist himself, and was now in a directorial role, analysing trends and determining marketing strategies. According to Murphy, Benton felt it was no longer possible for the creative designer pure and simple to produce a saleable typeface, except by accident: ' … the successful designer, under current conditions, must have all of the professional requirements demanded of the artist in this field. In addition, he must be an economist, and student of distribution, of merchandising trends, be well informed on advertising tendencies, and so on down the list.'

Although Murphy was talking up the success of this new 'total' approach, ATF had already by this point gone bankrupt and been revived. Profits had been falling in the 1920s even before the slump, a downward trend ascribed by Caroline Benton to poor planning and an ageing management team. Furthermore, printers everywhere were having to deal with the impact of a new advertising medium, radio. By 1930 more than half the homes in America had radios, and the advertising spend for broadcast time alone that year was $40 million, revenue that formerly would have been spent on print.

Morris retired the year after Murphy's feature, after over forty years' service in the company. He had little to do with ATF from then until his death in 1948. He was a chain-smoker, but it was the ulcers which caught up with him first.

ABW
gxyz

28 Souvenir: disregarded at its inception, it was revived and enjoyed its heyday in the late sixties and seventies.

7 | An awful beauty: the private press movement

Why, then, since they had forced themselves to stagger along under this horrible burden of unnecessary production, it became impossible for them to look upon labour and its results from any other point of view than one – to wit, the ceaseless endeavour to expend the least possible amount of labour on any article made, and yet at the same time to make as many articles as possible. To this 'cheapening of production', as it was called, everything was sacrificed: the happiness of the workman at his work, nay, his most elementary comfort and bare health, his food, his clothes, his dwelling, his leisure, his amusement, his education – his life, in short – did not weigh a grain of sand in the balance against this dire necessity of 'cheap production' of things, a great part of which were not worth producing at all. (William Morris, *News from Nowhere*, 1891)

The evil habit of buying bad unnecessary things is necessarily prevalent in industrialized countries like England. In such countries God is unknown or forgotten, and nothing is done for His glory or in His fear. Moreover, in such a country the majority of the people are not themselves responsible workmen, being merely slaves in factories who never make more than a small part of anything. They cannot know good from bad. Most women are mere buyers nowadays, and have lost all remembrance of the life of their great-grandmothers. They cannot apply any sane criticism to the things they buy, for they have no good standard of criticism. (Eric Gill, *The Game*, October 1921)

By the latter half of the nineteenth century, the consequences of the mass production culture let loose by the Industrial Revolution – both its toll on the human condition and spirit, and the actual quality of the goods it was manufacturing – were a growing source of unease for many designers and craftsmen. In Britain the manifestation of this concern was the Arts and Crafts movement, and its ideas and influence were to spread to Europe and the United States, profoundly influencing some of

29 William Morris: despite coming to typography late in his career, his customary inspiration and energy in running the Kelmscott Press would give his ideas wide influence in both America and Europe, and probably hasten his early death.

the most significant type designers of the first half of the twentieth century, not least Eric Gill. Although the Gill extract quoted above was written thirty years later, it shows how Morris's ideas were still highly influential – the view expressed is essentially the same, albeit cranked up a notch by some fairly typical Gill invective, and given a religious dimension for the magazine in which it was published. Gill was later to sneer at the movement, but in a generous slice of his highly complex personality he was and always remained an Arts and Crafts man.

In a game of word association, say Arts and Crafts and you think of William Morris; say William Morris, and 'wallpaper' inevitably follows. Yet there was much more to Morris than his wallpaper and textile designs, attractive and enduringly popular though they are.

Morris (1834–96) was born in Walthamstow, then still a village in the Essex countryside, and not, as today, a London suburb. His father was a financial broker in the City of London, and although he died when Morris was only thirteen, prudent speculation in a Devon copper mine left the family, by Morris's own admission, rich. Morris remained a wealthy man throughout his life, with pecuniary resources that allowed him to put into action all his creative urges, but which didn't desensitize him to the everyday hardships of the majority who didn't

share his good fortune. He was to become a socialist and ardent campaigner for social reform.

Morris went to Marlborough public school, an institution he was later to roundly condemn for the poor quality of the education he received. He attempted where he could to educate himself in things that interested him, and began to develop a love of the medieval. Later, at Oxford, he was to meet like-minded spirits, and a lifelong friend, Edward Burne-Jones.

Morris studied architecture, and on leaving Oxford became articled to the firm of G. E. Street, who designed the Gothic Revival Law Courts in London. Burne-Jones became a painter, enlisting as his mentor Dante Gabriel Rossetti. Rossetti had been a member of the Pre-Raphaelite Brotherhood, a short-lived English art movement whose paintings were characterized by a highly detailed, almost jewel-like depiction of nature. Painted on to canvas with a white ground, many of their colours retain a cathode-ray intensity. On meeting Rossetti, Morris too decided to become a painter. Only one of his oil paintings survives, and the frescos that he, Rossetti and Burne-Jones painted to decorate the new debating hall for the Oxford Union Society faded within a year owing to a wrongly prepared painting surface.

Morris was soon turning his considerable energies elsewhere. In 1859 he married Jane Burden, an artist's model introduced to him by Rossetti. Although she was to bring him lasting sadness by virtue of her lengthy relationship with Rossetti, to which Morris appears to have resigned himself, Jane was a remarkable figure in her own right. The classic Pre-Raphaelite beauty, model and inspirational force of so many Rossetti paintings, she was also a skilful embroiderer and wood carver. Photographs in her middle years show her still in possession of a smouldering beauty. Her influence also extended to suggesting to the directionless Thomas Cobden-Sanderson that he become a bookbinder (see page 86).

With his Oxford friend and colleague at Street's, Philip Webb, Morris designed and created the couple's first home, the Red House in Kent. Not stopping at the architecture, Webb and Morris, assisted by other artistic friends, designed all the interiors and the furniture as well. Morris was inspired to start his own company, designing furniture, stained glass, textiles, wallpaper – everything for the

home. His ideals stemmed from the belief that the mass production of the nineteenth century had turned the workplace into a scene of drudgery rather than pleasure, and had robbed the craftsman of joy in his work, without which true beauty could not be achieved. In contrast, he believed that the medieval craftsman had had control of his materials, his tools and, crucially, his time, and it was this working environment he wanted to re-create.

> The craftsman, as he fashioned the thing he had under his hand, ornamented it so naturally and so entirely without conscious effort, that it is often difficult to distinguish where the mere utilitarian part of his work ended and the ornamental began ... All this has now quite disappeared from the work of civilization. If you wish to have ornament, you must pay specially for it, and the workman is compelled to produce ornament, as he is to produce other wares. He is compelled to pretend happiness in his work, so that the beauty produced by man's hand, which was once a solace to his labour, has now become an extra burden to him, and ornament is now but one of the follies of useless toil, and perhaps not the least irksome of its fetters.

Morris came to printing and typography late in his career, but none the less the influence of his work was to be far reaching. In 1888 he attended an Arts and Crafts Society lecture on printing given by Emery Walker at the New Gallery in London's Regent Street. Also present was Oscar Wilde, in his capacity as reviewer for the *Pall Mall Gazette*: '[Walker] spoke of Elzevir in the seventeenth century, when handwriting began to fall off, and of the English printer Caslon, and of Baskerville whose type was possibly designed by Hogarth, but is not very good.'[1]

Emery Walker (1851–1933) worked commercially in printing and engraving and had known Morris since the early part of the decade. However questionable Wilde's grasp of the content of the lecture, it proved inspirational to Morris, and by extension can be seen as a crucial event in the development of typography and printing until at least the outbreak of the Second World War.

Morris and Walker (had Walker already acquired the habit I found in him thirty years later, of punctuating all his remarks with 'D'you see? D'you see? D'you see?'

1 *Useful Work versus Useless Toil*, Hampstead Liberal Club lecture, 1884.

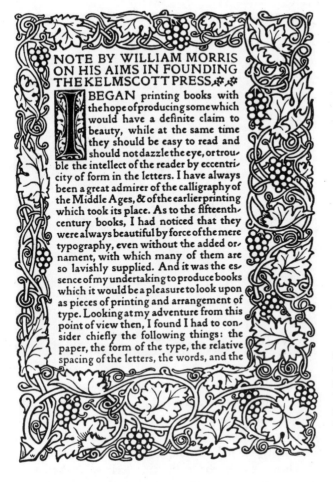

NOTE BY WILLIAM MORRIS ON HIS AIMS IN FOUNDING THE KELMSCOTT PRESS.

I BEGAN printing books with the hope of producing some which would have a definite claim to beauty, while at the same time they should be easy to read and should not dazzle the eye, or trouble the intellect of the reader by eccentricity of form in the letters. I have always been a great admirer of the calligraphy of the Middle Ages, & of the earlier printing which took its place. As to the fifteenth-century books, I had noticed that they were always beautiful by force of the mere typography, even without the added ornament, with which many of them are so lavishly supplied. And it was the essence of my undertaking to produce books which it would be a pleasure to look upon as pieces of printing and arrangement of type. Looking at my adventure from this point of view then, I found I had to consider chiefly the following things: the paper, the form of the type, the relative spacing of the letters, the words, and the

30 A typical Morris page style – heavy type, intensive decoration. His type created a 'black page' in its visual effect, rather than the 'grey page' we're accustomed to today.

always in triplets?) went home together, with Morris hardening into a resolve a quarter-formed project to start a press of his own. Within a few months he was at work upon his first type designs.[2]

The pressures of the age had taken their toll on printing too. Increasing literacy, brought about by the introduction of compulsory education, created a larger reading public. To meet this growing demand, the emphasis was on quantity rather than quality, cheaper items printed on cheaper materials. Although this was by no means universal – Morris's poetry was printed by the Chiswick Press, whose quality was to be a benchmark for his own productions – he was determined to make his contribution to reversing the general trend of decline. He asked Walker to become his partner in the new venture.

2 Francis Meynell, *English Printed Books*, 1946.

31 Emery Walker: although he lacked confidence in his skills at public speaking, his 1888 Arts and Crafts lecture was a pivotal moment in the history of type and design.

3 Owning a personal typeface seemed to go hand in hand with running a private press. Charles Ricketts designed Vale Type and King's Fount for his Vale Press; the painter Camille Pissarro's son Lucien designed Brook for his Eragny Press. St John Hornby, a director of the newsagent and bookseller WH Smith, had Subiaco for his Ashendene Press, designed by Sydney Cockerell and Emery Walker.

Walker declined the offer, but agreed to become Morris's typographical adviser. The Kelmscott Press, named after Morris's home in Hammersmith, west London, where he now lived, was founded as a small private press, using its own types, and printing on handmade papers.[3]

Morris had intended the first Kelmscott Press production to be a new edition of Caxton's *Golden Legend*, but the complexity of the task made him switch to a piece of his own fiction writing, *The Story of the Glittering Plain*. It was set in Morris's first typeface, which he based on the type used in two books from 1476, Nicholas Jenson's *Pliny* and Jacobus Rubeus's *Historia Florentina*. Walker photographed and produced enlarged prints of pages from the books. Morris then traced off the characters and redrew them to make his first typeface, Golden, named after the original *Golden Legend* project. Influential as ever, by refusing to make the type commercially available Morris induced foundries to cut their own Jenson-inspired faces, a trend that reached across the Atlantic; by 1895 the Dickinson Foundry in Boston, by now part of ATF, was advertising a Jenson revival face to the printing trade.

Morris designed two more typefaces, Troy for the press's edition of Froissart's *Chronicles*, and Chaucer, for what is considered the Kelmscott's finest achievement, *The Works of Geoffrey Chaucer*, completed only months before Morris's death in 1896. Although the life of the press was short, considering the highly illustrated and decorated style of its books, and the care that went into producing them, its output was prolific. Between 1891 and 1898 it published fifty-three books. Morris was only sixty-two when he died. One doctor described the cause of death as simply being William Morris – he had packed more into the last five years of his life than many people would have achieved in a lifetime.

> … many who look at [the Kelmscott Press books] today are puzzled at their profound effect. His types are archaic, his page hard to read, his decoration insistent, his books few in number and in the copies printed of each, his prices high… The contrast of Morris's socialism with his production of books for the few, the rich and the eclectic, has often been commented on. What has been overlooked is the fact that Morris was convinced that the social revolution was just around the corner – that the workers would seize the factories and destroy all of them that were substitutes for creative hand-labour, and that then men would make for themselves their own textiles and tapestries and furniture, and even books: priceless because in fact unpriced.[4]

This vision was elaborated in Morris's 1891 novel *News from Nowhere*. William Guest, essentially Morris himself, wakes one morning to find himself in the Hammersmith of the future, a world in which all Morris's hopes for society have come to pass. London has become largely countrified; King Street in Hammersmith has gone, 'and the highway ran through wide sunny meadows and garden-like tillage'. Quite what Morris would have made of the six-lane highway that now intervenes between the Thames and King Street we can only guess.

It is easy to chuckle at Morris's utopia, where everyone wears vaguely medieval garb – which on the women, along with their suntanned skin, gives Morris an obvious erotic charge. The book is too long, contains seemingly interminable political discussion and has virtually no plot; yet the common sense of Morris's ideas on the

4 Meynell, op. cit.

ordering of society, work, the class system, crime and punishment, and his ultimate faith in the goodness of human nature on which this future society could be built, remains striking.

Although working conditions for the majority in Britain have vastly improved since Morris's time – indeed, many of us would now fall into the grouping that he defined in *Useful Work versus Useless Toil* as 'a class which pretends to work but which produces nothing' – his ideas about the production of useless, unwanted items still remain highly relevant today, particularly from an environmental perspective. The production process of Morris's day has snowballed, a snowball composed largely of non-biodegradable material.

Even more significant than the Kelmscott Press's books was its inspiration for the private press movement; in America, most notably Daniel Berkeley Updike's Merrymount Press in Boston and Will Bradley's Wayside Press in Springfield, Massachusetts. Frederic Goudy started his own press before he ever designed a typeface. In Britain the Kelmscott's direct descendant was the Doves Press. The Doves Bindery, admirably named after the local pub, had been founded in 1893 just down the street from Kelmscott House, and had bound the press's books. In 1901 Emery Walker teamed up with Thomas Cobden-Sanderson (1840–1922) from the bindery to found the Doves Press.

Upper Mall in Hammersmith remains something of an oasis even today; it faces directly on to the River Thames, and emanates an aura of tranquillity despite the persistent muted roar of the traffic from the nearby A4. Kelmscott House is now the headquarters of the William Morris Society. The Dove is still there (having reverted to the original singular form of its name), a charming, intimate, low-ceilinged bar, and the site of the Doves Press, two doors down, is marked with a blue plaque: '... the gentlemanly, reticent, revolutionary typographer Walker ... Cobden-Sanderson, the strange, charming, slightly crazy visionary bookbinder. Walker and Cobden-Sanderson were a kind of Laurel and Hardy of fine printing; one of those comically ill-assorted, exceptionally creative balances of personality.'[5]

Cobden-Sanderson was later to resemble more closely Buster Keaton, a deep layer of melancholy underlying

5 Fiona MacCarthy, *Eric Gill*, London, 1989.

32 Take me to the river: Thomas Cobden-Sanderson; a visionary in search of 'The Book Beautiful'. 'He became literally poisoned by the effect which these ideas made upon his mind.' (John Dreyfus)

the sometimes comical antics. In fact the combination of personalities and of individual expectations in the partnership was off balance from the start. For Walker the Doves Press was just one of his many activities; for his partner it was the sole focus of all his phenomenal passion and energy, channelled into his quest for beauty. Harmony was to be short lived, and as a result of Cobden-Sanderson's actions, the press's own typeface, Doves Type, became the focus of some truly bizarre behaviour, and a posthumous lawsuit.

Of Walker, the partners' loyal friend and one-man peacekeeping force Sydney Cockerell[6] was later to say there was 'nothing remarkable about him personally', and refuted the story that Walker's breakfast used to consist of a single large onion. As print and type adviser, Walker's day-to-day involvement in the Doves Press was fairly minimal; none the less, Cobden-Sanderson's resentment towards his partner began early in their association. In an unposted letter written in 1902, Cobden-Sanderson outlined his objections – that all the work devolved on him, and that Walker's only contribution was to criticize any of his partner's proposals.[7] However, Walker's input was critical to the look and style of the Doves productions; he

6 Sir Sydney Cockerell (1867–1962) secretary and assistant to Morris at the Kelmscott Press, and later director of the Fitzwilliam Museum in Cambridge. He served as a mediator between Walker and Cobden-Sanderson on more than one occasion.

7 Dorothy A. Harrop, *Sir Emery Walker 1851–1933*, London, 1986.

was to become an eminent figure in his field, a latter-day friend of Lawrence of Arabia, and with a knighthood to his name by the time of his death in 1933.

In the introduction to the 1969 edition of the diaries of Thomas Cobden-Sanderson, the publishers describe the writings as 'the aspirations of a troubled soul journeying towards the Unknown'.[8] Reading the contents it is clear, even allowing for Victorian intensity of expression, that here was a man who lived day to day on an emotional knife-edge. 'The face was long and thin, the eyes bright but sombre – as of a man who dwelt too much in himself – and the manner had the reserve of the typical Englishman and of the untypical Englishman who is a dreamer rather than man of action.'[9]

This certainly describes his early, drifting years before the Doves Press fired his soul; he left Cambridge before he took his degree, and considered and abandoned the Bar and the Church before coming to bookbinding in his early forties. Cobden-Sanderson's wife, Annie Cobden, was an equally engaging character, but her exploits could hardly have provided mental repose for his old age. A suffragette and close friend and associate of Mrs Pankhurst, she was arrested and went to trial in 1909 for presenting a petition to the Prime Minister, Herbert Asquith, and the following year was involved in a 'raid' on Downing Street.[10]

The Doves Press's greatest work, for which the Doves Type was designed, was its five-volume Bible, printed in a limited edition of five hundred and bound in plain white vellum, at a cost of three pounds, three shillings a volume, a figure in excess of three hundred pounds in to-day's values. Beyond the binding, the austerity continued inside; in complete contrast to Morris's productions, the pages of the Doves Bible, and of the whole Doves oeuvre, were devoid of illustration or any decoration beyond large drop capitals, and consisted of solid pages of Doves Type, tightly leaded. It is an attractive face for this purpose, however, highly readable, and generous of x-height and counter, with flat unbracketed serifs. The full stops and colons are diamond shaped, and bring to mind Edward Johnston's later punctuation for his London Underground lettering (see page 118) – the Bible's spare decorative type was drawn by Johnston, most notably a huge I for the start of the Book of Genesis. Doves Type, like Morris's

8 *The Diaries of T. J. Cobden-Sanderson*, published by Burt Franklyn, New York, 1969.

9 T. P. O'Connor, Cobden-Sanderson's obituary, *Daily Telegraph*, 1922.

10 Knocked to the ground by the surge of bodies fleeing the onslaught of the police, she got to her feet in time to see Winston Churchill, then Home Secretary in the Liberal government, advancing towards her. When she tried to speak to him, Churchill merely said, 'What is this woman doing here?', and she was unceremoniously hustled into nearby St James's Park by his police escort.

> # IN THE BEGINNING
> GOD CREATED THE HEAVEN AND THE EARTH. ¶ AND
> THE EARTH WAS WITHOUT FORM, AND VOID; AND
> DARKNESS WAS UPON THE FACE OF THE DEEP, & THE
> SPIRIT OF GOD MOVED UPON THE FACE OF THE WATERS.
> ¶ And God said, Let there be light: & there was light. And God saw the light,
> that it was good: & God divided the light from the darkness. And God called
> the light Day, and the darkness he called Night. And the evening and the
> morning were the first day. ¶ And God said, Let there be a firmament in the
> midst of the waters, & let it divide the waters from the waters. And God made
> the firmament, and divided the waters which were under the firmament from
> the waters which were above the firmament: & it was so. And God called the
> firmament Heaven. And the evening & the morning were the second day.
> ¶ And God said, Let the waters under the heaven be gathered together unto
> one place, and let the dry land appear: and it was so. And God called the dry
> land Earth; and the gathering together of the waters called he Seas: and God
> saw that it was good. And God said, Let the earth bring forth grass, the herb
> yielding seed, and the fruit tree yielding fruit after his kind, whose seed is in
> itself, upon the earth: & it was so. And the earth brought forth grass, & herb
> yielding seed after his kind, & the tree yielding fruit, whose seed was in itself,
> after his kind: and God saw that it was good. And the evening & the morning
> were the third day. ¶ And God said, Let there be lights in the firmament of
> the heaven to divide the day from the night; and let them be for signs, and for
> seasons, and for days, & years: and let them be for lights in the firmament of
> the heaven to give light upon the earth: & it was so. And God made two great
> lights; the greater light to rule the day, and the lesser light to rule the night: he
> made the stars also. And God set them in the firmament of the heaven to give
> light upon the earth, and to rule over the day and over the night, & to divide
> the light from the darkness: and God saw that it was good. And the evening
> and the morning were the fourth day. ¶ And God said, Let the waters bring
> forth abundantly the moving creature that hath life, and fowl that may fly
> above the earth in the open firmament of heaven. And God created great
> whales, & every living creature that moveth, which the waters brought forth
> abundantly, after their kind, & every winged fowl after his kind: & God saw
> that it was good. And God blessed them, saying, Be fruitful, & multiply, and
> fill the waters in the seas, and let fowl multiply in the earth. And the evening
> & the morning were the fifth day. ¶ And God said, Let the earth bring forth
> the living creature after his kind, cattle, and creeping thing, and beast of the
> earth after his kind: and it was so. And God made the beast of the earth after
> his kind, and cattle after their kind, and every thing that creepeth upon the
> 27

33 The Doves Bible, with a rare flourish, its over-sized opening letter, printed in red.

Golden, was based on the Jenson model, and cut by Edward Prince, who had also cut Morris's type, but the press's design style was to be a more accurate indicator than Morris's highly wrought decoration of the direction book design would take in the twentieth century.

After calculating the production costs, Cobden-Sanderson had considered approaching the subscribers for an advance payment, but reproached himself in his diary in January 1902:

> Let me give all my thoughts to the work itself.
> Let it be my life's work.
> Let me now live for it, and, if needs be, die for it.
> Never count the cost!

This gives some flavour of his intensity. He told Edward Johnston that he wished he could put a notice up in his workshop saying 'For God's sake do something careless!', and indeed here was someone who cared almost

too much. His diary entry for 12 January 1909 records: 'We love, in our vulgar day, the sense of consecration, and of dedication and devotion. It is so, I would dedicate and consecrate the Doves Press type, and so dedicate and consecrate it I will.'

It was this religious identification with the Doves Type which was to be the root of the discord between the two men long after their partnership had been dissolved in 1909, and the cause of Emery Walker bringing an action for damages against Cobden-Sanderson's estate after his death in 1922. In his statement to his lawyers, Walker recalled: 'if the partnership should be dissolved at any time I should have a right to have a fount cast from the matrices for my own use.'

When Cobden-Sanderson later told Walker he wanted to terminate their business relationship: '[Sydney Cockerell] … made a suggestion to me, that I should allow Sanderson the entire use of the type without payment as long as he lived, and if he should die first, the whole of the punches, matrices and type should belong to me… An agreement was drawn up by our respective solicitors and signed by us.'

The problem, and the reason for the legal action, was that, despite Cobden-Sanderson's death, neither Walker nor anyone else would be able to use the type again. On 31 August 1916 Cobden-Sanderson had begun what he called 'the final consecration of the Type'. In an uncharacteristically light-hearted diary entry (31 August 1916), he notes: 'The Doves Press type was designed after that of Jenson; this evening I began its destruction. I threw three pages into the Thames from Hammersmith Bridge. I had gone for a stroll on the Mall, when it occurred to me that it was a suitable night and time; so I went indoors, and taking first one page and then two, succeeded in destroying three. I will now go on until I have destroyed the whole of it.'

This 'consecration' had actually begun back in 1913, when Cobden-Sanderson had thrown the matrices from the bridge. The culmination had been simmering in his mind ever since, following the initial decision that he would dump the type when the Doves Press finally closed. But he now began a process that was to last over three months, and not without drama.

On 28 October he threw two packets of type, wrapped

in white paper and tied up with string, into the river. His aim was awry, and the packets fell on to a projecting ledge on one of the bridge supports near the water level. He now tormented himself with fears of their discovery and of his subsequent arrest. He even contemplated hiring a boat to try to retrieve them, but felt this would only attract unwelcome attention to the problem. To his relief no retribution followed, and the dumping continued. On 5 November 1916 he recorded in his diary:

> And I am now on my guard, and throw only type,
> and clear of the bridge ... I have to see that no one is
> near or looking; then, over the parapet a box full, and
> then the audible and visible splash. One night I had
> nearly cast my type into a boat, another danger, which
> unexpectedly shot from under the bridge! And all nights
> I feared to be asked by a policeman, or other official
> guarding the bridge – and sometimes I come upon clus-
> ters of police – what I had got in my 'box'... Hitherto I
> have escaped detection, but in the vista of coming nights
> I see innumerable possibilities lurking in dark corners,
> and it will be a miracle if I escape them all. I am doing
> this wholly 'on my own'; no one is aiding me, no one is
> in my confidence; no one, not even Alice or Albert, and
> of course not Annie, knows.

Renewed interest in recent years in the 1914–18 conflict has understandably focused on the experiences of the front-line soldier; less attention has been given to the psychological effect of four years of war on the population at home. The cartoonist Osbert Lancaster (1908–86) recalled in his autobiography *With an Eye to the Future* 'the memory of the overall and increasing depression which ... coloured life on the home front during that earlier conflict ... The endless casualty lists, the appalling prevalence of mourning ... and, later, the constant hunger ... all combined, in a way in which queues, bombings and blackout never did, to induce a permanent lowness of spirit.'

The length of the war, with its daily lists of the slaugh-tered, lives lost for little or no military gain – what the historian Richard Holmes has described as turning 'jovial uncles into stark newsprint'[11] – had been unimaginable before the outbreak of the fighting. With Cobden-Sanderson's accounts of his disposal of the type go his

11 Richard Holmes, *Fatal Avenue*, London, 1992.

12 Cobden-Sanderson's actions, grotesque and technically illegal, nevertheless formed part of an odd trend. The artist and designer Charles Ricketts (1866–1931), whose *Songs and Poems of Sir John Suckling* inspired Frederic Goudy, founded the Vale Press in 1896, but in 1903 consigned his self-designed type to the Thames, rather than have it fall into the hands of those who might not use it in the proper manner. To some commentators, this was no great loss; Roderick Cave, in his book *The Private Presses*, described Ricketts's King's Fount as 'horrid – one of the worst faces ever designed for private press use'. A harsh judgement.

Three years after Lucien Pissarro's death, and thirty-three years after the last Eragny Press book, his widow and partner in the press, Esther, dumped all the type, punches and matrices of their Brook fount into the English Channel. A few specimens were preserved by the Cambridge University Press.

There seems to be an irresistible attraction between metal type and water. The earliest surviving examples, dating from the end of the fifteenth or early sixteenth century, were found in the bed of the River Saône at Lyon in 1868, perhaps thrown out of a window overlooking the river by an apprentice who couldn't be bothered to return the characters to their tray. The same motive may well be behind the incident recounted by Martyn Ould and Martyn Thomas in *The Fell Revival* (2000), the story of the Oxford University Press types of Dr Fell. The 1895 ledgers for the press foundry contain a copy of a notice offering one pound reward for information leading to the identification of the person or persons who threw type belonging to the press into Oxford Lock.

13 Walker's reopening of

frequent expressions of despair; he was now seventy-six, and the slaughter in the trenches and the nocturnal air raids on the city had combined to cast him into a deep depression. His diary entry for 14 March 1916 records: 'Some 400,000 or half a million men slaughtered or maimed, all in a few days, and more waiting to be slain. And no one now can help it. On it must go until one side or the other … is spent, beaten to the ground as a field of ripening corn by storms of wind and rain and hail.' On 17 December 1917 he wrote: 'The war, the war, the war, always, always, the war.'

Although he always writes fluently, the Hammersmith Bridge entries have a manic levity to them – it is easy to surmise that by this point the always fragile balance of his mind was undergoing considerable disturbance. Months later, however, he shows no remorse, seeming to regard the dumping of the type as part of a deep spiritual communion. In the entry for 28 July 1917, he recorded standing on the bridge recalling his earlier actions: 'Then I lifted my thoughts to the wonder of the scene before me, full of an awful beauty, God's universe and man's – joint creators. How wonderful! And my Type, the Doves Type was part of it.'

William Rothenstein's 1923 tribute to Cobden-Sanderson in *The Fleuron* spoke of his 'demonic spirit of faith in the power of human idealism'. The war quashed any such faith; in its place the old bitterness he felt towards his former partner resurfaced, driving him to this pointless act of destruction.[12]

When Walker discovered what had been done to the type, it once again needed the adjudication of Sydney Cockerell to patch up the quarrel, Cobden-Sanderson handing over £500 as compensation, a sum Walker gave to charity. However, following Cobden-Sanderson's death, he renewed action against his estate.[13] The dispute was finally settled out of court. All mention of Walker was removed from the published editions of Cobden-Sanderson's diaries.

hostilities may have been occasioned by his unsuccessful attempts to re-create the Doves Type, and the fact that Edward Prince, the celebrated punch-cutter who had cut all the significant private press type, for Morris, Ricketts, Pissarro and for Doves Press, was now seventy-seven and unlikely to reach his past heights of excellence. Prince died in December 1923.

8 | Under fire: Frederic Goudy, type star

Frederic Goudy either liked people very much or disliked people very much. He straddled no fences on personalities. To print some of his comments on certain leaders in the graphic arts would likely constitute so many outrageous libels. (Paul Fisher, *The Inland Printer*, 1951)

There was no greater contrast of character in the world of early-twentieth-century American type than that between its two most prolific exponents, Morris Fuller Benton and Frederic Goudy. In contrast to Benton's eternal self-effacement at ATF, Goudy talked it like he walked it, as a freelance operator with a perpetual need for self-promotion that came not just from financial necessity. Goudy was the first type designer to name one of his creations after himself. But like ATF, as well as designing type he was in the business of selling it. The way he told it, Benton's Lady Luck was never a muse that stood at his shoulder:

> When I began my work as a type designer there were
> few who made type designs except incidentally to some
> other allied avocation … their work seldom included
> the *creation* of a letterform with an expression of its own.
> I really believe I am the first (in this country at least) to
> attempt to draw letters for types as things artistic as well
> as useful, rather than to construct them as a mechanic
> might, without regard for any aesthetic considerations.[1]

His work always retained an ambience of Arts and Crafts and private presses, and he liked to present himself as the artist-craftsman. Goudy undoubtedly had Benton in mind when he wrote the above. He saw the ATF man as a tinkerer, not a designer, making alterations to existing faces or producing revivals – Benton actually designed the first version of Goudy Bold. Goudy fell out with ATF over its modifications and developments of his designs, which no doubt accounts for the acidity of his opinions.

Frederic Goudy was born in Bloomington, Illinois, in March 1865, of Scottish ancestry. The family spelling

1 Peter Bielenson, *The Story of Frederic W. Goudy*, Mt Vernon, 1939 and 1965.

34 Frederic Goudy (left) entertains his public; his outgoing, self-promotional style inspired intense dislike among his peers in the industry.

of the name was changed from Gowdy in 1883. Frederic showed some boyhood talent by winning a county drawing competition, and painted the lettering on his local baker's wagon. But his first business venture, in 1888, was an attempt to set up a loan and mortgage company, after which he went to Minneapolis to become a bookkeeper for a department store.

In 1890 Goudy moved to Chicago, and although he was working in real estate the submerged creative side of his nature began to stir. Chicago was a stimulating place to be in the early 1890s. The American city most influenced by the English Arts and Crafts movement, with many craft and design shops, it was the venue for the World Fair in 1893.[2] Goudy developed itchy fingers, and started designing some of the property advertisements that were passing through the company. In 1892 he even launched his own short-lived magazine, *Modern Advertising*. Inspired by Charles Ricketts's *Songs and Poems of Sir John Suckling*, designed by Ricketts and Thomas Cobden-Sanderson, Goudy now decided he wanted to set up his own press.

According to Will Bradley (1868-1962), graphic designer and founder of the Wayside Press, he himself was the catalyst for this move:

2 The 1893 World Fair was held to mark the 400th anniversary of Columbus's arrival in America.

Mrs Bradley got a letter from her sister in South Dakota, asking me to look up a neighbour's son who was interested in drawing and painting.

I found him working as a cashier in a real estate office. I now wanted to play with type again, so I took a studio in the Caxton Building on Dearbourn Street in Chicago and bought a small outfit on time payments. One day I met the young cashier on the street. Stone and Kimball had promised him a book to set in 10pt. I told him there wouldn't be any money in setting it by hand, but if he wanted to go ahead, I had some 10pt Caslon, a little Caslon Black, a Golding Press, a small stone, a couple of galleys and a double stand. If he would assume future payments he could have my equipment. He accepted the offer. His name was Frederic W. Goudy.[3]

With a schoolteacher friend, Cyrus Lauron Hooper, Goudy founded the Booklet Press. The book Bradley referred to was Ingalls Kimball and Herbert S. Stone's new literary magazine, *The Chap-Book*, an illustrious commission for the fledgling outfit.

One evening in 1896 Goudy sat down at his kitchen table and drew a set of capital letters which he named Camelot, as the Booklet Press had now been retitled. Speculatively he sent his work to the Dickinson Foundry in Boston. They liked the face, paying him ten dollars – double what he had asked for it – and it was released by ATF, Dickinson's parent company. This was his first venture into typography, but his creative career was almost immediately to go on hold – the Camelot Press folded, and Goudy was back to bookkeeping again.

Fortunately freelance design work continued to come along, and through the auspices of the advertising agency J. Walter Thompson he drew some lettering for the Pabst Brewery. In 1900 he began teaching lettering at the school of illustration run by newspaper artist Frank Holme. Oswald Cooper and William Dwiggins,[4] both later to make names for themselves as type designers, were Goudy students.

In 1897 he married Bertha Sprinks, whom he had met at the beginning of the decade when they had both worked for a financial broker. In 1902 they founded the Village Press in Chicago. Bertha proved not only an admirable choice as a wife, but an excellent matrix cutter and typesetter. Bruce Rogers,[5] who was to be one of Goudy's most loyal friends, claimed she was the

3 *The Inland Printer*, July 1953.

4 Oswald 'Oz' Cooper (1879–1940) designed lettering for Packard and, most famously, his own Cooper family. He endearingly described 1925's Cooper Black as being 'for far-sighted printers with near-sighted customers'. William Dwiggins (1880–1956) worked for the Harvard University Press and founded Boston's Society of Calligraphers. He followed Goudy to Hingham, and stayed for the rest of his life. His best-known face was Caledonia.

5 Bruce Rogers (1870–1957), regarded by many as one of America's finest ever book designers, also designed one of the best Jenson revivals, Centaur, to which Frederic Warde's Arrighi was later adapted and added as an italic.

fastest compositor he had ever known, and one of the best. In 1904 Bertha, after hearing of an Arts and Crafts community at Hingham in Massachusetts, suggested that the Village Press relocate there. Business-wise it wasn't the best move, but they met Rogers there, and, less auspiciously, Daniel Berkeley Updike (1860–1941), the owner of the Merrymount Press in Boston, one of the finest examples of America's Morris-inspired private press movement.

In search of work for the press, the Goudys were soon on the move again, this time to New York City, and there Frederic met Mitchell Kennerley, an Englishman who had come to the city to set up as a publisher. Kennerley gave Goudy design and print work, and things began to go well – that is until January 1908, when fire destroyed Goudy's office and all its contents, apart from the matrices for his Village type, which had been stored in a fireproof safe. Goudy could only stand helplessly and watch his whole uninsured business go up in flames.

But there was a silver lining; the disaster forced Goudy to change direction, and he began to concentrate on drawing letter forms. Monotype asked him to design a face for the original *Life* magazine. They called the result Monotype 38-E, but it became known in the specimen books as Goudy Old Style, or Goudy Light. Goudy's obsession with lettering was now in full flow. In 1909 he and Bertha made a trip to Europe. In England Emery Walker introduced him to designers and printers. In the Louvre, while Bertha kept watch for museum attendants, Goudy made an illicit rubbing of three letters from a Roman inscription, which later became the basis of his face Hadriano. In Rome he studied the lettering on the Trajan Column and the arch of Titus in the Roman forum. As Goudy was later to remark: 'The old fellers stole all our best ideas!'

The moment that Goudy described as when he 'stopped being an amateur of design' came in 1911. He was now forty-six years old. Kennerley had asked him to design an edition of H. G. Wells's *The Door in the Wall and Other Stories*. Goudy considered a version of Caslon but, unhappy with the letterspacing, suggested to Kennerley that he design a custom face for him. Kennerley was wary of any extra cost, but Goudy assured him there would be none. The resulting face was titled Kennerley, modelled

on Dr Fell's Dutch types.[6] The lettering for the title page was Forum Title, inspired by Goudy's Roman holiday.

Goudy's type-designing career was now ready for take-off. In accordance with his agreement with Mitchell Kennerley, Goudy was permitted to sell the face to the trade, and to do this he set up the Village Letter Foundery – a spelling that caused ribald remarks in some quarters, in which Goudy was regarded as just an under-educated ex-accountant and estate agent from the Midwest. Resembling an amalgam of Lionel Barrymore and Henry Travers,[7] braces holding his trousers up to his midriff, Goudy looked both amiable and contentious. In the Goudy household argument was seen as the highest form of social interaction, but to some his personality was to prove a constant irritation. He was condemned by his detractors as a self-publicist, but although he loved public speaking and applause, he was, essentially, merely non-elitist. He would give a talk to anyone, not just those within the professional boundaries of his world. 'He was not as learned as some of his contemporaries, and not as original in argument, but his writing and lecturing were by no means uninformed or unsophisticated.'[8]

Of course, what caused most annoyance was Goudy's success. In 1913 the Caslon Foundry bought the rights to Kennerley, and Goudy sold them five other designs. In 1915 he began teaching lettering to the Arts Students League in New York and was in the same year hired as a consultant by ATF. They commissioned him to design a face for them, and he produced what became Goudy Old Style, his most enduring type. ATF shortened the descenders to bring the face into line with their other products, the first of their contentious interferences with Goudy's designs. Other, bolder weights were introduced by ATF without his consultation.

By the early twenties Goudy's stock was high. 'Goudy … was primarily a mellow, friendly fellow human, who had risen from the ranks through taste and skill; and what he offered to printers was the friendly, mellow beauty of types they could appreciate. And appreciate them they did.'[9] In 1920 he received the Gold Medal of the American Institute of Graphic Arts, and in 1922 the American Institute of Architects stepped outside their profession to give him *their* Gold Medal. He was now a celebrated figure, an indefatigable diner-out at banquets

6 Dr John Fell (1625–86), Bishop of Oxford and Vice-Chancellor of Oxford University, imported type from Holland in the 1670s, then set up a foundry for the University Press. The resulting types were highly regarded by twentieth-century revivalists. Stanley Morison's last work was his book *John Fell*, published on the day after his death in 1967, and hand-set in the Fell types.

7 Both actors appeared in Frank Capra's 1946 classic *It's a Wonderful Life*. Barrymore played the evil Mr Potter, Travers the angel.

8 D. J. R. Bruckner, *Frederic Goudy*, New York, 1990.

9 Bielenson, op. cit.

given in his honour. British Monotype's typographical adviser, Stanley Morison (see Chapter 10), had expressed admiration for Goudy Old Style, and considered Goudy's 1918 book *The Alphabet* the best instruction manual available in the United States. But a critical backlash was not long in coming.

His *The Elements of Lettering* (1922) was derided in *The Fleuron*, the British typographic journal which Morison had co-founded. While conceding that 'Mr Goudy's types are beautiful and his book contains much interesting matter', the unnamed reviewer objected to the fact that of the fourteen typefaces in the book held up as examples to study and learn from, nine were designed by Goudy himself. Goudy's claim that Forum Title was the first face to draw upon classical Roman lettering was indignantly refuted.

Stylistically, Morison was at odds with Goudy's Arts and Crafts influences; he was no admirer, describing Morris's Golden type as 'positively foul'.[10] In 1919 he had begun a transatlantic correspondence with Daniel Berkeley Updike, whom Goudy had earlier encountered at Hingham. Morison admired the work of Updike's Merrymount Press, and with typographical tastes and opinions in common, the two men continued their written exchanges until Updike's death in 1941. Early references to Goudy were neutral or mildly favourable, but by the mid-twenties the tone had become, and was to remain, vindictive.

In their eyes, without academic background and learning the unabashed Goudy was cutting in on other, more informed, people's territory and, worse, making a success of it. He spouted unoriginal opinions, cannibalized existing designs and, most outrageously, put his own name to his typefaces. His populist touch impressed what were deemed to be similarly under-educated minds; the New Englander Updike mocked Californian printers who believed that 'the forum only became interesting after Mr Goudy had visited it'.[11]

Morison and Updike's opinions became increasingly acerbic. This was Morison in November 1923:

Your note to FWG's latest (I say 'latest' but no doubt he has already done it once more elsewhere) piece of brag. I think it is time that we took some notice of Goudy in

35 Goudy affectionately caricatured by British cartoonist Cyril Lowe in 1930.

10 Letter to Daniel Berkeley Updike, October 1923.
11 Letter to Stanley Morison, November 1923.

the *Fleuron*. We hope to do 5 numbers and then close up … why not a critical summing up of Goudy & his work (sans portrait) in wh. the truth wd. be told? This cd go in No 5. After this we could take to the woods or otherwise flee from the wrath to come.

Updike was in two minds: ' … if I were you, I should be rather disinclined to flatter Goudy by including him; though on the other hand I should be tempted, when you tell me that the truth would be told, because it would be such fun to have the truth told for once in that quarter!'[12]

Goudy had already annoyed Morison by producing a Garamond revival called Garamont; unlike the many rival Garamonds, it was based in part on actual Garamond type used in the Richelieu folio Bible. Furthermore, Garamont was proving a commercial success. Morison had also learned that Goudy was working on a revival of Blado Italic, a project he had in mind for Monotype. The American was proving too much competition.

Time did not soften Morison and Updike's stance. In October 1937, Updike wrote:

36 Type star: Goudy courted and enjoyed the kind of exposure never before given to a type designer. He loved celebration dinners in his honour; ' … turn my birthday over to Mr Goudy who, it would appear, cannot have too many of them!' wrote Daniel Berkeley Updike waspishly in 1939.

12 Letter to Stanley Morison, January 1924.

…you add that Mr Goudy 'has designed a whole century of very peculiar looking types.' He certainly has. Poor man, I have never seen anyone with such an *itch* for publicity, or who blew his own trumpet so artlessly and constantly. He once asked me why I did not employ him for decorative work instead of Dwiggins, for 'I taught Mr Dwiggins all he ever knew.' I replied that the result was surprising because I liked Mr Dwiggins' work and not his. Since then our relations have not been so cordial.

In 1935 Bertha Goudy died, a loss from which Frederic, who had worked so closely with her in what was one of the longest-running private presses, was understandably never quite to recover. He designed a face in her honour, Bertham, but this too was lost when in January 1939 the second fire of his career destroyed the old mill in which Goudy's Deepdene Press was housed, at Marlboro-on-Hudson, north of New York City. Several other faces were destroyed too, the molten lead falling into the river as the fire raged above. The singed remnants of Goudy's records were eventually sold to the Library of Congress in Washington, DC.

Goudy's final years found him seemingly out of fashion and increasingly disillusioned with the type business. The perception that he was out of step with current taste stemmed from the influx of European sans serif faces, and the arrival in America of exiles from Hitler's Germany such as Walter Gropius and Herbert Bayer from the Bauhaus (see Chapter 11). In 1939 the American Institute of Graphic Arts held a function to honour the best book designs of the year. Goudy was invited to speak formally but refused, instead asking why, of the fifty books on show, forty-seven were set in German type:

> I've probably gotten more praise during my lifetime than any other type designer. But the trouble is you can't take it to the bank and draw on it. Here I've given 40 years of my life to the service of printing but at a time when I need the help of the printers they fail me. Instead of using native type they import it from Germany. How can you establish an American school of type design unless you give American designers a chance to live? I'd have starved if I had been forced to depend on the printers of the United States.[13]

AEL fgm

37 Goudy Old Style: its creator's most enduring and distinctive face, seen below in the still highly popular 'hand-tooled' version.

13 Bernard Lewis, *Behind the Type: The Life Story of Frederic W. Goudy*, Pittsburgh, PA, 1941.

With the influx of new typographical thinking from Europe, many of Goudy's designs looked decidedly late-nineteenth-century in style, drawing on the private press founts or medieval scripts for inspiration. Of all the faces Goudy designed, and there were at least a hundred (he claimed more), only one family is an unequivocal sans serif, 1929's Sans Serif Heavy, with a light and italic version. D. J. R. Bruckner, in his extensive survey of Goudy and his work, *Frederic Goudy*, calls it an 'unhappy face', and it's a just description. It had been created for Lanston Monotype as a counter to the European sans serifs, but Goudy's heart clearly wasn't in it, and it's not a convincing design.

However, his Goudy family has stood the test of time. An extremely distinctive text face, with its large counters and generous x-height with short descenders, it is most recognizable in the upper case characters; the bottom arm of the E and the arm of the L are a gentle swash, and that curve is also perceptible at the tops of the B, E, F, P and R. Goudy Old Style capitals give the impression that they have no straight lines; they feel fluid. The face manages to look both serious and friendly, slightly eccentric.

Personal favourites are Goudy Heavyface and Heavyface Italic, which are fat and fun, and look like something that could have been created in the 1970s; very much the kind of thing that Morison would have abhorred. These Goudy designed at the request of Harvey Best, who became president of Lanston Monotype in 1925, although he himself did not have a high opinion of them: 'I am quite certain my design was more or less a disappointment to Best.'

Bruckner is dismissive of his 1905 Copperplate Gothic, which he calls a 'hodgepodge'. But this upper-case-only face, with small, slightly bracketed serifs, also belies its age, and enjoyed a considerable vogue in Britain during the early part of the 1990s.

In August 1951, *The Inland Printer* ran a feature, 'Deepdene: the Last Summer', in which the writer, Paul Fisher, recalled his last visit to Goudy in 1946, a year before the designer's death. It was a revealing interview. Goudy was living alone, although a 'Californian girl' – actually a woman of forty – came in to see to some of his needs. Age was clearly taking its toll, but the old personality

ABM fgm

38 Goudy Heavyface Italic: Stanley Morison must have loathed it, but it's a fun typeface decades ahead of its time.

M ABC

39 Copperplate: Benton designed a version too, but Goudy's was first. In essence an expanded sans serif form with tiny serifs added, in capitals only. It experienced a great revival in popularity in the early nineties.

still crackled, and Fisher noted his kindness too, which gradually emerged after some time spent in his company. Looking through drawers of Goudiana, any expression of admiration would invoke a response of 'Keep it'.

Fisher had the impression that Goudy believed the last ten years of his life had been lived in reduced circumstances, 'enfeebled in mind, a lonesome and disappointed old man verging on total invalidism in a large rambling frame house – Deepdene – that was rapidly deteriorating for lack of attention'. Although hoping for a revival, Goudy now believed his work to be completely out of favour. In the 1920s, he lamented, 'more than 50% of *The Saturday Evening Post* display was in my types'.

Fisher noted how Goudy, signing a copy of *The Alphabet* for him, scrupulously put the letters denoting his degrees and honours after his name. To a successful self-taught man, such recognitions clearly still meant a lot. Lanston Monotype had kept him on as an adviser, providing an income that Goudy referred to as his 'pension', commenting ruefully, 'I'm an advisor who is never asked for advice.'

Frederic Goudy died in bed of a heart attack in May 1947. His perception, at the end of his life, of his current status as a designer was largely correct. He was out of favour, lacking the approval to which most of his prodigious output would still be a stranger today. Unless there is a massive Arts and Crafts style revival it's hard to see many of his designs being resuscitated. But although Goudy the designer was essentially a man of the turn of the twentieth century, his persona and appetite for publicity would have allowed Goudy the man to feel very much at home in the world of twenty-first-century media. It's easy to imagine him ensconced in a swivel chair, beguiling a chat-show host with some entertaining yarn, or leading a television crew around his workshop, proudly holding up his latest design for the approving eye of the camera.

Detour | Typecast: on the trail of the metal fanatics

The reports of my death were greatly exaggerated.

The almost complete takeover of 'here today, gone tomorrow' printing by digital and photolithographic processes has not brought about the death, but rather the emancipation of letterpress.

The text of real books – visual and tactile delights destined to be read and re-read, lovingly sniffed and fondled and handed on to the next of kin – are still printed letterpress! (Flyer printed by the Old Forge Press, 2002)

It has been said that when a technique becomes obsolete it is then free to become an art form, and that is what has happened to letterpress printing. Old technology can be surprisingly tenacious in the hands of enthusiasts and specialists – just look at the vinyl record. Metal typesetting continues to inspire an affection and devotion that have long outlasted its commercial usefulness, but what is the root of this appeal? There are, after all, no small societies still carrying on the fine craft and traditions of the technology that replaced hot metal, photosetting, or collecting and swapping old sheets and catalogues of Letraset – at least as far as I'm aware.

The typography magazine *Baseline* ran a feature in 2001 on the popular letterpress course running at the Royal College of Art in London, using resources that were narrowly saved from being dumped in a skip in the 1980s. The course leader Alan Kitching commented: 'The organic feel, the unique imperfections of letterpress … provide a useful counterpoint to the glossy and unsatisfying uniformity of those acres of bland digital design and print churned out by the design industry every week of every year.'[1]

The metal letters themselves possess a tactile appeal, a physicality that can invoke a slightly misty-eyed response even in those with no first-hand experience of printing in letterpress. Over the years I've found myself increasingly susceptible, even though my initial encounter with hand-setting at college was not one to inspire immediate devotion to the art.

1 Jeremy Myerson, 'Letterpress at the RCA', *Baseline* 33, 2001.

A couple of years ago, browsing in an antique shop, I came across a pile of old type trays, the wooden flat drawers in which metal type was stored. They are divided inside by thin wooden walls into numerous compartments, one for each character. I had seen these trays before, on sale in craft markets in London as unusual items of interior decor. They could be mounted flat on a wall and small objects could be arranged in the different compartments. The trays were always beautifully restored, and came with a price tag to reflect this loving care. These had received no such attention, and were consequently priced at a level at which I felt I could justify the whim of wanting to own one. Trapped in the edges of some of the wooden dividers were still a few pieces of the type the drawer had held, 9pt Times Roman. I picked these out, and asked the owner whether he had any more in larger sizes. 'I had so much of that stuff,' he confided, 'but to be honest, I chucked it all away. What could I do with it? Large wooden letters, I can sell those, but the metal stuff, who wants it?'

Who indeed? However, it occurred to me a couple of weeks later that it might be interesting to take the tray and the type into a college to show some students I was working with. Their reactions surprised me. I had expected them to laugh and just make comments along the lines of 'Thank God we don't have to use this stuff now', but they gasped in amazement at the tiny metal letters, running their fingers over them as if they couldn't quite believe that a letter could have a physical existence beyond the printed image on a page. Clearly the magic still lingered.

My visit to the Type Museum had inspired me to seek out one of their customers who was still using metal type at the beginning of the twenty-first century, and to see what they were producing with it. Duncan Avery gave me the number of the Alembic Press, who bought matrices produced at the museum. A phone call put me in touch with David Bolton, who was happy for me to come and have a look round. 'I've got to do some casting next week, but I can wait until you arrive, if you'd like to watch,' he offered. I assured him that I would.

The Alembic Press is located in the Oxfordshire countryside just west of Abingdon, housed in the 700-year-old outbuilding of an equally venerable main house,

home of Claire and David Bolton. There was something about David's appearance, the bushy grey beard and check flannel shirt and jeans, begrimed with noble toil, which brought to mind an Old West gold prospector, or at least the owner of an illegal still. But it was a different kind of equipment which David was tending, and when he opened the enormous studded wooden workshop door, curved at the top in a gothic arch, its roar came out to meet me. Accustomed to the faint hum of a computer, this was a factor I hadn't anticipated – the sheer industrial volume, a sound somewhere between a chug and a clatter, that was produced by a typecaster in action.

My 1996 copy of *The Writer's Handbook* had described the Alembic Press as a 'publisher of hand-produced books by traditional letterpress methods. Short print runs. Publishes bibliography, book arts and printing, miniatures and occasional poetry. 3 titles in 1994.' However, things had moved on since then. In 1997 the Boltons had acquired some Monotype casters and some keyboards, given to them by a friend who had obtained them years before as printers' cast-offs. Another recent source had been Camberwell School of Art in south London. The college had kept their hand-setting type, but the person who knew how to operate the caster had long since retired. David was happy to take some of their equipment, but it was new territory to him, and a steep learning curve. Finding helpful advice was a problem in itself.

> If you could get your hands on a technical handbook, it nevertheless assumed the reader had already done the Monotype five-week instruction course. It didn't tell you how to switch the machine on – stuff I needed to know! And most people who have any experience operating them have usually retired twice by now. We managed to get Harold Dotterill, who had supervised the machines at Oxford University Press, to come over and have a look at them. He was eighty-seven. He said he'd give advice, but wouldn't get involved beyond that. But once he saw them running, he couldn't resist getting his hands dirty. It was amazing, he could just listen to them and tell you what the problem was.

Sometimes, even if old hands could be located, they were not necessarily willing to cooperate. 'When the switch-over to litho came, many old metal operatives

were just moved on to other jobs, and there was a lot of bitterness in the industry,' explained David. 'Some left and never wanted to have anything to do with it again – still don't. These days we use the Internet to look for answers to any problems.'

The workshop was a delightful typographer's toolshed, full of ranks of wooden drawers holding type, and components for the casters – wedges and moulds, and various sets of typeface-related adjustment bars for the keyboards. Containers of machine oil were dotted everywhere, and their heavy aroma permeated the atmosphere. Sets of keyboards lay propped against cupboards, some customized for alphabets of special, non-Latin characters. David had already keyed in his copy, and had a roll of punched paper tape to show for his efforts. This he fitted to the caster, where the metal, Gutenberg's formula of lead, antimony and tin, was already molten, ready for action. The balance of the alloy can be adjusted according to the projected lifespan of the type; type to keep, or type to be used once and then recycled.

The caster was set running with an agreeable rattle as metal parts moved forward, back and across; the paper roll clicked through, and separate characters of 6pt type were produced at an astonishing rate, about two per second. When I commented on this, David stepped up the speed, and the rate became closer to three a second. Amazingly, even at this pace the metal was already hard as they chugged in a little line out of the innards of the caster.

'The beauty of these machines,' David shouted above the din, 'is that despite all the critical tolerances and temperature requirements, any fool can run them and get away with it!' I wasn't so sure. David had an encyclopedic knowledge of their quirks, and was able to reel off impressive lists of specifications and calibrations without catching breath. Here, truly, was an enthusiast. I caught an echo of that affectionate regard which Mr Avery seemed to have for these beasts from a bygone age.

The Alembic acquired their first printing press in 1972. At first it was a hobby for both David and his wife Claire – she had been a teacher, and he worked in educational administration. Once their children reached school age Claire wanted a new challenge, and so the press began.

'We produce about three or four books a year, our

own concepts, usually about printing or paper. We sell them to American universities, or at book fairs, to collectors. There are quite a few people who collect miniature books, for example.

'You can't really make a living out of running a small press like this.' David then corrected himself. 'Actually, we can. The trips to America recoup the air fares, and more. When I was made redundant we were able to pay off the house, and the children have long since left home, so our needs aren't so great any more.'

David showed me a copy of *Dig*, an intricate production inspired by a recent local excavation of a Roman amphitheatre, with lots of different-coloured 'flags' in different papers. It measured three inches square. 'They're not cheap,' said David. 'People are sometimes shocked by the prices, but, as we say, a small book takes just as long to produce as a big one.' *Dig* retails at £36.

I asked whether they took on commissions. Occasionally, David replied, if they liked the sound of the job – volumes of poetry, a book about trees for a local WI group. But perhaps their most striking job, and regrettably an intermittently ongoing project, is a huge memorial book for the news agency Reuters. Whenever a Reuters reporter is killed in the course of their professional duties, a short biography of them is included as a tribute in a memorial book measuring 30 by 24 inches which stands open for viewing in the agency's offices in Gray's Inn Road in London. Two journalists had died reporting the conflict in Afghanistan that followed the 2001 terrorist attack on the United States. The Alembic Press had just finished setting and printing these pages, which would be added to the main book. Thirty copies of each page are printed, and as each one deteriorates with use, it can be replaced.

Conscious of perhaps asking a stupid question, I nevertheless wanted David's opinion on what, for him, made letterpress special. To my relief his eyes didn't roll skyward. 'It's the feel,' he said. 'It's a combination really, of the paper, and the impression of the letters on it. You're not supposed to notice the indentation of the letters, but you do, that's all part of it. It's very physical.'

I could easily see why the designer of the Reuters book had wanted it to be printed letterpress. It gives the pages weight and dignity, but also warmth, a tangibility

beyond that 'glossy and unsatifying uniformity', which gives life to the memorial. They bear the imprint, not just of the type, but of the human effort that went into producing them – a worthy tribute to courage.

9 | Going Underground: Edward Johnston's letters for London

Part of the task of a graphic designer is to establish a style, a 'look', and to apply it consistently throughout the project in hand. In corporate terms this is the identity, the house style, and type plays a crucial role in this. The designers will produce a logo, an accompanying set of colours, and create or select a typeface or two, which will be used throughout the organization. For the house style to work effectively, it has to be applied everywhere, with unsparing thoroughness, from the exterior of the company headquarters down to the business card of the lowliest sales rep. When a new house style is implemented, a user's manual will usually be produced to accompany it, showing exactly how it should be used, filled with ferocious admonitions against any incorrect application or abuse.

All this is as it should be. However, I suspect I'm not alone in having the desire, once a style has been created and has been used for a while, to want to start tinkering with it or to subvert it — occasionally just for one's own amusement, but sometimes from what I would like to think is a more laudable desire to see what creative variations on a theme can be produced. Linked to this impulse is an odd affection for any piece of signage or graphic which has managed to escape the blanket application of a current house style.

Often in London, as with so many things of interest in the city, you have to turn your eyes upward to see these 'style survivors'. Although raincoat and leisure-wear company Burberry's headquarters in the Haymarket carry their new sleek identity wall to wall at eye level, an earlier generation of letters can be seen higher up on the building (albeit clumsily truncated to conform with the new name styling). And so it is with London Underground. Sitting on the upper deck of a bus waiting for the lights to change at Oxford Circus, you more readily notice on the façade of the station entrance, above the more recent projecting canopy, the lettering of an earlier era. It's still beautiful, despite the unavoidable accumulation of city grime around the gold relief lettering, possessing

40 Edward Johnston: he started with goose-quill pen in hand, but his most celebrated work was to be a major corporate redesign, an inescapable part of London's visual fabric.

an elegance and sense of permanency in stark contrast to most of the plastic shop fascias below.

The lettering at Oxford Circus and at some other surviving sites on the Bakerloo line, the Baker Street to Waterloo Station link built at the start of the twentieth century, is itself part of a 'house style', that of the Yerkes Group. The company of American financier Charles Tyson Yerkes, it built the stations on this section of the line. The exteriors are clad with dark red glazed tiles, and have the same name lettering, in a gold relief serif face, which has some of the fluidity of Goudy, or the art-nouveau-tinged lettering of the period. Forming as they do part of the fabric of the buildings, the letters actually have more intrinsic permanency than the celebrated corporate redesign which was to follow, and which was applied in various types of easily removable panelling.

The lettering of the Yerkes Group was consistent, but it was an exception. The signage of the London Electric

41 Pre-Johnston lettering still lingers around the London Underground system; a crude but powerful grotesque above an abandoned entrance on The Strand.

Railway Company (as it was then called) was an often vigorous but totally uncoordinated pot-pourri of styles. There are still copious examples of these earlier letters around the Tube system. Until a few years ago Covent Garden station still retained the original art nouveau frontages to its ticket desks, and although these are now gone, the massive lettering of the station name on the ceramic tiles that cover the walls of the platform still survives, as does some directional signage. Aldwych station, on an odd appendix to the Piccadilly line, was finally closed in the mid-1990s, but two styles of sans serif lettering, one of them definitely a 'grotesque' in its brutal assertiveness, still survive over its old entrances.

Although not the first example of a custom typeface, an alphabet produced to meet one immediate, specific need (Linn Boyd Benton's Century, for one, had been designed twenty years earlier for the magazine of the same name), the lettering created in 1916 for London Underground, the British capital's by then already extensive network of subterranean railways, stands out as a landmark corporate commission. The book that Colin Banks, whose partnership Banks & Miles redesigned and extended the family of the original face in the 1980s, wrote about its development was entitled *London's Handwriting*, and it's an apt description. London Transport themselves clearly considered the subject matter of such significance that the book was produced in 'stun-an-ox' dimensions, with a page size of 510×375 mm. Not a volume to just slip into your bag for some leisurely reading on the Circle line.

The lettering is everywhere, an unobtrusive but quietly distinctive feature of this particular urban landscape. It's sometimes called Johnston Sans, after its creator, Edward Johnston (1872–1944), although its original designation, Underground Railway Block-letter, is probably more apt, as Johnston never contemplated designing a typeface, with the implications the word carries of a family of different weights, of roman and italic. The London Transport Museum recently licensed a version for commercial use, which has been plainly entitled London Underground.

Two aspects of the lettering are remarkable, before one even begins to consider it in terms of its design. First, that it exists at all. As a nation, Great Britain has made considerable progress since the 1980s in taking into account the visual appearance of things – not just whether they work (for at least part of the time) and meet budgetary requirements. But there is still enormous room for improvement. In and around Leicester Square in the heart of London, an area crossed and recrossed by thousands of foreign visitors, the lettering and design of the frontages of many of the shops, cafés and restaurants is an eyesore, a defacement of a city that too often just doesn't seem to care enough about its appearance.

London Transport itself has not been above criticism. Sitting on a bus at night while the glare of the internal fluorescent lighting bounced off the yellow, orange and brown of the seating upholstery made me wonder on more than one occasion just what fabric designs were rejected in favour of the chosen one, or whether any sort of selection process had been involved at all.

This is all part of the attitude that what is part of the public environment, what ordinary people have to look at on a day-to-day basis, and from which no extra profit can be accrued by its providers, is of no importance, and it doesn't matter what it looks like. But it is finally being realized that it does. It costs no more, and takes no more effort, to choose a seat fabric that isn't visually oppressive. And there can be a subsequent cost in disregarding the nature of the environment that's been created. Looked at in economic terms, happier people are more productive; it is ugly architecture and cityscapes which get vandalized and graffiti-covered.

Fortunately, Edward Johnston didn't subscribe to this attitude, and his typeface has been rightly held up as a

superb product of the belief that even the least significant member of society deserved something that was both functional and of beauty in his or her everyday life.

The second surprising factor about the lettering is the date of its inception – in the middle of the most cataclysmic conflict yet to engulf Europe. Not the obvious time to decide to design a radical new style of public lettering, perhaps. There is, however, no written reference to the ongoing conflict throughout the whole process of the design of Johnston's lettering apart from an early, unfinished poster using the new alphabet, recommending the Underground as a means of travelling without fear of enemy bombs.

In some respects, though, his lettering could be seen as a contribution to the war effort. Johnston was being urged by 1911 to design a typeface to counter a perceived typographical invasion from Germany. The Klingspor Type Foundry had introduced a series of faces which they had called 'Wren' – to some the use of this English word seemed a particularly underhand move, an attempt at clandestine infiltration of British industry – and the designs were considered to show the influence of Johnston's own ideas. Johnston spoke in a letter of being asked to counter these new faces with something of his own, so that the Germans would not 'invade' – an emotive and significant word.

Ever since 1871, when through force of arms Bismarck had united the various German-speaking states and principalities in northern central Europe into a new superstate, Britain had been keeping an anxious eye on its neighbour. Whatever the British rhetoric about the glories of its empire, which reached a territorial peak towards the end of the nineteenth century, economically the nation had been slipping ever since the Great Exhibition of 1851, which Queen Victoria's husband Prince Albert (a German himself) had helped organize, to celebrate the cultural achievements of the civilized world, and Britain's dominance of it in particular. First into the Industrial Revolution, for a while Britain had leaped ahead, but others were now catching up – or in Germany's case getting ready to overtake.

As well as increasing productivity on the domestic front, Germany was competing for the few remaining areas of Africa that hadn't already been grabbed by the

other imperial nations. It wanted its 'place in the sun', and if that meant squaring up to the British Empire, and building a navy (traditionally Britain's stronger defensive arm) to accompany its already all-conquering army, then so be it.

Worrying stuff for the British. Traditionally proudly isolationist in its attitude to its neighbours in mainland Europe, Britain started looking around for allies, even coming to an 'entente', an understanding, with the traditional enemy France. There was a small but significant thread in the arts which used and played on fears of a military invasion on the part of Germany in the years from the turn of the century until the actual outbreak of conflict. Guy du Maurier, the brother of novelist Daphne, had a huge stage hit in 1909 with his play *An Englishman's Home*, in which a British Everyman meets his death heroically defending his house against foreign invaders. The play became a national talking point, provoking calls in the newspapers for compulsory military training. Erskine Childers' 1903 thriller *The Riddle of the Sands* featured two amateur yachtsmen stumbling on the German infrastructure for a future seaborne invasion from its North Sea coastline, and called for alertness and a reorganization of the nation's defences. In 1913 the humorous short story writer Hector Munro (Saki) published the unhumorous *When William Came*, which imagined the state of the nation after German annexation, following a short, disastrous war for which the British were hopelessly unprepared.

Johnston's work forms an unlikely link in this chain. In 1915, with the conflict now under way, the Design and Industries Association was formed. Already there were worries that Germany was producing better-designed and better-marketed goods than those made in Britain. Once again, it was suggested that the German type-founding industry was using the ideas and methods of William Morris, Thomas Cobden-Sanderson and Johnston himself. In essence, Britain was coming up with the ideas, but other people were exploiting them.

Who was Edward Johnston? If we picture a Kipling-esque imperial warrior, we will be far from the truth. He was born in Scotland in 1872, and came to London in 1898, having already been an office boy and a medical student in Edinburgh. His daughter Priscilla wrote

an affectionate biography of him in the 1950s; in it she relates a childhood incident in which 'some rowdy boy cousins, no doubt regarding Edward as a "sissy", threw him into a cold bath. From this he emerged gasping and, between chattering teeth, exclaimed "How glorious!" and thereafter had a cold sponge-down every day for the rest of his life.'[1]

This was no mean feat in a climate as frequently unforgiving as Britain's. But the story gives a clue to the inner resilience and determination that were to gently guide him through what, until his mid-twenties, seemed to him a directionless life. While staying with friends in London, Johnston was startled to discover that they knew personally Harry Cowlishaw, an architect whose illuminated pen lettering in an issue of *The Artist* had impressed him a year earlier. Johnston had experimented with pen lettering while still in his teens, and now felt it was something he wanted to pursue seriously.

Cowlishaw gave him advice and encouragement, and Johnston made his way to the British Museum to study early manuscripts. But he was soon formulating ideas on using what he considered the best examples as a springboard for his own scripts, rather than just copying them. Calligraphy had fallen very much out of favour by the end of the nineteenth century; one of Johnston's relations, on hearing what he was doing, exclaimed: 'But that's dead, isn't it?'[2]

Cowlishaw showed Johnston how to properly cut a goose quill to make the essential broad-nibbed pen, and, in what Johnston later came to regard as an event of almost unbelievable serendipity, introduced him to William Lethaby, principal of the Central School of Arts and Crafts. Lethaby wanted to start an illuminating class at the Central School, and offered Johnston the job of teacher. The classes started in September 1899, and quickly grew in popularity. Priscilla tells us: 'There was no question of his playing the expert; he told [the students] how little he knew, and how much there was to discover, and enlisted their help.'

Johnston proved an inspirational and highly influential teacher, although he would have fallen foul of the systematic ticking off of attainment targets according to which British education currently runs. One planned series of three half-hour talks, intended to cover the

1 Priscilla Johnston, *Edward Johnston*, London, 1959.
2 Ibid.

115

whole alphabet, ran to twelve sessions, by which point he had just started on the letter C.

His students were to include Harold Curwen, who went on to design his own sans serif face in the 1920s and ran the Curwen Press in east London, German-born Anna Simons, who translated Johnston's *Writing and Illuminating, and Lettering* into German, and returned to Germany to spread and teach his ideas there, Thomas Cobden-Sanderson, and most significantly Eric Gill, who we will look at in detail later.

Although Johnston's stance was a deeply held belief in the tenets of the Arts and Craft movement – a profound opposition to what he termed 'industry', and the whole concept of mass production – the jump from being a teacher of calligraphy, using a pen made out of a feather, to designing corporate lettering for an urban transport system was not such a great or illogical one as may be supposed. As early as 1906, in a talk he gave to students at Leicester School of Art, Johnston criticized the prevalent styles of public signage. One of the aims of the Arts and Crafts Movement was that craftsmen should not produce items that were beautiful but expensive, but should aim to bring higher aesthetic standards to bear on objects in daily use by the mass of the population.

Walking home one evening with Gill and another student, Noel Rooke, he found himself admiring the lettering on some tradesmen's carts: 'Here on their covers, in one small backwater of the lettering trade, tradition had preserved an otherwise extinct species; a really good block letter.'[3] Johnston had already revived calligraphy; he was soon to raise another alphabetical Lazarus.

In 1911 Johnston designed an italic face for a private press in Germany, and in that same year met Gerard Meynell, owner of the Westminster Press, who printed posters for London Underground. Meynell helped launch a magazine, *The Imprint*, whose mission was to extend the boundaries and outlook of the printing trade. Through one of his former students, Johnston was brought on board to design the masthead and assist with the creation of a modified form of Caslon, called Imprint, as a text face. Crucially, in 1913, Meynell introduced Johnston to the commercial manager of the London Electric Railway Company, Frank Pick.

3 Ibid.

Frank Pick (1878–1941) worked for London Transport

(as it became in 1933) from 1906 until 1940. He was, to use a modern term, a design supremo. One of his assistants observed that with Pick there was no need for a committee; he had the vision, and also the 'people skills', to get any committee to do things the way he saw it. And luckily, the way Pick saw it was impressive – very impressive indeed.

The idea for some sort of integrated design scheme to be applied to a transport system wasn't a new one. The Great Western Railway in England had used a slab serif lettering on its engines and carriages, and a 'livery', a colour scheme for painting the carriages, had been in force since the 1840s. The Budapest underground railway, the second oldest in the world after London's, had its own distinctive lettering for its station names, and the Copenhagen Tramway Company had unified the design of its interiors, tickets, livery and buildings through the hand of one designer, Knud Engelhardt.[4]

This is also what Pick wanted, and was steadily implementing through the railway system that was in his charge. The strong visual identity, the blue bar through a red disc, and later a red circle – the 'bull's-eye', also designed by Johnston – and its application throughout the network, the graphics of publicity materials, often with beautiful illustrations by MacKnight Kauffer, the care taken in the design of platform furniture and the detailing of station architecture – all this was down to Pick. He didn't design them, but he found the people who could. And what Pick needed in 1913 was a typeface.

He had clear ideas about the kind of thing he wanted; the typeface had to 'belong unmistakeably to the times in which we lived', must be capable of being read quickly and without difficulty by passengers on a moving train, and each letter should be 'a strong and unmistakeable symbol'. He had already played around a little himself with the idea of an alphabet based on squares and circles. He took into account the quality of the lighting in different locations, and also stressed the need for the lettering to be clearly different to that of any surrounding wording on advertisements or shopfronts.

It may have been this last stipulation which made Johnston decide to design a sans serif letter that was monoline, all the strokes having the same thickness. There had been a recent vogue for Trajan-style lettering,[5] and

4 Colin Banks, *London's Handwriting; The Development of Edward Johnston's Underground Railway Block-Letter*, London, 1994.

5 Inspired by the stone-cut capitals on the Trajan Column in Rome.

abcdefghijklmnopqrstuvwxyz ABCDEFGHIJKLMNOPQRSTU VWXYZ

42 Johnston's Underground Railway Block-letter, as originally titled; he imposed classical Roman proportions on the debased form of the nineteenth-century grotesque, and paved the way for the twentieth century to become one of stylistic dominance for the sans serif.

Pick had earlier admired Gill's lettering in that style for W H Smith the booksellers, although he felt it was unsuitable for his requirements. Furthermore, Smith's stalls were often to be found in Underground stations, providing just the sort of visual competition Pick wanted to avoid.

Nineteenth-century sans serif faces, or grotesques as they were then called, were by this time regarded as an ugly, debased letter form, but Johnston turned to the Roman proportions of the Trajan Column inscription to create his new letters, giving them a fresh, simple elegance. Having made this decision, with typical modesty Johnston said: 'the alphabet designed itself'. Also typically, Johnston blew his self-imposed deadline to deliver Pick some alphabets by the end of 1915. However, by the middle of 1916 he had produced an upper case alphabet, which made its first appearance on a poster in the summer of that year. The lower case followed shortly afterwards, and in 1922 Johnston completed a condensed version for use on the route boards of buses. The bold version, supervised but not drawn by Johnston, did not arrive until 1929.

How good is Johnston's lettering? Clearly, it's now impossible to fully appreciate how different it must have appeared at the time to everything around it. It still looks distinctive today, although we recognize it subliminally, forming as it does part of a strong corporate look that has become diffused into the visual fabric of London. In a sense, Pick had already created the garden in which Johnston's typographical seedlings could flourish. The typeface has so many visual links: the London transport colour scheme, the bull's-eyes, all the beautiful and humorous illustrated posters that were produced during the inter-war years, and Harry Beck's ground-breaking topographical route map which has achieved the status of a work of art in its own right. With all this accompanying baggage, it's hard not to feel a warm glow towards Johnston's letters. Normally I hate the stylistic

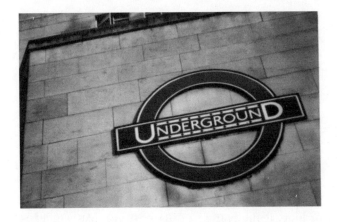

43 One of Johnston's beautiful bull's-eyes, high on a wall at Leicester Square station.

device, much used during the 1980s, by which in a word composed of capital letters both the first and last letters are made larger to create some sort of visual balance, but in consequence placing a nonsensical overemphasis on the latter. But when I see it on one of Johnston's surviving signs, I like it.

Looking at Underground Railway Block-letter in unadorned black on a white page, the layman would probably say that there was 'nothing to it', that the upper case in particular is as simple as the letters in a child's first reading book. But therein lies its strength, and to get a sense of this power one would have to compare it to what else was present in the visual landscape in 1916. And it's a strength which is still there. Standing on an Underground platform, I compared Johnston's letters on an original bull's-eye to the san serif capitals used on the headline of a huge Jack Daniel's advertisement which was next to it. With no disrespect to Jack Daniel's, whose ad was perfectly good in its own right, Johnston's capitals just looked clearer and more elegant. Those classical proportions are still paying off today.

The lower case brings to mind a description that the American designer Tibor Calman made of the title lettering created for the film *Matewan* in 1987: 'There is no warmth, charm or humanity in perfection. Only in imperfection. We wanted [the logo] to look like it was drawn in 1911 by someone without skill or knowledge but with an enormous desire to do it well.'[6]

Now clearly this is not a description of Johnston, but there is something in his opposition to 'industry', his confession to being 'not entirely "businesslike"', his

6 *Baseline* 11, London, 1989.

119

notoriety for leaving work on commissions to the absolute last minute, or even not starting them at all, which gives him the air of a gifted amateur, a dreamer, not quite at one with the world in which he found himself. In the most famous picture of Johnston, seated at his desk with quill pen in hand, there is an almost saintly, other-worldly glow about him.[7]

His lower case alphabet has a quirkiness to it that suggests, especially in comparison to later sans serif faces like Gill Sans or Futura, something of Calman's 'charm in imperfection' – the asymmetrical lower counter of the g, the long crossbar on the t, with its corresponding finial, or loop, at the bottom of the vertical stroke. The l has a similar loop, criticized by some at the time, although useful in making it distinctive, in a way that Pick would have approved, and preventing any following letter from being set too close, a sin that the printers of the day often fell into with Johnston's type, much to his annoyance. The bowls, the curved strokes, often seem to meet the verticals awkwardly, lacking smoothness and fluidity. On the w, the two inner strokes meet at a level lower than that of the two outer strokes. The diamond-shaped dots on the i and j and the shape of the punctuation clearly show the influence of the broad-nibbed pen.

Despite its success, by the late 1970s Johnston's lettering had reached a crisis point. The type still only existed in wooden blocks and metal in a now faster age of photosetting. Various advertising agencies were often using a different typeface for each separate campaign. The design partnership Banks & Miles had been working for London Transport for many years, designing brochures, leaflets, timetables and related promotional items. John Miles recalls:

> The advertising agency working for them at the time had become frustrated with the face's limitations, and were recommending that London Transport ditch it altogether. There was no italic, and to be honest, the lower case had never worked very well, especially as a text face. LT were considering replacing the face altogether and using Helvetica, but we persuaded them that they had a really valuable 'signature' in Johnston Sans that was worth retaining and developing to make it work for contemporary needs.

7 The impression one gets of Johnston's character is of a lovable but slightly eccentric figure, one who crammed the different pockets of his jackets with the essential items he needed to have with him at all times. The Ditchling Museum in Sussex, the village where Johnston lived from 1912, has preserved his studio door, complete with a system of string and pulleys which Johnston had devised to raise the draught excluder when the door opened. He had a habit of covering books with newspaper and then drawing his own designs or lettering on them, a treatment he extended even to books he borrowed.

heightx¯xheight

The Banks & Miles report concluded: 'The lettering could act like a ribbon to tie up the disparate parts of the LT business into one well organised parcel.' As John Miles adds: 'It's understandable for designers to want to change things and make their mark, but *not* changing something is a perfectly legitimate design decision. It can sometimes be better to retain the existing core and make modifications – and perhaps improvements – around the edges.'

44 Adapting and preserving: New Johnston modified Johnston's proportions, but maintained and extended his quirky use of the calligraphic 'diamonds'.

The resulting redesign, called New Johnston, created a whole new family of weights – light, medium, bold, with condensed versions, and also a book face. It broke with some of Johnston's basic principles, sometimes out of necessity, by, for example, varying the stroke width in the bold weights. Johnston's cap height to stroke width ratio was also altered, and the x-height was increased. It offended some purists, who claimed it was a different face altogether, and although there may be some substance to this, Banks & Miles always claimed that they only used Johnston's original as a springboard for the new version. Some of Johnston's quirks were retained: the long crossbar on the lower case t, the loop at the bottom of the lower case l, and the diamond-shaped dots on the i and j, a calligraphic feel that was carried through to the punctuation more positively than in Johnston's original.

Criticized in the 1980s for removing some beautiful but now impractical art nouveau ticket windows from Covent Garden station, London Transport pointed out that the Underground system was not a museum. Although the windows would be properly preserved elsewhere, the network had to function as effectively as possible in response to modern demands. The same could be said of Johnston Sans. New Johnston looked stronger, and more contemporary. But it also helped preserve original Johnston. You can still see examples of Johnston's own 'style survivors' on older signage dotted about the Underground system, and on some bus destination blinds. Banks & Miles's update harmonized with it – London Transport had no need to rip

it all out where it wasn't necessary to do so. And his blue plaque, on Hammersmith Terrace in west London, is the only example of these London markers to use a distinctive typeface – his own, of course.

'It was with Johnston's Underground Railway block letter alphabet that the first large "corporate image" of modern design was created and the sans serif typeface acquired its dignity.'[8] In typographic terms, there can be few greater tributes than this. Johnston, who began the twentieth century with a sharpened goose quill in his hand, went on to open the floodgates for a style that was to dominate the rest of the century and make the early years of the next its own.

8 *Adventure on the Underground*, Society of Typographic Designers typographic supplement, 1993.

10 | The doves and the serpent: Stanley Morison and the Wardes

'The detection of types is one of the most elementary branches of knowledge to the special expert in crime, though I confess that once when I was very young I confused the *Leeds Mercury* with the *Western Morning News*. But a *Times* leader is entirely distinctive … ' (Sherlock Holmes, *The Hound of the Baskervilles*, Sir Arthur Conan Doyle, 1902)

Whatever brand of computer you have, and whatever its age, it's a sure-fire certainty that the font library contains Times Roman. Along with Helvetica, the digital age has made Times the world's best-known typeface. Ask someone who is not a designer to choose a serif typeface, and they would at least *consider* using Times. The man with whom it is inextricably linked, Stanley Morison, did not physically create it, but caused it to come into being. A Catholic would-be communist whose enduring memorial is a typeface for *The Times*, Britain's voice of the Establishment, Morison was a rebel freethinker who came to be the embodiment of a large corporation playing in a global market.

Morison's upbringing was a hard one. He was born in 1889 in Essex, on the outskirts of London, and his father, a violent drunk, eventually abandoned the family. His mother struggled to support Stanley and his two sisters but managed nevertheless to provide an intellectually stimulating home environment; she was a keen follower of Thomas Paine, the radical eighteenth-century thinker and author of *The Rights of Man*, whose ideas proved influential in both the American and French Revolutions.

Working first as a bank clerk, Morison applied for a job as a sub-editor at *The Imprint*, Gerard Meynell's magazine for the printing trade. Meynell was the owner of the Westminster Press, a Catholic printing firm. Morison had converted to the faith in 1909, and although people who knew him well have questioned the true depths of his political beliefs, he also held strong Marxist views, applying unsuccessfully to join the Communist Party

in the 1920s. Although communism is not incompatible with a deep Catholic faith, at that period the two stances would, politically, have been polar opposites. 'He was an individualist, and though he liked to take an unpopular and indeed individualist point of view about the events of the day, and to lay down the law occasionally ... there was no real consistency of viewpoint with this or that party or this or that class in Morison's thinking.'[1]

Morison was sincere enough in his convictions to become a conscientious objector when war broke out in 1914. This was no small act of moral courage when symbols of cowardice in the form of white feathers were being handed to men of military age not wearing uniform in public. It has been understandably suggested that Morison married his wife Mabel Williamson, sixteen years his senior, only to take advantage of the current exemption from conscription for married men.[2] The law was altered, however, and Morison's stance earned him two years in prison. There he taught calligraphy to Walter Holmes, a future journalist on the left-wing journal the *Daily Worker*, in a style that later resurfaced in the heading of the paper's Worker's Notebook. After the war Francis Meynell, Gerard's cousin, became editor of the *Daily Herald* and passed to Morison his old job as typographer at the Pelican Press, one of the *Herald*'s offshoots.

By the mid-1920s Morison had two jobs. As a result of proposals he made to the Monotype Corporation concerning type revivals and type design, they offered him the job of typographical adviser. Through a former colleague at the Cloister Press in Manchester, where he had worked briefly in 1921, Morison took up a similar position for the Cambridge University Press. Monotype's typesetting machines had been hampered by a lack of good founts, and Morison set about remedying this with a series of revivals: Bembo, Baskerville, Ehrhardt, Fournier, Bell and Garamond were just some of the faces added to the Monotype roster under his supervision.

Morison used his joint roles to advantage. He knew that to get Monotype to produce the typefaces he wanted, they had to be commercially successful. If a leading book printer ordered them, they would be, and this could be achieved by advising CUP to buy the faces. He extended his influence by founding the typographic journal *The*

1 Graham Pollard, BBC radio portrait, 1969.
2 James Moran, *Stanley Morison: his typographic achievement*, London, 1971.

Fleuron with printer Oliver Simon.[3] It ran from 1923 to 1930, Morison editing it from 1925.

In 1924 he made his first visit to the United States, and it was a trip that was to have serious consequences – beneficial for the world of typography, but with grave repercussions on a personal level both for Morison and others. At the end of his tour he wrote: 'Typographically there is little of importance in US. The only important typographical personages of the future are leaving US for England in January.'[4]

Morison's dismissal of American typography was a swipe at Frederic Goudy, for whom he had developed a deep dislike. Daniel Berkeley Updike, founder of Boston's Merrymount Press, had sent Morison samples of Goudy's Garamont, his version of Garamond, a face that all the leading type companies were currently producing versions of, asking whether it was the same as Monotype's version. Morison was furious; in his estimation Monotype's was far superior, and he hated the 'ugly swash characters' that Goudy had revived. To him Goudy was nothing but an egomaniac who put his own name to his faces, faces that were either reworkings of the same design or copies of older ones.

45 Stanley Morison, drawn early in his career in 1913 by William Rothenstein; the outbreak of war a year later would lead to his imprisonment as a conscientious objector.

46 Beatrice Warde, the First Lady of Typography, who worked for a while as a man, 'Paul Beaujon' – 'We gave him a long grey beard, four grandchildren, a great interest in antique furniture and a rather vague address in Montparnasse.' The photograph dates from the mid-twenties.

3 A fleuron was a printer's 'flower', a small decorative device.
4 Nicolas Barker, *Stanley Morison*, London, 1972. Letter from Morison to Oliver Simon, 23 September 1924.

In October 1923 Morison wrote to Updike:

Yesterday I received from a man at the Princeton University Press (of whom I had not previously heard) a huge letter of four quarto pp in 10 point. He is pro-Bullen & anti-Goudy and I must quote these lines to you:' … you would not have been quite at home at the recent celebration, jubilee, medal-pinning orgy with wh. the more audible bandar-log of this land indicated that they were proud of Mr Goudy. It was very loud & very long & it may be that they chanted

Goudyamus igitur: and rend the air with cheers;
Iuuenes dum sumus: for discretion comes with years.'

This amused me very much …[5]

Updike informed Morison that his correspondent was 'a gentleman named Warde, who, for some extraordinary reason, spells "Frederique" as if he were a Frenchman and "Warde" as if he were a Spaniard'. Updike was uncertain of Warde's abilities; in his view one strike against him was that he had recently married an 'uncommonly silly person'.[6] In this judgement Updike couldn't have been wider of the mark.

These, then, were Morison's 'important typographical personages' about to cross the Atlantic – Frederic Warde and his wife Beatrice. At this point Frederic was the better known. Born Arthur Frederick Ward in Minnesota in 1894, he claimed that he added the 'e' to his name to revive the spelling used by an ancestor who had fought with William the Conqueror. During training at the US Army School of Military Aeronautics there was further tinkering with his name; 'Frederique' temporarily took his fancy before he settled on Frederic.

The Great War ended before Warde could see action, and he became supervisor of Monotype composition at the publisher William Edwin Rudge. He also attended the Lanston Monotype School in Philadelphia, learning to operate the machines to produce an aesthetically higher level of setting. In 1922 he became Director of Printing at Princeton. His dedication and ability were admired, but his search for perfection, described by one colleague as 'ruthless', made for uneasy working relations. Anything less than excellence, even in the smallest details, could drive him into a rage.

5 With allowance for the obvious play on words: For let us be happy … While we are young …

6. Letter from Updike to Morison, 13 November 1923.

Beatrice Warde, born Beatrice Becker in New York in 1900, was the daughter of May Lamberton Becker, a book reviewer for the *New York Herald Tribune*, and Gustave Becker, a composer and music teacher. When Henry Lewis Bullen advertised for an assistant to help him at the ATF library while he compiled the monumental 1923 specimen book, Beatrice turned up for the interview armed with a letter of recommendation from Bruce Rogers. As Beatrice was to tell it, Bullen gazed reverentially at the letter, then gave her both the job and a duster, instructing her to apply it to the tops of all the books in the library. If, in the course of her work, she wanted to stop and read any of the books, that was perfectly acceptable. Beatrice later claimed that no one ever visited the library, so the post afforded her ample opportunity for study. Whatever the truth of this, she absorbed a vast fund of knowledge which she was soon to put to formidable use, turning a key area of accepted typographic scholarship on its head.

Beatrice Warde became that extremely rare thing in the 1920s, a woman in the male-dominated world of typography. In a 1923 photograph of the attendees of a lunch party for Bullen, she sits serenely amidst a phalanx of thirty-six suits. Of striking appearance, she was also possessed of great personal charm, that rare ability to make those she spoke to feel that they themselves were far more intelligent, amusing and impressive than they had previously supposed. When one reads her own accounts of her life and career, her supreme confidence, humour, erudition and strength of character ooze out of every sentence. An Englishman from Morison's background would never have met anyone like her before; he would not be the last to be swept away by the sheer force and charm of her personality.

Beatrice's marriage to Frederic in 1921 was probably fated to be a short one. She was later to imply that the arrangement had from the start been 'open', usually a blueprint for disaster. Both were extremely strong characters; Beatrice was able to use this strength to make things happen for her, while Frederic, often his own worst enemy, 'burned his bridges before he crossed them'.[7] Beatrice later wrote despairingly to her mother: 'Heaven knows I'm bad enough at taking criticism, but with him anything but praise is an at-

7 Theo Rehak, e-mail correspondence, 2002.

tempt to "discourage" or "belittle" him – even from me, mind you!'[8]

In the light of his later life and career, Frederic must have wished subsequently that he had never sent that letter to Morison, resisted the impulse to be clever at someone else's expense, and kept his mouth shut. Because like him Morison found Beatrice intensely attractive. And Beatrice was deeply impressed by Morison. Nick-naming him 'The Serpent',[9] she later recalled: 'Within five minutes I knew that I was not only in the presence of a wit and a scholar, but in that of as remarkable a personality, and as vivid and unforgettable a one as I'd ever encountered in my life.'[10]

The Wardes have been portrayed as doves to Morison's serpent, but a letter from Frederic to Bullen in January 1925 finds Warde determined to play things his way: ' ... I was very glad to receive your letter. It came yesterday, and it confirms in many respects my own opinion about Morison ... If Morison has any work which I *wish* to do, and which he will leave *entirely to me*, and pay well for my time, I may consider such work entirely upon – caution and contract – as you have suggested.'[11]

The work was forthcoming; Frederic was soon designing an italic face called Arrighi, based on a six-teenth-century Italian script. In 1928 it was chosen to accompany Bruce Rogers's Centaur, and renamed Centaur Italic. But long before this, an emotional cloudburst had deluged the main players. Mabel Morison, already feeling she was losing her husband to typography, found a letter from Beatrice to Morison which she believed betrayed their mutual attraction. Whether this was a correct interpretation or not, it spelled the end of the Morisons' relationship. The Wardes' open marriage also split at the seams. As Frederic and Morison for a time shared an office, the atmosphere must frequently have been unbearable.

Frederic, probably not guiltless himself, and increasingly disaffected with Morison and the British typographical world, left his marriage to pursue his aim of being what Bruce Rogers termed 'a tramp typographer'. He eventually returned to the United States, finding work as a book designer for Rudge, but the attempt to set up his own Watch Hill Press was frustrated by the economic crash of 1929. He died aged only forty-five in

8 Barker, op. cit. Letter, August or September 1926.

9 Quite why is uncertain. Possibly it was a Biblical reference that may have originated with Bullen – Morison compared to the treacherous, tempting reptile in the Garden of Eden.

10 BBC radio portrait, 1969.

11 John Dreyfus, 'A rejoinder and extension to Herbert Johnson's "Notes on Frederic Warde and the true story of his Arrighi type"', *Fine Print*, April 1987.

New York City in July 1939. The brief obituary notice in the *New York Times* described him as production manager for Oxford University Press in New York, but posterity seems to have judged the final decade of his life as one of professional failure and impoverishment; an empty life, yet oddly full of interests – cookery, perfume- and watch-making, landscape design – and devoted friends. There is a story still waiting to be told.[12]

Beatrice began writing for *The Fleuron*, and it was there she made her first great contribution to the world of typography. Because it was considered that no one would take the opinions of a woman seriously, she wrote under a male pseudonym, Paul Beaujon: 'We gave him a long grey beard, four grandchildren, a great interest in antique furniture and a rather vague address in Montparnasse,' she was later to recall.[13] As we have seen in Chapter 3, it was 'Beaujon' who unravelled the mystery of the Garamond types. Beatrice sent a triumphant telegram to Morison from Paris, following her examination of the archive material there, announcing that Jannon's types had been appropriated by a 'rapacious Papist government'. This humorous dig at Morison's religious affiliations reveals how at ease she felt with him. Morison was by all accounts a formidable character and an expert at hitting a table with his fist so that the blow reverberated the length and breadth of the furniture – something he frequently did.

Deeply impressed by Beaujon's scholarly detective work, the Monotype Corporation invited 'him' to edit their magazine, *The Monotype Recorder*. Morison clearly hadn't alerted the top dogs at the company as to who Paul Beaujon actually was, for as Beatrice recalled:' ... "he" then turned up in London to the petrifaction of the Monotype executives. They had never hired a woman in their place above the rank of secretary, and had no idea how to deal with "her"!'[14]

Once the Monotype executives had recovered from their astonishment, they gave her the job, and she was to remain a dominant force as publicity manager for the company until her retirement in 1960. Her publicity material included somewhat grandiloquent pronouncements, and even poetry, on the nobility of the printer's calling and the pursuit of truth. If the profession wasn't in reality peopled with clear-eyed idealistic apprentices and

12 Although the doctor who attended Warde during his final months officially ascribed his death to natural causes, rumours still linger that it was at least a half-hearted suicide attempt that succeeded, possibly brought on by alcohol-related ailments. But his end remains obscure; Frederic's small but loyal coterie of friends were protective, even after his death. Will Ransom, of the University of Oklahoma Press, and a former associate of Goudy's at the Village Press, wrote Warde's obituary for *Print* magazine in 1941. He said of him: 'As a human being Frederic Warde may best be described as an impersonal personality. He gave generously of affection to a few intimates, who reciprocated in full measure, but that was a phase the world never saw.' Frederic's old friend Henry Watson Kent vetted the copy, and all reference to Beatrice was deleted.

13 John Dreyfus, 'Beatrice Warde, the First Lady of Typography', *The Penrose Annual*, vol. 63, New York, 1970.

14 *The Monotype Recorder*, June 1970.

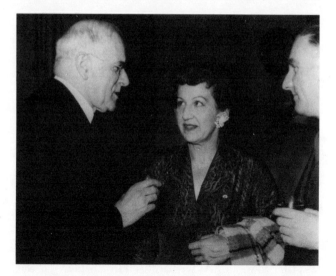

47 Isn't this a lovely day? The Fred and Ginger of Monotype, Stanley Morison (left) and Beatrice Warde, still wining and dining in the cause, decades on.

Capra-esque seniors with green eyeshades, talking slow and making sense, then it wasn't for want of Beatrice's efforts. She died in 1969; with Morison gone two years before, it was the passing of an era.

Morison ventured into type design only once, but the result became the most successful typeface ever designed. The advertising manager of *The Times* newspaper had approached Monotype with a view to selling them some ad space; as part of the deal he offered to have the advertisement set by *The Times*' compositors. Morison, outraged by this suggestion, announced he'd rather pay them *not* to set it, so poor did he consider the current state of the paper's typography. This remark eventually made its way back to the newspaper's management, who responded by challenging Morison to come up with something better. In the proposal for the new typeface that Morison submitted, under the sub-heading 'No "arty" types required in *The Times*', he stated: 'It is hoped that the experimental fount now in preparation for scrutiny by the Committee will have at least the merit of being free from all that is academic or "arty" ... Type should not ape calligraphy; it should first and last, look like type, but good type – i.e., good for its purpose.'

To the contemporary eye, *The Times* in the 1920s would not make for enticing reading – broadsheet pages, much larger than those of today's newspaper, divided into narrow columns of dense type unrelieved by pictures or large headlines. Morison's new face was drawn by Victor

Lardent, a draughtsman at the newspaper, and made its first appearance on 3 October 1932. Solid and businesslike, the characters were designed to have no sharp angles to trap ink and subsequently smudge, and could be read easily, even in the smallest-ever typesize, 4.5pt. *The Times'* leader for that day made note of its arrival, pointing out that the work of the private presses in improving book typography had also led to an increase in readers' expectations from their daily read: 'It is more of a commonplace to typographer than to layman how fine a shade of difference with how vast a consequence may distinguish type from type. But for the layman there is mystery enough, even after centuries of printing, in the facility with which its fixed mechanical symbolism can take so sensitive an impression of life and spirit.'

Clearly the paper recognized the significance of its makeover, and that it would be of interest to their readers too, if only to put at ease the minds of those who'd noticed that something was different about the paper, but couldn't for the life of them put their finger on what it was.

The Times had sole usage rights to their typeface only for a year, after which it went on general release. It's hard to imagine this happening today, when everything is nailed down as regards usage and copyright. Would *The Times'* management have been amazed if they had known that sixty years later Times New Roman, or a digitized version of it, would be a feature of every personal computer throughout the world? Possibly not, as no typeface has ever had such a high profile. As well as the announcement of its inception in 1932, Times the typeface has had no fewer than three publicly heralded redesigns.

The first, in 1972, was called Times Europa, designed by Walter Tracy, for many years head of typeface development at Linotype; he had already worked on newspaper typography for *The Daily Telegraph*. Newspaper print technology had changed since 1932; the presses were faster, but the quality of the paper had worsened, and the clarity of impression that Times New Roman yielded was suffering. Subsequent research had shown that, as an aid to legibility, the x-height area and the ascenders were of far more importance than descenders, the truth of which can easily be demonstrated. Choosing any line of text in this book, cover up the descenders of that

TME
fgm

48 Times New Roman: Morison said of his only type creation: 'It has the merit of not looking as if it had been designed by somebody in particular', a quality that made it ubiquitous in the age of digital type.

131

line with a sheet of paper. The words remain easy to read, but cover the ascenders instead and they become slightly less legible.

With this fact in mind, the x-height had been increased (at 8pt in particular it had been considered too small). With its new, squarer serifs, Times Europa took up more space than New Roman, the increased x-height meant that 8pt in Europa looked as large as 9pt in New Roman, while still, it was claimed, beating Ionic, the face used by rival papers the *Daily Express* and the *Daily Mirror*, for economy of space.

By 1991, it was time for version three. Times Millennium was a response to developments in newspaper design – *The Guardian* had launched a clean and modern redesign in the late eighties, and with the enormous changes in style that had come about in magazine layout since the middle of the decade, *The Times* was starting to look dated. In the search for an airier feel to the pages, Aurobind Patel, fresh from his work on *The Economist*, was drafted in to take a look at the paper's requirements with the help of Gunnlaugur Briem and head of design David Driver. The typeface was restyled on computer for the first time, becoming slightly more condensed, with angular serifs and less prominent ascenders and descenders.

More words could now be included in any given space than with Times Europa, with more white space around them. In addition the gutters, the spaces between the columns of text, could be widened, to give an overall lighter look.

Times Classic, by Dave Farey and Richard Dawson, was introduced in 2002, intended to work more effectively on very narrow column widths; it is bolder with flatter serifs and a smaller x-height, which helps the eye not to be distracted by lines above and below. Being more compressed than Millennium, it works better for headlines, with more letters, and taller ones, for the available width.

Morison continued to work for Monotype and *The Times* for many years, at one point becoming editor of *The Times Literary Supplement*. He also helped devise the distinctive type-only book jackets, black and red on yellow paper, for publishers Victor Gollancz. Apart from Times New Roman, his greatest other contribution

to type was his commissioning of Eric Gill's faces for Monotype (see Chapter 12). He refused a knighthood three times.

For many years Stanley Morison *was* Monotype, and Monotype was the dominant force in British type.[15] Much writing about him borders on hagiography, but he was a powerful man in a powerful company, and the world of type was a small one. Appraisals tended to be written by friends and colleagues, and these were usually fulsome − 'greatness' was the quality he was commonly agreed among his devotees to have possessed. Work seems to have formed the whole of Morison's waking life; he took a dim view of leisure, as associate Arthur Crook recalled:

> We were there [at *The Times*] together once on a Saturday morning, and Morison discovered that I was going to a matinée in the afternoon; and I was reproached for this as a terrible waste of time. He said to me, 'If you want to get on on this paper, you can't do it without a thorough grounding in medieval Latin. You haven't any medieval Latin, but you can put this right. Why not medieval Latin instead of the theatre? Now there's a parish priest in Esher called Dr D. J. B. Hawkins, you can go to him every Saturday afternoon from half past two until half past five. I will arrange it.[16]

The offer was declined.

Understandably, a man in Morison's position and of his temperament made enemies too: 'I am rather a peace at any price person and wd. give my very trousers to be on ordinary terms with people,' he wrote to Updike in 1924. 'Nevertheless "suffering fools gladly" is not my strong point and I easily get bored with our own typographical worthies.' After his death, reappraisal wasn't long in coming. In his 1971 book *Stanley Morison: his typographic achievement*, James Moran took a critical stance, claiming that since the 1950s Morison had been subtly rewriting his own history, shifting a date here and there to make it seem as though he had had the original ideas for new developments. Many of Monotype's and Morison's personal records were destroyed by bombing in 1941, so claims were difficult to refute. In the 1980s, the American journal *Fine Print* ran accusations and rebuttals, from Herbert H. Johnson and John Dreyfus respectively,

15 It was a position of pre-eminence that was contested, until his retirement in 1936, by Frank Hinman Pierpont (1860–1937), the American works manager at Monotype, who ruled his domain with a mailed fist. No velvet glove was deemed necessary; employees found seated while working were liable to have their stools personally kicked from under them by the draconian Pierpont. Morison's involvement was resented, and Pierpont proved himself quite ready to interfere, regardless of company interests.

16 BBC radio portrait, 1969.

over whether Morison seriously attempted to claim the credit for commissioning the Arrighi typeface before Frederic Warde had even arrived in Europe.[17] Warde had certainly been at pains to assert his ownership of Arrighi, financially as well as intellectually and creatively, although this may merely have been paranoia induced by his dislike and distrust of Morison. Whatever the truth of the matter, acrimony seems fated eternally to link the two men.

Aesthetically, Morison's passion was for the world of pre-nineteenth-century type. For this his scholarship and enthusiasm were unbounded, but he had little warmth for contemporary developments. Times New Roman, though a response to a modern problem, inhabits the same typographical landscape as Monotype revivals Plantin and Bembo. 'It is very doubtful if Mr Morison personally approves of the products of those contemporary typographers to whom a centre line is anathema and asymmetry all, in spite of the final words of the introductory essay in this book ... "We must not despise the new".'[18] Of his own design, Morison wrote to Updike in 1937: 'I wish it could be redesigned, but it seems to be doing its job day by day in *The Times*. It has the merit of not looking as if it had been designed by somebody in particular – Mr Goudy for instance ...'

At the inception of Times Classic in 2002, New Roman was described in the newspaper as 'handsome, clinical, detached, easy to recognise, commercial'.[19] Detached, looking as though it was designed by no one in particular: herein lies the problem. As a student, the first typefaces I had presented to me as named entities were Times and Univers, both remarkably impersonal sets of letters. It's little wonder that for a long time I believed typefaces were designed by machines responding to mathematical formulae.

In my early years as a designer I occasionally used Times, but after concluding that style-wise it could never add any qualities I was looking for, I resolutely left it alone. It is handsome in its way, but for me its charm works only in the one place it was designed for. Maybe in the back of my mind I was always searching for one of those 'arty faces' which Morison so reviled. As *The Times*' feature conceded: 'Its universal overuse has now become, ironically, a serious threat to the very future of

17 Herbert H. Johnson, 'Notes on Frederic Warde and the true story of his Arrighi type', *Fine Print*, July 1986, and John Dreyfus, 'A rejoinder and extension', op. cit. Dreyfus, who followed Morison as Monotype's typographical adviser, and was a good friend of both him and Beatrice Warde, contested Johnson's claims, citing Morison as only ever having said he *thought* he was solely responsible for negotiations about the type, but that his memory was not reliable on the subject.

18 Walter Tracy, review of 1948 reprint of Morison's *Four Centuries of Fine Printing*.

19 Susan Shaw, 'A big impression in a narrow column', *The Times*, 17 April 2002.

typographic variety and creative writing.'[20] So it's official: ignore it and try something else.

Beatrice Warde claimed she wasn't essentially interested in typography at all – it was the unimpeded delivery of the message, of truth, which was her prime concern. Typography was just a means of doing this. She had no time for what she termed 'avant-garde' type – it was 'too preoccupied with making a picture on the page'.[21] In 1955 she published *The Crystal Goblet – Sixteen Essays on Typography*, in which she propounded the much debated and often repeated theory that printing should be invisible: 'There is nothing simple or dull in achieving the transparent page. Vulgar ostentation is twice as easy as discipline. When you realise that ugly typography never effaces itself, you will be able to capture beauty as the wise men capture happiness by aiming at something else … Nobody (save the other craftsmen) will appreciate half your skill.'

Should good typography, or printing, as she phrased it, be invisible? Yes, when you want the reader's eye to have as easy a ride as possible through lines of text. But sometimes you want the type to jump up, grab the attention and score a few goals. It's hard to evaluate, though, how much typography of either variety the non-designer eye registers, except on a subliminal level. Beatrice Warde was right about one thing: most of the time, whatever your chosen field, only your fellow craftsmen will appreciate your efforts, however you play it.

20 Ibid.
21 John Dreyfus, 'Beatrice Warde', op. cit.

11 | Dangerous passions: radical European typography in the inter-war years

As Europeans go, the English are not intellectual. They have a horror of abstract thought, they feel no need for any philosophy or systematic 'world-view'. (George Orwell, *England Your England*, 1941)

The knock at the door was brusque, peremptory. Annie Renner froze, her heart beating lightly but more insistently. She had been expecting something like this, but now the moment had arrived, she was uncertain she could cope with it as Paul would wish. Steeling herself, she opened the door. Four brown-shirted men immediately pushed their way past her into the apartment, each wearing a red armband bearing the black hooked cross, the swastika. They were armed, and appeared tense, like a coiled spring waiting to be unleashed.

'We would like to speak to Herr Renner,' announced the leader. 'Bring him here, please.'

Annie swallowed. 'I'm sorry. He's not home. He's in Berlin. Please – what's this about?'

The speaker allowed himself a grim smile. 'We have evidence that your husband has been producing Russian propaganda against Germany. He is a graphic artist, is he not?' He thrust a copy of the magazine *Gebrauchs-graphik* towards her. 'I believe he is also responsible for an article in here.'

'He is a type designer,' Annie replied through dry lips. That article – she knew nothing good could come of it. 'Political idiocy,' Paul had written, 'growing more violent and malicious every day, may eventually sweep the whole of western culture to the ground with its muddy sleeve.' He was right of course, but these days it wasn't safe to say such things. Now how on earth was she going to get these men out of their home?

In the first century AD, Boudicca, queen of the English tribe the Iceni, led a rebellion against their Roman rulers which ultimately came to grief in open battle against a

much smaller but well-organized Roman force. Working as a unit, they used a shield wall and the short stabbing sword to systematically reduce a rebel force reliant on the broadsword-wielding warrior hero. It was an early triumph of the system over the individual.

Orwell wrote his lines during the Second World War, but they still hold true today. Mainland Europe largely favours the 'system', at least as an overriding idea, however much individual behaviour may stray within it. It is this discrepancy of outlook which still informs Britain's dealings with its partners in the European Union, feeding the national uncertainty about membership and the unified monetary system that France, Holland and Germany seem to be able to adopt without the soul-searching that goes on across the Channel.

Moving from the world of British and American typography to that of Europe in the aftermath of the First World War feels like a shift from the domain of the maverick to a terrain where philosophy transcends the individual, however gifted. Design subscribed patently to one system of thought or another. In the English-speaking world, Baskerville, Goudy and Gill were all essentially creative loners, as was Edward Johnston, a solitary spirit putting his talent at the disposal of a corporation, but with no wider game plan for the application and development of his work beyond the design of a single upper case alphabet. The Caslons and the Bentons worked with a constant eye to the market; it was business first, aesthetics next. Stanley Morison would claim a 'programme' of type revivals, but it hardly amounted to a creative vision for the future, or a radical reshaping of the present.

The German mindset is usually characterized by its detractors as one obsessed with order and efficiency, and lacking in humour. Yet there is a strong romantic, and even superstitious, side to the German nature.[1] The language has been described as ordered yet dreamy; it follows numerous strict rules, yet the grammatic convention that pushes any second verb to the end of the sentence means that the listener or reader takes in information in quite a different way to how they do so in English or French. You have to wait. It is also perhaps only an ordered but dreamy nature which can believe that such a gentle thing as lower case sans serif typography can

1 The British newspaper *The Observer* reported on the morning of the 2002 World Cup final that the German team, generally regarded as having reached the final by dour Teutonic organization rather than talent, had actually been relying on a lucky penny, a common German talisman, which they buried in the pitch prior to each game. Security for the final meant this was not possible, and the coin had to be held by a suspended player. They lost the game.

tangibly improve people's lives. Few in Britain would have thought this, or probably even have cared, but in inter-war Germany a fierce ideological battle was fought, a struggle that was later to threaten the lives of those who found themselves on the wrong side.

For Germany the Great War of 1914–18 had ended in defeat, with over two million men killed. Germany had not started the war, but the nervousness induced by the aggressive military presence of the German state and the resulting system of alliances had been the major reason for its outbreak, and it was Germany which carried the vast weight of the struggle on behalf of itself and its allies. Exhausted by four years of attritional warfare, the country took a gamble on one last great offensive before the weight of American reinforcements began to tell on the Western Front. It was a gamble that came close to succeeding, but after the tide of the German advance had been halted, retreat and a naval mutiny quickly followed. The German Emperor abdicated and an armistice was called with the German Army – although materially unable to carry on the fight – technically undefeated in the field, and still on foreign soil.

The Paris peace conference in 1919 found the opposing forces in unforgiving mood. Germany lost a large tract of its territory in the east and its coalfields in the west, and a republic was created. Punitive payments were demanded by France to compensate for the devastation that had been inflicted on its northern industrial territory.

In an unstable post-war world, the German economy was particularly vulnerable. Its inability to meet war reparations sparked a French invasion of the German industrial regions in 1923, causing astronomical inflation in which the German currency became almost worthless. The political situation was equally volatile. Extreme left- and right-wing groups had been in conflict since the end of the war; in 1923 Adolf Hitler carried out an early, unsuccessful bid to seize power. He was not the first to attempt to do so.

It seems improbable that in such a climate anyone would have time to think about art and design, so absorbed would they be in mere survival. But the years 1919 to 1933 were golden ones for creative innovation in many branches of art and design, not least in the graphic

ones. Artists such as Max Beckmann, Otto Dix, Georg Grosz and the Dadaists Max Ernst and Kurt Schwitters were just a few of those for whom the era was a particularly fruitful one, a creativity that was ruthlessly quashed once Hitler gained the reins of power in 1933.

Long before he was able to turn his attention to the rest of Europe, the first damage the new leader inflicted was on his adopted nation, not least by his suppression of all artistic thought and activity that did not chime with his own ultra-conservative outlook and serve the propaganda needs of his party. Any train of thought that led elsewhere was branded as decadent or 'Bolshevist'.[2] The subsequent repression usually culminated in the persecuted leaving Germany for permanent exile – scientifically Germany experienced a 'brain drain' that robbed it of the capacity to win the next war, and artistically a loss of cultural standing from which it has arguably yet to recover. It was a creative pogrom that was also to make its influence felt in the world of typography.

But even as Germany's fate was being decided at the Paris peace conference, an architect called Walter Gropius was founding a new type of art school. The Bauhaus was to have a peripatetic existence, starting life in Weimar, capital and soubriquet of the new German republic, later moving to Dessau, and ending its life in Berlin, where it was closed by the new Nazi regime in 1933.

The original aim of the Bauhaus was to reconcile design with mass production. Following German unification in 1871, industrialization had taken place at a far more rapid rate than it had in Britain, as Germany strove to catch up with and overtake its European rivals. With this development came the inevitable social transformation as large numbers of people moved from rural areas to the cities in search of work. The Bauhaus was responding to what it saw as the dehumanizing influences of mass production, the division of labour it brought about, and the resultant dishonest and degraded nature of the artefacts produced.

In this it was drawing on earlier ideas, those of the English Arts and Crafts movement and the German Deutsche Werkbund. This had been founded in 1907 to address concerns about the quality of goods being produced in Germany, with a view to improving economic performance and exports. But whereas the Arts

2 Bolshevism, or communism, was for many in the inter-war years the great terror from the East. Fear of it was a considerable factor in the tolerance of Hitler; he was seen as a force to oppose Soviet Russia. Karl Marx had always believed Germany the most likely candidate for revolution, with a more cohesive and potentially organizable working class than Russia. After the success of the Russian revolution, it seemed, with the end of the war, that Germany might follow suit. Councils of workers and soldiers were forming all over the country even before the armistice, and a short-lived socialist republic was proclaimed in Bavaria. An attempt to establish a communist government in Berlin, by the Spartacists, led by Karl Liebknecht and Rosa Luxemburg, was violently crushed by right-wing irregular forces in January 1919.

49 Familiarity breeds legibility: blackletter as a text face, from a German novel of 1916.

and Crafts movement turned away from mass production, the Bauhaus philosophy saw it as a means by which everyone could have affordable good things, rather than just affordable bad things.

Gropius had been a member of the Werkbund; it had tentatively concluded that the way forward was to address the surface style of things, to appeal to middle-class taste. But Gropius wanted to cut deeper, to start with the actual methods of working – to concentrate on craft rather than art. His belief, undoubtedly a sound one, was that if one concentrated on one's craft, on doing something to the limits of one's abilities, then 'art' would sometimes result, almost as a bolt from heaven.

The Bauhaus is associated in the modern mind chiefly with three-dimensional design, architecture, furniture and household items, but it also produced and influenced graphic design, and by extension typography. Design reform was in the air in Germany in the 1920s, and the Bauhaus and its fellow travellers were to make an indelible mark.

Germany after the First World War was a unique typographic environment offering an unparalleled opportunity for profound and radical change – if such reforms were allowed to happen. Ranged against any such attempts were the urgings of tradition and conservatism, a perception of national identity, and later the full force of Adolf Hitler's Third Reich.

Germany was the last bastion of blackletter (*fraktur*), the heavy, jagged typefaces based on monastic script that had been in use since Gutenberg. Some German type designers, such as Emil Weiss (1875–1943), whose elegant roman alphabet Weiss is still commercially

available, also attempted to design better, more legible blackletter faces – his Weiss Fraktur of 1913 was a highly regarded example. But although blackletter represented a very traditional, inward-looking German culture, it had also been a symbol of national identity when that identity was under threat. Although during the eighteenth century German scientific textbooks began to be printed in roman lettering, the period of Napoleon's domination of the continent gave blackletter a symbolic role as a beacon of a national culture under attack from outside forces.

Later, in the nineteenth century, there were calls for its abolition, those in opposition arguing that blackletter was detrimental to the international standing of German literature and thought. Notable among its opponents was Jakob Grimm, famous, with his brother Wilhelm, as a collector of traditional folk tales. Many who supported blackletter's retention felt that it was inherently tied up with the handwritten and printed representation of the German language. The first Chancellor of united Germany, Otto von Bismarck, claimed that it took him considerably longer to read a page of text set in roman than it did one set in blackletter, which supports the theory that people find legible that with which they are familiar; readability is not intrinsically a question of type design.

The issue became political. In 1911 the German parliament debated a proposal for roman type to be made standard, and also to be taught as handwriting in German schools. The argument split roughly along party lines, liberals and social democrats tending to form the pro-roman lobby. The final vote was considered to be inconclusive. Later debates by academic bodies also produced results in favour of both roman and blackletter.

So the question of the retention of blackletter was a heated issue, at least in intellectual circles. It was into this arena of debate that the progressive design forces of the Bauhaus and its sympathizers would stride in the 1920s; they were to side unequivocally with roman text, but not just any roman text – it had to be sans serif.

The debate was made complex by the uniquely German question of orthography. In the sixteenth century, capital letters were adopted for every noun in written German – table, chair, house, everything. Again,

there had been subsequent attempts to change this. Jakob Grimm's *German Grammar* of 1822 was set in roman and used capitals only for the start of sentences and for 'proper' nouns, as in English usage.

In 1920 Walter Porstmann published *Languages and Writing* in which he went one step farther, and proposed the total abolition of capital letters. The book was read by László Moholy-Nagy (1895–1946), a Hungarian designer, photographer and painter, and teacher at the Bauhaus. One of the students, and later himself a Bauhaus teacher, Herbert Bayer (1900–85), designed a lower-case-only alphabet, called Universal. Universal it never became, seeing little usage beyond some Bauhaus-designed exhibition stands, but it was an interesting contribution to a typographic hare that was already up and running.

Jakob Erbar (1878–1935) designed Erbar, a geometrically based sans serif released in 1926, for the Frankfurt foundry Ludwig and Mayer. In 1927 Rudolf Koch (1876–1934) produced the distinctive Kabel (Cable), with large ascender to x-height ratio, a traditional roman shape to the lower case a, a tail to the t, a Venetian e,[3] and oblique endings to many of the strokes. But both these faces, excellent though they are, were to be eclipsed in popularity by the most famous German typeface of the period – Futura.

The designer of Futura was Paul Renner (1878–1956). Like Edward Johnston, he was an unlikely figure, in the light of his early work, to become a standard-bearer for a change in typographical thought. He was born in Wernigerode in the Harz region, south of Brunswick and Magdeburg. His father was a theologian, and had been the court chaplain to the Earl of Stolberg in Wernigerode. On leaving school, Renner studied art, studies that concluded at the turn of century in Munich, a city and area where he was to remain for most of his life. His initial aim was to be a painter, and from this he first made a living, also contributing illustrations to the satirical magazine *Simplizissimus*. When the Deutsche Werkbund held its first meeting in Munich in 1907, Renner attended and was impressed by the call to reconcile art with mass production. He joined the Werkbund, and took part in its early debates on the role of art in society.

It was at this time that Renner started working in the field of applied arts. He met the publisher George

3 The Venetian-style e has a sloping crossbar.

50 Paul Renner, 'a modern of the moderns' who argued for the value of the past; his outspokenness against Hitler's regime and its cultural policies was to cost him his career.

Müller, who handed him a strip of cardboard the size of a book spine, and asked him to create a design for it. It was the first of many commissions. The company published French, Italian and Spanish literature as well as German authors, and as Renner was trying to use typefaces sympathetic to the texts, this meant both black-letter and roman faces. At this stage he didn't consider type style as an either/or situation – he was happy with coexistence. It was only later, in the 1920s, that he moved to a position where he considered blackletter to be a decadent form. Indeed, he argued that it was not particularly German, having been developed in northern France, whereas the lower case letter forms of the roman alphabet were developed in what now constituted Germany. He concluded that sans serif was the way forward, but that it was a style that needed development.

Müller originally used Renner purely to design the bindings, but gradually his workload increased, and painting took a back seat as he began designing the pages as well. He developed ideas about text, admiring in particular the typesetting of the English private press movement. In the years leading up to the First World War, he was involved in two educational establishments, setting up the Munich School for Illustration and Book

Production, which merged in 1914 with the state-subsi-dized Debschitz School, of which Renner then became co-director. He gave this up at the end of his contract, the exigencies of wartime having left insufficient fund-ing to run things as he would have wished. He was by then also serving in the army, in charge of a recruiting depot near Munich. His experiences of trying to teach artillery skills by means of a system of diagrams, laying down a set of guidelines, led him to try this approach with typography, an idea that came to fruition in his first book, *Typography as Art*, published in 1922.

But between 1919 and 1924 Renner largely gave up book design and returned to painting, unwillingly taking a position as adviser to the German Publishing Association in Stuttgart when disastrous inflation took hold of the German economy. Many of the middle class lost their savings during this period, an experience that Hitler was later to play on to his advantage, with his promises of escape from political and economic anarchy. The work at least enabled Renner and his family to survive, but he gave up the job at the end of 1923 and returned to his home near Lake Constance to concen-trate on painting.

Oddly, it was Renner's credentials as a painter which gained him the commission to design what would become Futura. He was visited by Jakob Hegner, who ran a publishing and printing company near Dresden, and was an adviser to a Dresden type founder. Hegner was looking for new roman typefaces. He believed that only painters had the necessary fresh, left-field approach to the problem of designing lettering, unhindered by a type designer's preconceptions, a theory he had already put into practice. Inspired, Renner began work the next day, designing different versions of the words 'the type-face of our time', Hegner's phrase to describe what he wanted. Hegner was encouraging, and Renner duly drew the rest of the alphabet, and sent it off. Hegner then fell strangely silent; after months of waiting, Renner asked for the drawings back. A former student of his, Heinrich Jost, was now an adviser to the Frankfurt foundry Bauer, and showed the alphabet to Georg Hartmann, the owner. Hartmann liked what he saw, and by the winter of 1924 a trial cut of Futura had been made.

The earlier versions of Futura contained a set of lower

AHM
fgi

51 Futura: Renner skilfully breathed warmth into what is at first glance purely an exercise in ruler and compass. The j, shown here, is a stylistic oddity that survived the culling of his alternative radical letter forms offered in the first specimen.

case characters with alternative versions that were radically different to the Futura available today – particularly the a and the g – while the r was an unconnected stem and spot. Renner's approach to the design of the typeface was very geometric; a marriage of the circle and the straight line. When he applied this approach to the lower case, some strange character shapes resulted; g's with angular lower loops, a's with right angles in the upper loop. The first type specimen of Futura released in 1927 featured some of these characters, but by the second edition in 1928 they were gone. Renner later stated that he considered there to be two versions of Futura, a more conventional and a 'Constructivist' one, but the foundry, doubtless with an eye to sales, abandoned the more radical forms. Renner himself conceded that type design, if the type was to work as a legible face, could not depart too drastically from traditional forms. He clearly still had affection for some of his earlier versions, and the stem-and-spot r turned up in his book *Mechanised Graphics* in 1931.

Futura was an immediate success on its release, and has remained so ever since. Bauer's full-page advertising in *The Inland Printer* heralded it in impressive terms: 'Futura, the type of today and tomorrow, the finest expression of the sans serif ideal in types, was designed in fullest sympathy with the modernist trend, by Paul Renner, himself a modern of the moderns.'

Renner developed Futura as a whole family from the outset. On first release there was Light, Regular and Bold, followed in 1929 by Futura Black, a stencil version; 1930 saw the arrival of Semi-bold, a slanted version of Light and Regular, and Bold Condensed.

Along with Gill Sans, Futura stands as the classic sans serif face. It works as text and as headlines, and it carries a style and personality that to an extent defy close analysis. Such a geometric face should look cold and sterile, but it doesn't. But there was more to it than just circles and lines. In a 1930 essay called 'The problem of form in printed type', Renner spoke of the almost imperceptible visual adjustments and careful drawing needed to design letters that seemed purely geometric in character. On studying the face, you can see that the counters, the spaces in a, b, d, p and q are not circular, and their bowls become narrower as they meet the stem.

52 Some of Renner's original alternative lower case characters for Futura: a, g and the stem-and-spot r.

This version of g never made it past the development stage, but it is a form which has been taken up by some designers in the modern wave of san serifs.

53 No discussion will take place: wunderkind Jan Tschichold in his early years in Leipzig.

There are subtle features too; the top counter of the B is smaller than the lower, the G is a broken circle with a cross-piece, with no straight edge on the right. The M is splayed. The j has no tail. But overall it is the proportions combined with the stroke weights, that elusive factor, which makes Futura so appealing. Like Gill Sans, it can evoke the period in which it was created, yet still look utterly modern today.

If, as Orwell said, the British shy away from abstract thought, this is not true of the Germans. This intense typographical debate needed a philosopher to make sense of it, to point the way ahead, and one was duly to arrive. Johannes Tzschichhold (1902–74) was born in Leipzig, the son of a sign-writer. Lettering was in his blood, and in his teenage years he studied calligraphy, typography and engraving, enrolling at the Academy for Graphic Arts and Book Trades in Leipzig, and then studying at the School of Art and Crafts in Dresden. At sixteen he drew an italic alphabet, an impressive blueprint for his later creation Sabon Italic. By the time he was seventeen

he was not only studying but teaching calligraphy and lettering at evening classes. Although he was essentially of a different generation to Renner (and there was always some clash of outlook between the two), from the mid-1920s their careers, and their later problems, would become interwoven.

In 1923 Tschichold, as he now spelt his name, visited the Bauhaus Exhibition in Weimar, and was deeply impressed by the work and the manifesto of the art school. The phrase 'New Typography' was first used by Moholy-Nagy in the exhibition catalogue, but it is a tag that will for ever be associated with Tschichold. Bayer's design of the catalogue used heavy sans serif or '*grotesk*' lettering which employed the Russian 'Constructivist' approach; type didn't just have to run horizontally on the page. It could go vertically too, or at angles. This was typography that was heading in the right direction – for Tschichold, the art as traditionally practised in Germany, was, frankly, a mess. He set about laying down some guidelines, which first saw the light of day in 'Elementary Typography', a feature he contributed to a special issue of *Typographische Mitteilungen*, which he edited in 1925, and which also featured work by the the Russian Constructivist El Lissitzky[4] and Kurt Schwitters.[5] Tschichold's ideas would find full expression in 1928 in his enduring monument, *The New Typography*, still a valuable manual today.

Before this, his and Renner's paths had already crossed. In 1925 Renner had taught a course in elementary typography at Frankfurt School of Art, and then later in the year was invited to take up the post of principal of the Munich Printing Trade School. At the beginning of 1926 he had contacted Tschichold in Berlin, with a view to offering him his former job in Frankfurt. Tschichold had read Renner's *Typography as Art*, and Renner would have seen 'Elementary Typography', so both knew something of the other's work and viewpoints. They had further ground in common, in that two publications had labelled both of them as 'Bolshevists', a loaded accusation in this period. This was provoked by Renner's publicly stated views on typographical reform; Tschichold's own sympathies with Russia, at least on the design front, were self-evident, and he had changed his name to Iwan in tribute. Renner invited Tschichold to join the staff

4 El Lissitzky (Liezer Markovich), 1890–1941, the Russian designer best known for his red and black graphics, featuring geometric forms and angled, sans serif typography.

5 Kurt Schwitters, 1887–1948, the German Dadaist famous for his collages, language experiments and Merzbau interior design construction project. He moved to England from Norway in 1940, but died impoverished in 1948 in the Lake District, where he had been working on the Merzbau.

at what was now called the Graphische Berufsschule (graphic trade or vocational school) in Munich. Although neither took the Bolshevist tag seriously, it was one that was to have grave consequences later on. Nevertheless, Renner advised Tschichold to undergo another name change to secure the post in conservative Munich. Iwan became Jan.

'The essence of the New Typography is clarity.' Tschichold argued that with the increasing amount of print and information battling for the reader's attention, greater economy of expression was needed. Old typefaces were concerned with beauty, but this was achieved by super-fluous ornamentation, which now had to be stripped away in the search for purer, clearer forms.

As we read from left to right, the proper layout was left aligned. Centred type created a central focal point that was meaningless, especially in terms of delivering a message effectively. It was purely decorative. Ornamentation, said Tschichold, came 'from an attitude of childish naivety'. Tschichold carried this philosophy through to the question of typefaces:

> None of the typefaces to whose basic form some kind of ornament has been added (serifs in roman type, lozenge shapes and curlicues in fraktur) meet our requirements for clarity and purity. Among all the types that are available, the so-called 'Grotesque' (sans serif) or 'block letter' ('skeleton letters' would be a better name) is the only one in spiritual accordance with our time...
>
> There is no doubt that the sans serif types available today are not yet wholly satisfactory as all-purpose faces... Most of them, in particular the newest designs, such as Erbar and Kabel, are inferior to the old sans serifs, and have modifications which place them basically in line with the rest of the 'art' faces. As bread and butter faces they are less good than the old sans faces. Paul Renner's Futura makes a significant step in the right direction ...
>
> The essential limitation of this restricted range of typefaces does not mean that printers who have no or too few sans serif faces cannot produce good contemporary typography while using other faces. But it must be laid down that sans serif is absolutely and always better.[6]

6 Jan Tschichold, *The New Typography*, translated by Ruari McLean, 1928.

On the subject of orthography, Tschichold unsurprisingly opted for the complete abandonment of capital letters. He argued that historically capitals and lower case forms had begun life as separate entities, and were only artificially grafted together during the Renaissance. The New Typography required economy in type design, so one set of letters should go. Lower case was easier to read, so it should be the one to stay.

> Of course such a revolution in orthography and type will not happen in a day, but its time will assuredly come. Whether consciously or unconsciously, cultural developments take place and men change with them. The typeface of the future will not come from a single person but from a group of people ...
>
> Personally I believe that no single designer can produce the typeface we need, which must be free from all personal characteristics: it will be the work of a group, among whom I think there must be an engineer.[7]

This small sample of Tschichold's ideas might provoke accusations of 'type fascism'. This would be unfair; with the use of *fraktur* Germany was labouring under a considerable and well-entrenched visual handicap – strong declarations of logic and intent would be needed to remove it. Also, Tschichold was only in his mid-twenties when he wrote the book. In this it's remarkable, but at that age one is more inclined to see the world in black-and-white terms. Certainly he and Renner, nearly a quarter of a century his senior, did not always see eye to eye. Renner believed that anyone who was truly 'modern' would not discard everything that had gone before as without value. Tschichold described Renner as an *überläufer*,[8] someone who has changed sides, and his opinion of Futura is not effusive; it is 'a step in the right direction', but that is all.

In 1927 Renner was instrumental in setting up the new Master School for Germany's Printers, at which Tschichold also taught, but the two men never became particularly close. Tschichold's wife Edith thought Renner a rather distant figure with the rest of his staff, including Jan. However, it's all too easy to imagine how the wunderkind Tschichold must have irritated his seniors with his confident, absolute opinions. After all, here was someone set on overturning centuries of tradition

7 Ibid.
8 Christopher Burke, *Paul Renner, the Art of Typography*, quoting a 1927 letter from Tschichold to the Dutch designer Piet Zwart.

and who wasn't interested in considering any counter-opinions. A poster advertising a lecture Tschichold was to give on the New Typography carried the caveat: 'No discussion will take place.'[9]

While the orthographic debate was raging with renewed intensity in Germany, across the border in France one man was proposing go in completely the opposite direction; abandoning lower case letters for just capitals. His name was Adolphe Mouron, but he was better known to the world as the celebrated poster designer and artist Cassandre.

Cassandre was born in January 1901, in the Ukraine, then a part of Tsarist Russia; his mother was Russian, his father was French. One of Cassandre's great-uncles ran a successful business importing French wine into the Ukraine, and his father had moved there to help in this enterprise. Following the outbreak of the First World War and the early death in action of one of Cassandre's older brothers, the family returned to France, to Paris, and there Cassandre was to stay. By the end of the war he had made the decision to become an artist, and studied at the Ecole des Beaux Arts and the Académie Julian.

He designed his first poster in 1923, and until the start of the Second World War this was the work on which his reputation was built. His powerful and beautiful advertisements now stand almost as a visual shorthand for inter-war France, broadly art deco in feel, but with that elusive something extra that the French bring to most things they do, not least their type design. His most memorable work was for the railway company Chemin du Fer du Nord, and the delightfully playful Dubonnet poster, in which, in a series of images, an outline man, seated at a café table with bottle and glass, gradually fills with colour and substance as he drinks.

In 1925 Cassandre was awarded first prize by the Exposition Internationale des Arts Décoratifs for his poster for the Au Bûcheron furniture store in the rue de Rivoli. Through this he met Charles Peignot of Deberny & Peignot, one of France's most adventurous and innovative foundries. Deeply impressed by Cassandre's posters, which were the total creation of the artist – both illustration and lettering – he commissioned him to design some new faces for his company. The first result was Bifur, which appeared in 1929; it was in bold sans serif capitals only,

9 Hans Schmoller, *Two Titans, Mardersteig and Tschichold, a study in contrasts,* New York, 1990.

54 Cassandre: his posters are now almost a visual shorthand for inter-war France. His type design, its philosophy influenced by his work in poster advertising, was a small but striking part of his creative palette.

and tried to eliminate all unnecessary verticals. Cassandre said of it: 'I want to stress the fact that Bifur is not an ornamental letter. Bifur was conceived in the same spirit as a vacuum cleaner or an internal combustion engine. It is meant to answer a specific need, not be decorative. It is this functional character that makes it suitable for use in our contemporary world ... It was designed for a word, a single word, a poster word.'[10]

Despite this rationale, Bifur was a commercial failure. A year later Cassandre produced Acier, another all-capitals bold sans serif, this time an outline face with two versions, featuring internal sections of either black or grey. But his most famous typeface came in 1937, named Peignot in honour of Charles and his company. Cassandre had always liked capital letters best, for their block geometry, and in Peignot he took this a step farther. Cassandre agreed with Tschichold that the union of capitals and lower case letter forms was an unnatural one, and he also favoured sans serifs, but there the consensus ended. In his opinion, it was the minuscules that should go, being as they were simply debased versions of the upper case, and in the case of the lower case a, a distortion of the

10 *Arts des Métiers Graphiques*, 1929.

capital form, brought about by scribes. Why not discard them altogether?

Cassandre recognized that lower case letters did have a vital contribution to make, the varied 'word-shapes' created by the ascenders and descenders which aid prolonged reading. To avoid the visual monotony of all-capitals text reading, he took the upper case letter forms and modified them for use as a lower case, giving them ascenders and descenders:

> The eye has become accustomed to long ascenders
> and descenders and this habit must be respected. That
> is why, in Peignot, we have not done away with those
> indispensable aids to rapid reading. None of the ascend-
> ers or descenders is anachronic, however: l, b and f are
> atrophied capitals; h and k are capitals transformed into
> lances, for easy reading; p, q and y are capitals which
> have dropped from the baseline. Only one minuscule
> has been retained – the cursive form d. Our reading
> habits being what they are, it would not have been feas-
> ible to conceive it differently.
>
> This new principle may jar at first. But while there
> are honourable habits which deserve to be respected,
> there are others which can easily be dispensed with,
> since they have no deep physiological roots in the indi-
> vidual. New habits will replace them.[11]

Cassandre came by this route to design a delightful, quirky and very distinctive face strongly evoking the period in which it was created. Needless to say, his ideas didn't catch on. Testament to Peignot's style and grace is the fact that it has remained commercially available ever since. A modified version, designed in 1947 with Charles Peignot, and named Touraine, had more conventional lower case characters.

By the onset of the 1930s the cultural horizons in Germany were starting to darken. Since the stabilization of the currency in 1924 the economy had been a house of cards, built on huge American loans. The 1929 crash threw America into an abyss, Europe inevitably pulled in after it. The resulting mass unemployment and the helplessness of the government to cope with the crisis created a fertile campaigning ground for the Nazi Party. The 1930 elections gave them 18 per cent of the vote,

11 Peignot specimen, 1937.

and made them in parliamentary terms the second-largest party.

Hitler and his supporters were now on an unstoppable upward surge. Even though political power was more than two years away, those who supported and fed the Nazis' extreme views grew increasingly confident in airing their opinions. Paul Schultze-Naumburg, an architect and founder member of the Werkbund, was also a member of the Bund Heimatschutz, the Association for the Protection of the Homeland, a body dedicated to preserving what were seen as pure Germanic styles in art and design. He objected to the flat-roofed style of architecture of the 1920s as being non-German. The editor of the Nazi newspaper the *Völkischer Beobachter*, Alfred Rosenberg, backed this theory, and Schultze-Naumburg undertook a lecture tour of German cities to expound his views. A lecture in Munich, at which Renner was present, branded Asian art and modern Western art as the work of diseased minds. An artist in the audience who protested was hospitalized by Nazi guards.

Renner saw the cultural threat that National Socialism posed, and tried to organize another public meeting to give his viewpoint, to which the writer Thomas Mann, author of *Death in Venice* and *The Magic Mountain*, was to contribute. Unable to achieve this, he put down his thoughts in a booklet, *Kulturbolschewismus?* (Cultural Bolshevism?), questioning the whole racist attitude to art that Schultze-Naumburg and the Nazis were promoting. It was a plea for sanity at a time when Germany was falling into the hands of a madman. Two German publishers rejected the book; Renner had to go to Zurich to find someone prepared to back the project.

During March 1933, as Hitler was consolidating his grip on his newly acquired power, Renner was supervising the German stand at the fifth Triennale exhibition in Milan. His choice of material for the stand came under scrutiny from the Foreign Office, who deemed that there was too much roman type and not enough blackletter. Renner was unhappy about this interference, a resistance that was noted.

It is hard to imagine how holding a view on design and typography could be life-threatening, but that was exactly the situation that Renner and Tschichold were now to find themselves in. In the middle of March, Tschichold

abcdefghi jklmNOPQR STUVWXYZ

55 Peignot: the radical lower case. 'There is no technical reason in printing why we cannot return to the noble clasical shapes of the alphabet and discard the lower case forms, which will soon come to seem as archaic as the shapes of Gothic characters' (Peignot specimen, 1937).

and his wife were arrested. In the new reign of terror that was sweeping through Germany, this meant a concentration camp. At this stage, although Hitler had only been Chancellor for a mere six weeks, the Nazi camps were already up and running. Although these were not the death camps of the war years, they were nevertheless already brutal institutions in which those who had spoken against the regime were rounded up, and where some, such as Fritz Gerlach, the editor of the Munich Catholic magazine *Der Gerade Weg* (The Straight Path), were to die. The first concentration camp, its opening announced by SS leader Heinrich Himmler on 20 March, was nearby, at Dachau on the edge of Munich.

Renner protested, and Tschichold later believed that this shortened his term of imprisonment. But the net was closing around Renner too. His office and his home were searched; some slides of photomontages were taken on the grounds that they were Russian anti-German propaganda. In *Kulturbolschewismus?* and elsewhere Renner had publicly stated his opposition to the views of the new government. He too was arrested, but released the next day on condition he report to the police every two days. Renner was lucky – the father of his daughter's fiancé was a friend of Hitler's deputy Rudolf Hess. Hess asked for leniency in Renner's case. But there was a body of evidence against him, not least his association with Thomas Mann, who had now fled Germany, and his appointment of Tschichold, a 'Bolshevik'. He was finally dismissed from his position at the school in 1934 on grounds of 'national untrustworthiness'. Futura was labelled as anti-German, but ironically Renner's work on the stand in Milan won him the Grand Diploma of Honour, and Futura received much admiration from Mussolini's regime.

Tschichold was released after six weeks, but life in Germany was now impossible for him and his family and they moved to Switzerland. Renner moved there too for a short period, during which he was accused of spreading anti-German propaganda. He returned to Germany, and it was probably only Hess's further intervention which saved him from reprisals. He lived in semi-retirement until the end of the war, forbidden to earn a salary, and with no pension, although Futura sales provided royalties. He wrote, painted and designed some other typefaces. One, Renner-Antiqua, a distinctive serif

face with a slight calligraphic feel, was adopted by the newspaper the *Süddeutsche Zeitung*. He also designed a blackletter face, Ballade, which was released by Berthold in 1937, but with little success. After the war his health began to fail, but he produced a final sans serif face, Steile Futura, which today looks startlingly contemporary. He died in 1956, in Munich.

The war years would unexpectedly see the end of the blackletter debate. Although blackletter experienced official party backing as the true and only style of German lettering in the early years of the Third Reich, it never existed to the total exclusion of other forms. Indeed, Joseph Goebbels, Hitler's propaganda minister, had a certain taste for modern trends, and publicity material for the 1936 Berlin Olympics used roman and sans serif lettering, probably in an attempt to evoke connections with the grandeur of classical Greece. Herbert Bayer managed to carry on working in Germany until 1938, when he left for America. But to Hitler blackletter was synonymous with patriotism and a deep feeling for German culture.

Then, suddenly, the change that Tschichold, Renner and others had striven for was brought about by the Nazis themselves. In early 1941 a decree outlawed blackletter as a Jewish innovation into the printing trade. Roman was now to be the standard.

The probable true reason for this about-face was nothing to do with any supposed Jewishness. Germany now had many conquered territories in which blackletter was not a legible face; its use hindered the spread of German ideas abroad, ironically – although with different purposes in mind – a point that Renner had made in *Kulturbolschewismus?* ten years before, and Jakob Grimm over a century previously. It has also been suggested that a factor in the abandonment of blackletter was complaints by German pilots that it was hard to read at a distance when used for aircraft markings.

By contrast, Mussolini's Fascist Italy embraced sans serif lettering. The 1932 Exhibition of the Fascist Revolution, to mark the tenth anniversary of the dictator's rise to power, featured monolithic sans serif relief and three-dimensional lettering, a modern yet grandiose inscriptional style that accorded with Mussolini's vision of a Second Roman Empire.

12 | Leper messiah: Gill semi-light, Gill heavy

He really believed in it all. You see, there comes a time, you know, when people who, say, join the ILP or the Communist Party or something of that kind, and they get used to a certain jargon, they really think they believe in it. They *think* they believe in it. All of a sudden they find out – they find out they don't really. And they can't live up to it. Now Gill *did* live up to it. It takes a lot of doing, a lot of doing…
(Stanley Morison on Eric Gill, BBC radio portrait, 1961)

Stanley Morison, the man who commissioned Eric Gill to design the Perpetua typeface, and his most famous creation, Gill Sans, found him a deeply impressive figure. In this he was not alone. An immensely gifted sculptor, illustrator, letter carver and type designer, and a profoundly influential teacher, Gill also wrote passionately and with searing logic on many of the major questions of his age, plus a host of minor personal interests and obsessions.

Eric Gill is the most complex figure in the whole history of type design. A hero for many of his contemporaries, his posthumously published autobiography, surprisingly for a memoir of a stonecutter, became a bestseller. Gill told the publishers that they wouldn't dare print what he would want to write: 'I do not see how my kind of life … could be written without intimate details.' His frank approach to sexual matters doubtless played a major role in maintaining buoyant sales. But even so, there was much that he didn't tell. In the twenty-first century, we like to submit our heroes to detailed scrutiny, and if the microscope reveals deep character flaws, then so much the better. In this aspect, as in many others, Eric Gill does not disappoint.

Gill presented himself as a man of unswerving dedication to his beliefs, not just in religion, but in his work and every aspect of his life. In his autobiography he recalled overhearing a schoolteacher describe him as 'easily led', and claimed to recognize the truth of this. But there is nothing wrong with this, he asserted, as long as you are capable of choosing good leaders, a skill he considered

56 Eric Gill in full regalia: he brought the same attention to rolling a cigarette that he gave to cutting a letter.

himself to have. However, the impression Gill leaves is not of a devoted, clear-headed follower, but of a control freak, with a need to be in total charge, uncompromising in outlook and unbending in principles, except when he himself wished to compromise those principles.

He looks an odd and slightly forbidding presence in photographs, with his thick beard (which he saw as an essential part of masculinity), and beret or broad-brimmed hat. Sometimes he wore a square hat made of folded paper, of the type worn by the carpenter in Tenniel's illustrations for *Alice through the Looking Glass*, and also used by stonemasons to keep dust and chippings out of their hair while working.

Gill favoured medieval-looking smocks, not just for work clothes, and had an aversion to trousers. Indeed, he wrote a small book called *Trousers and the Most Precious Ornament*, in which he argued that the restrictions of the garment in question dishonoured the male sexual organ. His former apprentice David Kindersley – later himself to become a distinguished stonecutter and typographer

– recalled when he and Gill were working *in situ* on a set of carvings for the entrance to Dorset House in London. Following a complaint from 'an elderly spinster' living in some nearby flats, a policeman arrived on the scene to ascertain that Gill was not indulging in public cross-dressing.[1]

Gill's appearance was all part of what would now be called his image. He wanted to appear as the honest workman and craftsman, which on one level he was, but that wasn't the whole story. Gill also saw himself as a freethinker and social rebel. His appearance was a statement: 'I am not like you, and you cannot judge me on the terms by which you run your own life.' Understandably, such a personality tends to divide opinion, but many found him to be a man of great charm; Morison was convinced that if Gill had chosen to play the West End 'society' personality, he could easily have done so.

He was born in 1882, one of thirteen children. His father was a curate in Brighton, and although life was financially a struggle, the family was a caring one, and as Gill observed: 'it's impossible to be a poor relation without having rich relations'. With the help of said relations, on leaving school the young Eric was found a position as a trainee draughtsman in the offices of W. D. Caröe, a London architect whose large practice made a speciality of ecclesiastical commissions. 'I was not immediately told that architecture was "a rotten job"; but I was led gradually and surely to discover that fact … '[2]

Gill evinced a profound disgust for the whole industrial and capitalistic system of late Victorian and Edwardian England. He considered inhuman the process whereby the builders and craftsmen who realized the architect's designs were not entrusted with any task that the architect hadn't specified in minute detail, and the fact that as long as these specifications were properly followed it didn't matter what opinion the construction workers had of the building they were making. An increasingly reluctant part of this system, Gill hated making drawings of things that other people were then going to have to build. He subscribed completely to the Arts and Crafts ideals, which said that the person who conceived a design should execute it as well, and decided, despite his family's financial investment, to abandon this career path for one of his own choosing.

1 David Kindersley, *Mr Eric Gill; Further Thoughts by an Apprentice*, Cambridge, 1967, revised edn 1982.

2 Eric Gill, *Autobiography*, 1940.

Gill had retained an enthusiasm for lettering from boyhood, when he had been attracted to the name plates on railway engines. In Caröe's offices he had made the lettering on architectural drawings his speciality. He enrolled in classes in masonry and lettering: 'I would rather be a workman myself and start my rebellion from that end. I would be a workman and demand a workman's rights, the right to design what he made; and a workman's duties, the duty to make what he designed.'[3]

The teacher at the lettering classes Gill attended at the Central School was Edward Johnston. Gill compared first seeing him in action to being 'struck as by lightning': 'the first time I saw him writing, and saw the writing that came as he wrote, I had that thrill and tremble of the heart which otherwise I can only remember having had when first I touched her body ... '[4]

This was a characteristic Gill analogy. Johnston quickly recognized the potential in his new pupil; they became close friends, and before long Johnston even invited Gill to share his rooms in Lincoln's Inn. Walking home one night after college, they were struck by the painted sans serif lettering on some tradesmen's vehicles. Gill exclaimed, 'I wish I could do that!'[5] Like Emery Walker's 1888 Arts and Crafts lecture, this was one of typography's golden evenings. Johnston was to reclaim the sans serif lettering as an exalted letter form, Gill to produce one of the greatest twentieth-century examples of the style. Gill freely acknowledged the influences of Johnston's work and helped out in the early stages of the latter's Underground lettering, his former teacher recognizing his contribution by giving him 10 per cent of the fee.

In 1905 Johnston moved into Emery Walker's old house in Hammersmith, and Gill, now married with a baby daughter, was soon to follow. Walker was still in Hammersmith, a few doors away, as was William Morris's daughter May, with Thomas Cobden-Sanderson round the corner at the Doves Press. In some ways this Hammersmith coterie was an urban prototype for the creative communities that Gill would later establish in the country.

Lettering and stone cutting work began to flow in. He hand-painted the shop fascia for newsagent and booksellers W H Smith for their new branch in the rue de Rivoli in Paris, and in 1913 was given the prestigious

3 Ibid.
4 Ibid.
5 James Moran, *The Double Crown Club: a history of fifty years*, London, 1974.

task of carving the fourteen low-relief images depicting Christ's road to the crucifixion, the Stations of the Cross, for the new Westminster Cathedral. Gill was later self-deprecating about the commission, claiming he was only given the job because no more famous sculptor would have done it for the money on offer. Some of the reliefs were good, and some bad, he drily stated, but as no one had ever agreed as to which was which, he felt he'd got away with it.

The commission also proved useful to Gill in another way; an exemption from military service was obtained for him until he'd finished the work. This suited him; although not a conscientious objector, he hated the political and industrial systems that had brought the war upon Europe, and apart from its effect on enlisted friends and relations, felt the conflict was nothing to do with him. He was finally called up in August 1918 and spent a few miserable months in army camp. Military regulations meant he had to shave off his beard, not the least of what he saw as the degradations of army life. The war ended before he was sent into action.

Gill's long, close association with Edward Johnston also ended not long after this. In 1907 they had both left the city, moving to the village of Ditchling in Sussex. With Hilary Pepler, a former social worker who had been a near-neighbour of Gill's in Hammersmith, Gill worked on a self-produced magazine, *The Game*. At Ditchling, Gill and Pepler were steadily establishing an artistic and Catholic community of families, built around faith and Gill's ideas about how society should properly be run – all farming work was carried out using pre-industrial methods. Johnston's wife was strongly anti-Catholic in her religious leanings, and Johnston himself was too much of a lone spirit to be drawn into the communal life. He increasingly disassociated himself from the Catholic opinions expressed in *The Game*, and this accelerated the decline in the two men's relationship. Gill saw little of him in the last twenty years of his life. Edward Johnston died in 1944, and lies in the churchyard in Ditchling.

As time went on, Gill and Pepler's relationship, once so harmonious, also became increasingly fraught, a power struggle over who should be the paterfamilias of the community. Resentment grew over finances; Pepler had money, whereas Gill only ever charged a workman's

wage, not an artist's. Gill split the community in two by moving to the Welsh mountains in 1924.

For those interested in Gill's thoughts on typeface design, and his relations with Stanley Morison and the Monotype Corporation, the autobiography says disappointingly little. Beyond a list of the faces he designed, Gill says only that his association with the type designing business was honourable, pleasant and helpful. He states that although he hated the world of business, he had met many 'nice' businessmen. Obviously it was Gill's prerogative to select those areas of his life and philosophy he wanted to talk about, but perhaps he felt his involvement in what was industry and mass production ran too obviously counter to his own beliefs. Although in many ways Morison wasn't at all a conventional businessman, and he and Gill shared a similar approach; both regarded 'leisure' as an alien concept, and built working projects out of friendships and personal associations. It is tempting to play the amateur psychologist and speculate that Morison saw in Gill the depths of conviction that he himself lacked; Morison certainly believed this was so, at least in terms of the Catholic faith they shared.

David Kindersley recounted a story that illustrates Gill's prickly approach to men of business, an encounter that ironically only served to convince them that he was of their kind. Gill's proposals for the sculptures for the Dorset House entrance were over budget:

> Mr Gill was invited to appear before the Board. One member who had heard about Mr Gill's clothes thought he should warn his fellow directors. He explained that he wore a habit similar, though shorter, than a monk's, and being an artist of some distinction he should be treated with due respect. 'How could the cost be reduced?' they asked. At once Mr Gill said, 'Each leaf is £5, so if you do away with the whole branch that will save £25.' The Directors, already bitterly disappointed because Mr Gill had turned up in an overcoat, turned on the one that had thought to smooth the way saying, 'He is not an artist. He is a business man. Moreover, we have not seen his monk's habit.'[6]

Whatever moral dilemmas Gill may have undergone through his association with Monotype, we can be thankful he was able to override them. Morison had seen some

ACM
fgm

57 Perpetua: named after the first book in which it was used, *The Passion of Perpetua and Felicity*. The A bears Gill's approved flat top.

6 Kindersley, op. cit.

of Gill's work for the Ditchling Press, as well as his carved lettering, which he greatly admired. He first of all asked Gill to draw out the alphabet he had been cutting in stone, and this became the basis of Perpetua, Gill's first typeface for Monotype in 1925.

Morison believed that the greatness of Gill's typefaces stemmed from the fact that Gill was a letter cutter: 'A cut line is very different from a drawn line … When he was cutting, he *cut*. He committed himself. He wasn't *afraid* of committing himself.'[7]

In 1927 Gill painted the shop fascia board for his friend Douglas Cleverdon's antiquarian bookshop in Bristol, using sans serif letters. The probability is that Morison, who visited the shop in 1927, conceived the idea of asking Gill to produce a sans serif alphabet when he saw this lettering – from which request was to come Gill Sans. By the mid-1920s the spectre of German competition in the field of type design was beginning to loom once more – the reawakened fear that the Germans were taking Johnston's ideas and work on sans serif alphabets and turning out a new wave of type. Gill Sans was a British answer to the threat from across the Channel.

Of Gill's typefaces, both Perpetua and Gill Sans have long been personal favourites. Perpetua is an elegant face; its pointed serifs recall the speculative origins of these features – a neat way for a stonecutter to finish off a vertical or horizontal stroke. Perhaps as a text face it can suffer a little from its relatively low x-height, but for small quantities of wording it looks characterful and sophisticated.

Gill Sans has the same qualities as a piece of Charles Rennie Mackintosh furniture; timeless, yet unmistakably *of* its time as well, a superb combination of resonances. In his pursuit of the ultimate legible letter, Gill used Johnston's work as the basis for his own sans serif typeface, but while acknowledging the influence, stressed that Gill Sans was intended as a text face, whereas Johnston's was purely for display.

There are differences, of course. Gill was less enamoured of the classic Roman proportions – his capitals are a little narrower. The ratio of height to stroke thickness is slightly greater, so the strokes are thinner. Gill's V and W end as points rather than a blunt edge. The leg of the R is curved, not a straight line, something Gill felt

ACM
fgm

58 Gill Sans: it owes a debt to Johnston, but the drawing of the lower case is more delicate and skilful, and the Roman proportions were not followed.

7 Stanley Morison on Gill, BBC radio portrait, 1961.

strongly about. Crucially, on the lower case, again a little more condensed than Johnston's, the strokes are not all monoline. The a is quite distinctive, with its small counter and slightly top-heavy upper loop. The dots on the i and j are round, the t has a crossbar of more conventional length. The g looks more attenuated, its two counters farther apart, with a longer link.

It has been claimed that in the inter-war period sans serif type was hardly ever used for continuous reading in Britain or America. However, as one example, *The Daily Express Coronation Souvenir Book* of 1937 used Gill Sans for its text face, although large at 12pt (9 or 10pt would be more expected). But Gill Sans is the great text face that has never actually been used very much for continuous reading. Even today, when a lot of style magazines use sans serif fonts as text, Gill wouldn't be used. Compared to Futura, Helvetica and most decidedly Univers, there is a humanity, a gentleness, in Gill Sans that the others lack. It feels organic, like the work of a stonecutter. Its very character works against it as a sans serif text face – it's just not anonymous enough.

Although the italic, like many sans serif italics, is little more than a sloped version of the roman, it does contain a couple of features to differentiate it, and as a consequence has some contrast when used amidst the roman. In an advisory capacity for Monotype, Gill assisted in the creation of the more extreme versions of his face, such as Gill Sans Ultra Bold, also known as Kayo. These superb, quirky heavier weights look startlingly like a creation of the 1960s, but would definitely fall into the category Gill himself contemptuously described as 'suitable for advertisements of Bovril'[8] – not at all the kind of thing to which one would imagine him giving the go-ahead. But in the land of Gill, expect the unexpected.

Gill's boyhood love of locomotive lettering came full circle in the early thirties when the railway company LNER adopted Gill Sans as its corporate face, and Gill lettered the name plate for the *Flying Scotsman*. He also executed two important sculptural commissions, for the League of Nations building in Geneva, and figures of Prospero and Ariel for the BBC's Broadcasting House in London. (In 1928 he had carved the figures representing winds on the London Underground headquarters above St James's Park station.) The latter caused contro-

8 *Lettering, an Essay on Typography*, London, 1931.

versy even before they were unveiled. The governors of the BBC, viewing the work from behind the tarpaulin, were startled by what they considered the extravagant dimensions of Ariel's penis, and Gill was ordered to make a reduction.

Sex was a dominant theme in both Gill's life and his art, and he saw himself as frank and uninhibited, a crusader at odds with the hypocrisy of the prevailing moral climate. A visitor to the Gill workshops once described seeing what he called a 'nimbus', a halo, around Gill's head, and was convinced it was not just a trick of the light. But there was another side to this spiritual leader of the community; his sexual freethinking had a dark aspect.

Fiona MacCarthy, in the definitive biography, 1989's *Eric Gill*, had access to his diaries; these revealed Gill to have conducted possessive and incestuous relationships with his daughters, and to have had a steady stream of relationships with adult women outside of his marriage, to which his wife Mary seems generally to have turned a blindly tolerant eye, the perfect supportive and fondly indulgent artist's wife. Whether she accepted Gill's excesses as all part of his creative spirit, his hunger for knowledge and for pushing the boundaries of experience, we can only surmise. 'In all his close relationships with married couples he compulsively, inevitably sought the wife. He was childishly jealous of other people's women, not even allowing his apprentices at Pigotts [Gill's home and workshop from the late 1920s until his death] to bring their girl-friends into the workshops. He liked to feel all women in the world belonged to him.'[9]

As Gill's association with Stanley Morison developed, he inevitably came into contact with Beatrice Warde. She was the complete antithesis of what Gill expected a woman to be and how he expected her to behave. Childless, divorced, she lived alone, forging a successful career in a male-dominated world, lively, with strong opinions and a keen intellect: 'her powerful brain probed and tested facts and theories with the assurance of an experienced lawyer'.[10] Gill's opinion of the opposite sex was low; women were incapable of being artists of any worth, and unable to participate in serious debate. His own daughters were not formally educated. His whole view of sex was that it was a man's game; women were

9 Fiona MacCarthy, *Eric Gill*, London, 1989.

10 John Dreyfus, 'Eric Gill, Stanley Morison and Beatrice Warde: their collaboration at the Monotype Corporation', *Into Print*, London, 1994.

merely passive receptacles for male desire, ideally modest of dress and demeanour.

But despite all this, Gill was attracted. It was a meeting of type's two great sorcerers, each capable of casting a spell, albeit of very different formulae, over those they encountered. The two styles of magic were none the less compatible:

> Beatrice Warde had no official ties with Morison; his wife was still alive, although they did not live together. It seems unlikely, on the evidence of friends close to them both, that Morison's relationship with Beatrice was physical. He was a strict Catholic, still playing by the rules. But their obvious affection and dependence had made them a couple of a kind, and the triangular relationship … was irresistible to Gill.[11]

Gill soon joined the list of Warde's lovers; she in turn became one of the principal models for his *Twenty-Five Nudes* series of wood engravings. How did Morison take all this? At least publicly, he expressed only profound admiration for Gill, but it's hard to imagine he couldn't have felt some resentment; whatever the basis of their relationship (and close friends, especially those protective of posthumous reputations, can be self-deluding or evasive on such matters), this was the woman he had broken his marriage for – no light matter, especially for a committed Catholic.

But between himself and his workers Gill always maintained a distance; he insisted his apprentices call him 'sir', and when he set up a printing business with his son-in-law René Hague, he did so only on the condition that Hague called him 'master'. David Kindersley's widow Lida Lopes Cardozo recalled how Gill used a system of bells to summon apprentices across the yard when he wanted them. One bell for Laurie Cribb, two for Anthony Foster, and three for Kindersley. However, she says that for Kindersley, Gill was always jolly, full of anecdotes, lovable. 'David always said, if he could have loved a man, it would have been Gill.'

By the end of his life the rebel was slowly allowing himself to be reeled into the Establishment. He designed banknotes and stamps. He was elected an Honorary Associate of the Institute of British Architects in 1935, became an associate of the Royal Academy, and was awarded

59 What Gill called Beatrice Warde's 'fine American carcass', in the service of art.

11 MacCarthy, op. cit.

the Royal Society of Arts insignia of Royal Designer for Industry. This was Gill the arch anti-monarchist and anti-industrialist.

But it is unfair to criticize Gill for undertaking work that ran counter to previously stated beliefs; finances were always a problem for him, and he had several people to support by his work. Sometimes, like everyone else, he just needed the money. On starting his independent career, and in the midst of the Spanish Civil War, David Kindersley was offered a commission for a memorial for those killed in the Alcázar in Toledo.[12] The work would be used to raise funds for General Franco's rebels. Despite his Catholicism, Gill, like so many artists and writers, was fervently on the side of the Republicans, as was Kindersley: 'As I remember I wrote at some length to Mr Gill asking whether I should accept the commission, and how I felt and what my conscience would have to bear, until my dying day, if I undertook the job. Mr Gill's reply came by return on a postcard. "Plenty biz. no do! No biz. DO!" '[13]

Eric Gill died in 1940 following an operation for lung cancer. What are we to make of him and his work in the light of subsequent revelations about his life? Not long after the publication of Fiona MacCarthy's biography, a letter appeared in a Sunday newspaper calling for the removal of the Stations of the Cross from Westminster Cathedral. To have in a holy place the work of a man who had committed such acts as Gill had, argued the writer, was a profanity. It's interesting to consider that if Gill were alive today, and such details of his life were made public, we would be seeing him on the evening news, a coat thrown over his head, being bundled into a white security van, photographers holding up their cameras to the windows as it drove away.

But whatever we think of Gill the man, in the end his output must stand apart from its creator. He produced many beautiful works of art, and one of the best-ever typefaces, and these are his gifts to the world. It was to the world's benefit that the energies of such a personality as Eric Gill's were channelled into art. Perhaps we should be thankful he didn't go into politics. If only Hitler had succeeded as an artist ...

12 The Alcázar fortress was besieged by Republican forces in 1936. The siege and the subsequent relief were great emotive symbols and propaganda tools for the Nationalists, led by Franco.

13 Kindersley, op. cit.

13 | Europe after the rain: rebirth and twilight

In 1945 Germany's type business, like the rest of the country's infrastructure, was left devastated in the aftermath of the Allied invasion that had finally brought the Third Reich to its knees and an end to the war in Europe. The Frankfurt factories of Bauer, manufacturers of Futura, were destroyed, although all the punches and matrices had been removed for safety. The story was a similar one for Stempel, also with headquarters in Frankfurt, for Berthold in Berlin and Klingspor in Offenbach.

The victorious Allies were careful not to repeat the error of the 1919 peace settlement; the understandable desire to extract compensation from Germany after the earlier conflict left the country in a permanently weakened state, a perfect breeding ground for the discontent and resentment that Hitler was able to exploit so effectively. There was now the ominous presence of Soviet Russia to consider, in occupation of a sizeable chunk of the former Reich – what was to become for over forty years the East German Republic. If the rest of Germany was not to fall under Soviet domination, bringing the edge of communist Europe – Winston's Churchill's 'Iron Curtain' – to the borders of France, Belgium and Holland, then money and aid had to be injected into the shattered region, if only for political considerations.

American support enabled the new state of West Germany to recover rapidly, achieving by the 1960s an unimagined prosperity with a modern and successful democratic system. In this resurgent economy, the type foundries were viable forces again by the late 1950s; indeed, Bauer had rebuilt their Frankfurt factory by 1948. But the German typographic landscape had been changed for ever by the war. Black letter as a dominant form was now gone, but most of the foundries that had produced roman type had been concentrated around the book trade, based largely in Leipzig, now part of East Germany. New faces were needed in the west, and a new German typographical star would emerge to help meet this need.

Hermann Zapf had been born in 1918 in Nuremberg.

His father had been a trade union official in a car factory, but was removed from his post in 1933 by the new Nazi regime. The punishment extended to his son; Hermann was forbidden access to further education. Abandoning his plans to become an electrical engineer, he took up an apprenticeship as a printer's retoucher. But inspired by an exhibition of Rudolf Koch's calligraphy, Zapf began to teach himself the art; once again Edward's Johnston's *Writing and Illuminating, and Lettering* proved an invaluable aid. His apprenticeship over, he set himself to learn about printing with hand presses and punch-cutting, and by 1939 was working on his first type design, a black letter, for Stempel.

Zapf's career was interrupted by conscription into the German Army in 1941. He worked as a cartographer in France, but managed to find time nevertheless to draw a flower alphabet, which Stempel produced after the war. On his return to civilian life, he became art director at the company, and was soon to design his first great typeface, Palatino, its forms inspired by Renaissance lettering, and bearing the unmistakable fluid strokes of the penman. In 1952 he designed Melior as a newspaper text face, and in 1958 Optima, a remarkable design described by Zapf as a 'serifless Roman', and by other commentators as a 'flared sans serif'. He remained a prolific designer and writer on typography for over three decades.

Following Nazi persecution Jan Tschichold had moved with his family to Switzerland, and stayed there for the duration of the war, fortunate to find enough work to survive. In 1941 he began working full time for a publisher, and in 1942 obtained Swiss citizenship. In 1935 his work had been exhibited in England, and the publishers Lund Humphries asked him to design their Penrose Annual in 1937.

It was a useful showcase. In 1947 Allen Lane, the director of British paperback publishers Penguin Books, decided it was time for a visual overhaul. Tschichold was invited to take on the task, and he laid down design guidelines that gave a new elegance and refinement to the books' typography. He was also responsible for the redesign of the company logo, from the charming, slightly hunched and shuffling penguin then in use to the more streamlined badge still current – a small loss amidst a huge gain.

REX
fgm

60 Palatino: Hermann Zapf found early guidance and inspiration from the writings of Edward Johnston, and Palatino reflects the unmistakable touch of the calligrapher in its letter forms.

ABW
fgm

61 Optima: described as a 'serifless Roman', or a 'flared sans serif', it is a cool, elegant face that defies precise classification.

Tschichold managed to achieve these changes despite his struggles with the English language, and some resistance within the company to the 'foreigner' who had been brought in. But he was also able to use the language as a shield, sometimes overriding resistance with a pretence of non-comprehension. Typical of his autocratic style was a written battle of wills with Dorothy L. Sayers, the detective story writer, over three asterisks that Tschichold had placed on the title page of her translation of Dante's *Inferno*. Sayers couldn't see the point of them, and cited an opinion (Tschichold's own) that an asterisk had no place on a title page. Tschichold replied, 'It is the master who establishes the rules and not the pupil, and the master is permitted to break the rules, even his own.'[1]

Sayers graciously conceded, probably feeling that the whole matter had outgrown its importance, but if this altercation makes Tschichold sound unchanged from the uncompromising character of his youth, this wasn't entirely the case. He had moderated some of his opinions, even so far as to be tolerant of centred designs. Hans Schmoller, who succeeded Tschichold at Penguin, recalled how, when asked why his early work was so different to his later, Tschichold replied: 'Because I didn't know enough.' Schmoller explains this later change of opinion: '[he] linked his earlier dogmatism with the unhappy German bent for absolutes and for regimentation, which he felt he had left behind.'[2]

With hindsight, Tschichold felt that this kind of hardline opinion was exactly the approach the Nazis had taken; 'I detected the most shocking parallels,' he later reflected.[3] Indeed, in terms of typeface design his finest achievement is a serif face, not a sans serif. A group of German printers wanted a typeface that would look the same whether set by hand or on Monotype or Linotype machines. Tschichold produced Sabon, named after the French punch-cutter reputed to have brought the Garamond matrices to Frankfurt. It is one of the very best serif text faces, beautifully weighted, superbly readable, elegant yet friendly at the same time, an extremely difficult combination to achieve. It had a dignified gentleness that had permeated to other areas of Tschichold's life too; he collected *spitzen bilder*, eighteenth-century pictures in lacy paper vignettes – rather like early valentines – and Victorian greetings cards.

1 Ruari McLean, *Jan Tschichold: A Life in Typography*, London, 1997.

2 Hans Schmoller, *Two Titans, Mardersteig and Tschichold, a study in contrasts*, New York, 1990.

3 McLean, *Jan Tschichold*.

He was honoured with numerous international awards, and on his seventieth birthday in 1972 the Swiss magazine *Typographische Monatsblätter* ran a tribute entitled 'Jan Tschichold Praeceptor Typographiae', which stated: 'two men stand out as the greatest typographic motive forces of the twentieth century: Stanley Morison and Jan Tschichold'. The article was attributed to Reminiscor, 'he who remembers'. It was by Tschichold himself. He died in 1974.

The French verve for distinctive type design was maintained in the 1950s by that most creative foundry, Deberny and Peignot, and by Roger Excoffon (1910–83), whose designs were to personify French style in the 1960s in a way that Cassandre had done thirty years before.

Rebelling against his parents' wishes for him to become a lawyer, Excoffon had decided instead to be an artist. Born in Marseilles, he was drawn inevitably to Paris, but by the end of the war he was back in his native Provence. His brother-in-law, Marcel Olive, ran a type foundry, Fonderie Olive, which had benefited from the German wartime division of France. Deberny and Peignot was in Paris, in the occupied zone in the north, while Fonderie Olive lay in Vichy France, the larger portion of the country supervised by Marshal Pétain's collaborationist government. Deberny and Peignot could no longer send metal type south, so Olive were able to take over their markets, and expand.

Following the success of his first face, Chambourd, Excoffon became art director at Olive in 1947, a flexible arrangement which allowed him to run his own design company as well. In the 1950s he created a series of highly popular informal or script advertising faces – Banco, Choc, Diane and that digital favourite, Mistral. In his determination to produce a design for metal type without losing the handwritten quality, Excoffon avoided a constant baseline for Mistral's characters, and had an alternative lower case character that could serve as either an l or a p.

His most distinctive design, and his answer to the new wave of 1950s sans serifs, was Antique Olive. Using the principle of the x-height area and the ascenders being most crucial for legibility, he designed a face with very short ascenders; in the bolder weights it is absolutely

Qu'est-ce que c'est?

62 Mistral, Excoffon's most enduring script, popular in digital form. Somehow it always looks its best in French.

ab qm

63 Antique Olive: Excoffon's sans serif never achieved world domination, perhaps because of its overabundant personality. The ascenders and descenders are very short.

4 Julia Thrift, 'Roger Excoffon', *Baseline* 14, 1991.

unmistakable, a uniqueness that doubtless prevented its global domination as a go-anywhere sans serif. A version of it was used for the Air France logo. Excoffon's personality and design philosophy have been described as 'a peculiar mixture of logic and flamboyant elaboration', a combination both very French and universally appealing.[4]

For Cassandre the ending was not to be a happy one. Having served in the French Army until the 1940 armistice, he returned to Paris, and in the post-war years gradually drifted from poster design to theatrical sets and costumes. The most enduring work of his later years, and a design visible to anyone walking past a department store perfume counter, is the Yves Saint Laurent logo, a beautiful piece of lettering drawn for the couturier in 1963.

But his final years were dogged by increasing depression. His first suicide attempt was on 17 June 1967; the second, successful attempt took place exactly a year later. A letter from a German foundry lay on his desk, rejecting his final, delightful typeface as too revolutionary for them to consider. It was named Cassandre after his death, and a version called Metop was used for Charles de Gaulle Airport in Paris.

Had Orson Welles composed his famous speech in the film *The Third Man* – in which he reduces the Swiss contribution to world culture to the cuckoo clock – a decade later, he could at least have considered typography as an item in the nation's credit account. The 1950s and 1960s were to see a dominant Swiss influence, both in design style and the typefaces used to implement it, for it was from there that the next significant sans serifs would come. One, Helvetica, was destined along with Times Roman to be the world's most successful typeface. Although its popularity may now have waned in the face of the mass of new sans serifs which have been designed in the last decade, it is still inescapable, often the default face on computer programs. Along with its contemporary, Univers, it would become the medium for the school of Swiss design – grid-based, ranged-left typography, using one typeface only in a selection of different weights. It was a logical progression of the ideas of Switzerland's adopted son, Tschichold.

The designer of Univers, Adrian Frutiger, was born near Interlaken in 1928. After studying at the School of Fine Arts in Zurich, he joined Deberny and Peignot in 1952. By this time the company was looking at typographical alternatives to metal type. They were developing an adhesive alphabet system called Typophane, and had gained French distribution rights for the Lumitype photosetting machine. Frutiger supervised the adaptation of classic faces to the new machine, but he also worked on his own designs. The most notable was a sans serif face he had first started designing while still a student; it was Univers, the first face to be designed simultaneously for metal and photosetting. As type families go, Univers was a huge one – twenty-one members – and Frutiger created a unique numbering system to replace the customary 'bold', 'italic', 'medium condensed' tags. The first numeral denoted the weight of the face, and the second the amount by which it was condensed, so Univers 39 was light but very condensed, and Univers 83 was extra bold and expanded.

Neville Brody (see Chapter 18) was later to call Univers 'the coldest face ever designed': 'It's so mechanically pure in its intentions that it's still-born, it can't communicate any emotive quality whatever.'[5] It's hard to disagree. Univers only ever gains any character in the condensed or expanded versions. The straight-down-the-middle Univers 55, the medium weight, is, apart from the flat tail of the capital Q, devoid of any distinctive features – cool, eminently well designed and yet strangely enervated. Its position as the face that would typify Swiss style was immediately challenged by the arrival of Helvetica.

The designer of this worldwide phenomenon was Max Miedinger (1910–80), an in-house designer for the Swiss Foundry Haas, based in Munchenstein. *Typographische Monatsblätter* had made his previous face, Pro Arte, its alphabet of the month for July 1955. Described as a Modern-style Italian, it was a heavily serifed condensed face, clearly inspired by the early-nineteenth-century display faces. It gave no hint of what was to come.

In 1956 Miedinger was asked by Edouard Hoffman of Haas to design a new sans serif face, with the aim of superseding Akzidenz Grotesk, an 1890s German sans serif that was still proving extremely popular. Although Miedinger started with the brief of updating Haas's exist-

MNO
def

64 Univers: Adrian Frutiger's multi-versioned family. Efficient, but the coldest typeface ever produced?

5 Jan Wozencroft, *The Graphic Language of Neville Brody*, vol. 1, London, 1988.

MNO
def

65 Helvetica: Max Miedinger's design inexplicably escapes the chilliness of Univers, and swiftly became the definitive Swiss-style typeface.

ing sans serif, Haas Grotesk, the resulting face took on a life of its own. Originally entitled New Haas Grotesk, it was adopted in 1961 by Stempel, the German parent company of Haas, for sale to their home market. Unwilling to release a typeface that bore another company's name, Stempel unilaterally renamed it. The result, Helvetica, was greeted with disapproval by Hoffman. As a corruption of the Latin name for Switzerland, Helvetia, he considered it highly unsuitable, but the name remained.

Helvetica's popularity was built on two factors; it was representative of a design philosophy – Swiss style. But while being well drawn, it also had little to distinguish it, or cause offence. Helvetica has been called the typeface with no distinguishing features. It can go anywhere, do anything; it's everything – and nothing. Yet, it does have some elusive quality that gives it a friendlier feel than Univers. But Miedinger himself was not to reap the proportionate financial rewards for this world-beater. The introduction of royalty systems for typeface usage by Herb Lubalin's International Typeface Corporation would not happen until the 1970s, bringing benefits to designers that Miedinger, paid a straight company wage, would only be able to envy.

Detour | Portable serenity: the precision and the passion of the letter cutter

The main object of cutting words into slate or other hard materials is that they should last. (David Kindersley, *Letters Slate Cut*, 1981)

David Kindersley's words might seem obvious, but they're worth pondering. Very little lettering or typography stands for long. Leaflets and flyers are, it is hoped, read before they are discarded, newspapers linger for a day or so, magazines perhaps a month. During the 1980s, as design groups hitched a ride on the 'style' rollercoaster, the graphics that should have been designed to be the most enduring, company logos, had a flimsy feel to them, loosely constructed, often using a Matisse-derived brushwork illustration style that would inevitably look dated in two or three years, and ripe for another re-design. Good for the design business perhaps, but what about creating enduring, meaningful imagery? It's hard to imagine anything designed today lasting as long as the Coca-Cola logo.

Stonecut lettering is not typography. It exists in one place only, it cannot serve mass production or multiple usage – each example is a one-off. But as we've seen, most typeface designers did other things as well as design type; they either had a previous profession or pursued other creative directions parallel to their typographic work. Eric Gill was a prime example of the latter, more famous during his lifetime for his sculpture and stonecut-ting than his typography. Another instance is a former apprentice of Gill's, David Kindersley. He was both a letter cutter and a calligrapher as well as a type designer, and in Chapter 15 we will see how he was involved in a national typographical controversy.

He died in 1995, but his workshop still continues as the Cardozo Kindersley Workshop, under the guiding hand of his wife, Lida Lopes Cardozo. Step into the calm and welcoming ambience of the workshop premises, and you soon realize that you are standing in a direct descendant of the stone-carving workshops of Eric Gill.

Kindersley (whose name is probably best known to a wider public through the publishing company Dorling Kindersley, founded by his son Peter) joined Gill as an apprentice in 1934, working with him until 1936, when he left to start his own workshop. After Gill's death in 1940 he was persuaded, somewhat against his better judgement, to return to run Gill's old workshop for a while, after which, in 1946, he left again to establish a new workshop of his own at Barton in Cambridgeshire. This was the county where he would work for the rest of his life, and the city of Cambridge was to prove an invaluable source of commissions.

David Kindersley was born in 1915 in Hertfordshire, the son of a stockbroker and later Member of Parliament for North Hertfordshire. Three years at Marlborough School were cut short by an attack of rheumatoid arthritis. A stint in France followed to learn the language, but Kindersley also started taking life drawing classes at the Académie Julian, and became interested in sculpture. As a result he was sent to work with the Udini brothers, a firm of Italian marble-carvers based in Fulham, West London. They translated the clay models of Royal Academicians into stone, and although this was invaluable experience for the seventeen-year-old Kindersley, he had begun reading the writings of Eric Gill, who reviled this process. He decided that Gill was the man he had to work for.

A letter was sent requesting an apprenticeship, but Gill refused; he had all the help he needed. Undaunted, Kindersley headed for Gill's base at Pigotts in Buckinghamshire, and spotted the distinctively dressed figure on his way back from the post office. Again Gill said no, but finding that Kindersley had not taken the art school route to learn about stone carving, changed his mind, and suggested he come back in a month, by which time he thought he would be able to accommodate him.

Kindersley duly returned, and was soon to find himself working on a huge capital L that still graces the curved frontage of Bentall's department store in Kingston upon Thames. It was a fruitful time, and Gill's personality and ideas, as with so many people who encountered him, left an impression that Kindersley carried with him for the rest of his life.

Entering the Cardozo Kindersley Workshop on a

bright July morning, it wasn't fanciful to imagine that personality, and the personality of Kindersley himself, lingering still. The walls were covered with framed examples of Gill's designs and Kindersley's calligraphic inscriptions and aphorisms.

One of the workshop's publications, *Letters for the Millennium*, declares: 'Cutting is a supremely focused activity. It should take place in a quiet and calm environment. The Workshop must be such an environment.' They had succeeded. Maybe it was something to do with the sunlight streaming through the windows of the former infants' school building, and the stillness that you could feel there as a constant presence, even when people were talking and moving around. Stones half finished and stones with the designs drawn out preparatory to cutting were mounted on wooden frames, awaiting the return of their carvers.

Lida Lopes Cardozo seemed to carry this aura of calm around with her too. Conscious of its duty to pass on its skills and traditions to the next generation, the workshop takes on apprentices, and she explained how the learning process began, showing me two sheets of hand-drawn capital letters: 'We always get the new apprentice to draw an alphabet first as they see it. From this we can gauge what's in their head, and then we begin instructing them on the way *we* draw and cut letters here in the workshop. This second sheet was done only a short while afterwards, but you can see there's already an enormous change and improvement.'

On the first sheet the A had been drawn with the thin angled stroke meeting the thick at a point beyond which the thick stroke continued and then ended obliquely cropped. Lida had drawn my attention to this as an aspect that needed correction; by the second sheet the A had adopted a flat-topped apex. The first was a style that had stood Caslon in good stead, and I questioned why it was wrong. 'We do other styles of A in the workshop, but as a starting point, we do them that way because that's the way Eric Gill did them,' said Lida. In Gill's *An Essay on Typography* he describes the Caslon style of A as 'top heavy'; his influence was still making itself felt over sixty years after his death.

'Cutting is a quiet and solitary business. This act is our moment of meditation and concentration. All our

66 Lida Lopes Cardozo at work: 'Letters will not exist until they are cut with the blow of conviction.'

1 The Cardozo Kindersley Workshop, *A Guide to Commissioning Work.*
2 Fiona MacCarthy, *David Kindersley, a life of letters,* Cambridge 2000.

attention must be on the tip of the chisel.'[1] The workshop culture as practised by both Gill and Kindersley has been described as 'quasi-familial',[2] and although ultimately the work of the letter cutter is solitary, Lida was quick to express the importance of the group, how any truly successful piece of work is not a solo effort but the result of contributions from everyone, including the customers. 'If you go wrong, in the workshop you won't go too far wrong. There is always someone to guide and correct you.'

The workshop has about eighty customers a year, but this can mean a workload totalling more than one stone per customer, ranging from headstones (a memorial stone to the writer Malcolm Bradbury, who died in 2000, was in progress on the day I visited) to giant letters for architectural exteriors, or to a simple plaque or sundial for a garden. The entrance lettering to the

new British Library building, carved in stone and cast in metal for the gates, is a recent example.

I was interested in the process of drawing out the final design on the stone. A scale drawing has been produced and approved by the client, but it is not full scale, so there is no simple tracing off on to the stone. To follow this course would, it is felt, result in something being lost, the opportunity to improve on the drawing. No rulers are used; the letter form has to exist primarily in the letter cutter's head.

Although an atmosphere conducive to this kind of concentration is possible within a controlled environment like the workshop, sometimes cutting is done *in situ*, with an audience of passers-by. The letter cutters 'have to create their own calm', a test of temperament in a medium unforgiving of mistakes. There are no 'undo' keyboard commands here.

'What if you make a mistake?' is a frequently asked question, and one that naturally enters the head of anyone who looks at an inscription carved in stone. Mistakes do happen. David Kindersley and his team were working on the Trinity College war memorial in the early 1950s. Thirty feet wide and ten feet high, it was covered with the names of those from the college who had died in the recent conflict.

As they worked, people were wandering through the chapel at all times. When the task was nearly completed, a bystander approached David Kindersley and said, 'That's my name you've just cut.' Although Kindersley was insistent that this couldn't be the case, the man assured him he was the only person to have attended Trinity College with exactly that name.

The cutters downed tools, and Kindersley went to see the Dean of the college. It turned out that the college had written to everyone of an age for war service who had attended Trinity; if there was no response after a year they wrote again. If by the end of the second year there was still no reply it was assumed that the person in question was dead. When the list was gone through thoroughly, there were found to be six living inclusions, and seven genuine casualties who had been omitted.

To make corrections such as these, the stone has to be chiselled down into a large area around the mistake and then rubbed smooth, to create a new surface for

working. The wall in Trinity, if viewed close up, has a slightly wavering surface as a result of all these revisions. As a nice touch, one of the wrongly included names, J. C. Smith, was left on as an Unknown Warrior, to represent any who remained unhonoured.[3]

Aside from the corrections required when wrong information is given by the customer, Gill believed that any other mistakes should be left to stand. If the stone chipped at the edge of the letter, leave it. The letter form must not be corrupted by making the stroke wider to absorb the chip. To Gill, most mistakes were due to a failure of concentration on the cutter's part.

The whole letter cutting process and the nature of the workshop as described in the workshop's publications are always in terms that strongly emphasize the spiritual quality of the work. Here are a group of people who have a deep love for the work they do, who believe it matters. This commitment stems from a sense of the responsibility inherent in the act of cutting letters – the knowledge that they are going to exist for a long time, maybe centuries. 'Once a cut is made, it is there for ever for the world to witness.'

To an outsider, entering the workshop can feel like stepping into a religious community; in such a serene environment, the prime requirements for a letter cutter would seem to be a slow pulse and a steady hand. But Lida, in relating to me the history of her own personal journey to her present position as leader of the workshop, revealed a story of remarkable passion. The desire to create letters had come not gradually but, as for Gill seeing Johnston writing for the first time, as a bolt of lightning: 'I was studying at the Royal Academy in The Hague. One day the teacher, Gerrit Noordzij, walked in, broke a stick of chalk in half and starting drawing the most wonderful letters on the blackboard. And at that moment I thought, this is it, this is what I want to do!'

Noordzij encouraged his student. Trips abroad included a design conference in Poland. 'If you're interested in lettering, there's the man you should meet,' he said, indicating a figure on the other side of the room. It was Kindersley. And it was bolt of lightning number two: 'It was just like in a film. I walked across the room, and it seemed as though the crowd parted to let me through

3 Montague Shaw, *David Kindersley, His Work and Workshop*, Cambridge, 1989.

67 David Kindersley: a workshop 'paterfamilias' who saw the benefits of creative power sharing, with his last wife, Lida Lopes Cardozo. She brought a new sensibility to his work; he showed her how to cut letters and give up smoking.

until I was standing in front of David, holding out my hand, saying: "I'm Lida." And he turned to me and said: "I hate things that are almost perfect." '

For laconic, cryptic openings this rivals the first meeting of John Lennon and Yoko Ono.[4] Kindersley told her to call in at the workshop if she were ever in Cambridge. Two weeks later she was there. She wanted to become an apprentice, but Kindersley urged her to complete her course; 'Learn to see' was his advice. She studied anatomical drawing, and then her father paid for her to start at the workshop. But Lida's enthusiasm was not just for letter carving – she was deeply in love with Kindersley, indeed had been obsessed with him since their first meeting. She was twenty-one, he was sixty-one, and married. Their working relationship was of necessity intense, intimate. But Kindersley, conscious of his position, and the discrepancy in age between them, maintained a physical distance. It was torment for Lida: 'There was a lot of sexual energy there, and the only place it had to go was into the stones!' she says, laughing.

There was one beneficial side effect, however. The more contemplative creative pursuits, such as painting or writing, seem to go hand in hand with smoking; it has been remarked how Gill brought the same intense concentration and attention to detail in rolling a cigarette as he did to his stonework. Lida spent most of her early cutting wreathed in clouds of tobacco smoke, but one day, as Kindersley showed her how to stand and how to hold her hammer and chisel to achieve the

4 She silently handed him a card with the word 'Breathe' printed on it.

required angles, she placed her half-smoked cigarette on the edge of a nearby cupboard. The cigarette burned down, eventually scarring the surface of the wood. It was the last she was to smoke. To cut stone both hands were needed, to summon what Kindersley described as 'every grain of "more"'.

It took over two and a half years, but Lida finally got her man. She and Kindersley were married and had three sons. David Kindersley was by now over seventy.

'The mystique of the 20th century craft workshop has been built up around a central male practitioner. The prime example, of course, was Eric Gill whose workshop was compared by visitors to that of a Renaissance atelier,' wrote Fiona MacCarthy.[5] Although Kindersley was another example of this phenomenon, she points out that, unlike Gill, who had a low opinion of women as an artistic force, Kindersley was able to accept a much younger woman as his creative equal, and to allow her to bring new qualities to his own work.

Reginald Lawson, later to take holy orders, was convinced he once saw a 'nimbus' around Gill's head. Speaking to Lida, I got a similar impression of Kindersley, not as a holy figure, but as a spiritual and inspirational force. Although he died in 1995, she still conveyed an intense adoration and admiration when speaking about him. The spell of his personality was still at work, and I could even feel it settling benignly over myself. Leaving, I felt, despite the glorious sunshine, as though I had stepped out into a shallower world of superficial feeling and diminished understanding.

5 MacCarthy, op. cit.

14 | Two ghosts: forgotten technologies from the dustbin of history

Photosetting has been called a blip in the history of typesetting, a period spanning a little over thirty years in which metal type was gradually abandoned in favour of a system that would itself soon be rendered obsolete by the personal computer.

On its arrival in the late 1950s, photosetting was seen as providing far greater design freedom than had previously been possible. With metal or wooden type, the physical 'body' behind each character limited the tightness of the letterspacing. Especially with headlines, tight spacing was desirable – words could be bigger in the available space, creating a punchier headline. With photosetting, even for text, letters could be very tightly spaced, even touching, and lines could be set with negative spacing, so that the descender of one line could go below the top of the ascender of the line below it.

How did the new process work? Like the hot-metal composing machines, a keyboard converted the letters into punched holes on paper tape. But on the filmsetting machine, the matrix case, which on the hot-metal caster had contained metal matrices, now contained tiny photographic negatives of each character. As with the metal casters, compressed air passing through holes in the punched tape moved the matrix case into position for light to pass through the correct image and be exposed on to negative film, developed and printed in darkroom conditions on positive paper. This 'bromide' was what the customer received.

Because the image of the characters was created by light passing through a negative, there were new factors for the type designer to consider:

> The trouble with photography is that the amount of light from a constant source passing through a small and large aperture will not be in proportion to the sizes of the apertures ... The result on paper is that the dot [of an i] appears to shrink and the W to swell. Where the strokes of the W meet and there are concentrations of weight, the light will spread and eat into the counters,

68 Above: shunted by compressed air – the matrix case, developed here for photosetting. Left: the photosetting matrix – a tiny negative of the character.

exaggerating the heaviness of the letter. To compensate for this the dot has to be drawn large, the strokes of the W thinned and the crotches of the counters opened up to give the appearance of even weight.[1]

Inevitably the new technology was seen as a drop in quality. With a metal fount, adjustments were made to the cut of the characters according to size. Enlarge the image of 6pt metal type until it is the same size as 24pt, and it looks heavier. A compensation was made when cutting the punches for the small sizes so that the characters wouldn't weaken. There was also an allowance in the type body as well, so that the really small letters would be slightly wider spaced, to help legibility. One of the criticisms of photosetting was that the same image was just blown up or down for the whole range of type sizes.

The Monotype Recorder stated in its 1965 overview

1 Adrian Frutiger, 'Filmsetting in Focus', *The Monotype Recorder*, Summer 1965.

that there were actually up to three sets of matrices for each typeface; a set of 'B' matrices to cover 8pt to 24pt, and an 'A' set for 6pt and 7pt. Bembo had an extra 'C' matrix for 14pt to 24pt. Where a face such as Univers or 'Monophoto' Apollo has been specially designed for photosetting, one matrix served for 6pt to 22pt in Univers, and for 6pt to 24pt in Apollo. But the *Recorder* noted that some typesetters were already not bothering to switch to the 'A' matrix, because they set only a small amount of 6pt and 7pt type. Although the new technology catered for size compensations, for reasons of convenience or just plain corner-cutting, some typesetters were already starting to ignore this facility.

The *Recorder's* review of the current metal versus film situation in the industry reflected a relatively slow take-up of filmsetting machines, largely, it was felt, because of capital investment tied up in metal. The magazine was keen to promote the company's filmsetting machines, but conceded that in terms of speed and economy filmsetting only scored over metal at the end of the process. The keyboarding time was the same, and metal had the advantage that the ink-carrying printing surface was produced immediately, whereas with filmsetting the darkroom stage and the plate-making process were involved as well. Where filmsetting reaped dividends was at the printing stage. Set-up times with lithographic plates were shorter than with metal, and corrections to text could be made much more quickly and easily. The more complicated the job, the more filmsetting gained the ascendancy, such as in page imposition for books and magazines.[2]

A fringe benefit of film was in the storage of material for possible future reprinting. It was calculated that for a particular edition of Tolstoy's *War and Peace*, four and a half tons of metal would have been used for the typesetting, requiring about 22 cubic feet of storage space, whereas the film used would have occupied less than one-fifth of a cubic foot.

But the two technologies ran side by side for a long time. The first photoset book in Britain was Allen Lane's Christmas Book, an edition of *Private Angelo* by Eric Linklater. This small volume was privately printed and distributed to friends of the Penguin Books director in December 1957.

2 How the pages are arranged on a flat printed sheet, so that when it is folded up and bound they are in the correct order.

The book trade in general, though, was more suspicious of photosetting in its early years. There was a quicker take-up by magazines, the process of setting pictures amid text being a lot easier with photosetting.

When *Car* magazine was bought by the publishing company EMAP in 1992, it was still typeset in hot metal. Devcolight, a five-man company in the East End of London, set the magazine, their last account, on ancient Monotype machines. The new owners, concluding that it would be cheaper and far more practical to set *Car* digitally, withdrew the job, bringing about the end of the company.

And when photosetting died, a lot of jobs went too. One evening during the late 1980s I visited the offices of Conway's, a London typesetting firm that claimed to offer the largest range of headline faces. The night shift was hard at work, probably between ten and twenty people; within five years they, and the technology they were using, had gone.

In the early 1990s, design departments everywhere, as they started to feel at home with their Apple Macintosh computers, were throwing out or giving away large quantities of thin, transparent plastic sheets measuring 25 cm by 38 cm, each with an accompanying backing of pale blue paper. On the plastic sheet were all the characters of a particular typeface in a certain point size – usually black, but sometimes white or even coloured. All the characters were there in varying numbers, apart from e, which would be represented by a large empty space. For these sheets were rub-down dry-transfer lettering, and this was Letraset. And you always ran out of e's.

Letraset was one of those company names that came to represent any example of a certain type of product regardless of the manufacturer, much as in Britain any sort of vacuum cleaner is called a Hoover. Letraset was the first instant do-it-yourself lettering, for which no typesetter was needed, at least for small amounts of lettering; you could create your own setting merely by holding the sheet in position over a piece of paper or your design layout, and with a soft pencil (or if you insisted on the correct equipment, a proper Letraset burnisher – a moulded plastic stick with a curved end) rubbing the letters until they came off the sheet and

transferred themselves on to the surface below. Sometimes they cracked, or a fine serif refused to make the move, or if the sheet was too old the letters refused to come off at all. But usually it worked a treat. If you had the additional technology of a PMT camera[3] you could enlarge or reduce your lettering to exactly the size you wanted for reproduction. The sheets of letters even had a letterspacing guide, based on the spacing system devised by David Kindersley (see p. 195), who was a consultant to the company until 1986. This was a series of dashes which ran under the lines of letters, although no self-respecting designer would have dreamed of using it.

When Letraset first appeared on the market it was in a different form – water slide transfers, decals, the kind of thing used for the markings of model aircraft. The letters were cut off a sheet, then soaked in a saucer of water until they came free of their backing. They were then placed on a small silk-covered frame, which was turned over and pressed down on to the design. Before the letters dried there was an opportunity for slight re-positioning. It sounds fiddly, but these were large letters, and they became popular with advertising agencies for headline work.

This was 1956. Letraset was the brainchild of Charles 'Dai' Davies, a designer and lettering artist. His dream was to 'liberate the letter', and to this end he enlisted the technical mind of printing consultant Fred Mackenzie, who came up with the water slide transfer idea. Take-up by the market was slow, and from the word go Letraset was never cheap. When a promotional pack arrived at Penguin Books, the art director, Hans Schmoller, looked at it in disgust before dropping it into the bin.[4] But the company managed to survive, and a printers' strike in 1959 gave the product a much-needed boost.

By now they were working on a new concept. Ink manufacturer Jim Reed joined the team; the right formula was found for printing the letters in reverse on a polyethylene sheet, then over-printing them with a low-tack adhesive. In 1961 the dry transfer, the rub-down letter, was born.

Letraset went on to become a phenomenally successful company, with numerous international subsidiaries. As well as lettering, it produced rub-down illustrations,

3 PMT stood for photo-mechanical transfer, created by a large, vertical bellows camera in darkroom conditions. A sheet of negative photographic paper was placed on the glass screen top of the camera after the image of the type, projected there from below, had been adjusted to the required size. After exposure the negative was removed and placed against a sheet of positive paper. The two were then run through rollers into a chemical bath of developer, emerging pressed together. After a few seconds the sheets were peeled apart and you had a new image of the original.

4 Recalled by John Miles, working for the publishers at the time.

69 A quick rub-down: with Letraset, everyone could be their own typographer. But you always ran out of e's.

diagrams, symbols, sheets of tone and textures and, most usefully in the days when all rules and borders had to be drawn with pen and ink, rub-down lines, always one of the biggest sellers.

Although every design studio and designer had piles of the stuff, using Letraset always seemed slightly unprofessional, possibly because, before the typographical democratization brought about by the personal computer, the general public had access to it. Unforgivable elitism, but every profession must have its secrets. 'What's that, then, messing about with Letraset?' – how often you heard that question if you tried to explain exactly what a graphic designer did.

Used properly, though, once printed the lettering was indistinguishable from characters produced by photosetting. And true to his design background, Davies always kept a keen eye on the creative side. The reproduction of existing faces was extremely faithful, and the first original Letraset typeface, Compacta, was launched in 1963, designed by Fred Lambert. In 1970 Letragraphica was set up; under design director Colin Brignall an international panel of type designers selected new faces for the range.

The arrival of digital typesetting spelt the end of the golden age of rub-down lettering. Letraset reacted to this by producing their Fontek range of digital fonts, but style-wise they were stuck in a nightmarish early 1970s mindset, and didn't prove a financial success. But Letraset the company is still in existence, selling art and design materials and digital fonts. A very small range of dry-transfer lettering is, amazingly, still available.

15 | Motorway madness: David Kindersley and the great road sign ruckus

If, to paraphrase Beatrice Warde, good typography is invisible, then no example can better serve the analogy of the crystal goblet than the lettering on road signs. The motorist needs to absorb the message in seconds, maybe fractions of a second. Only if it impedes our processing of the information does the style in which the message has been delivered become an issue – otherwise it's irrelevant. If we can anticipate the correct turn off the motorway, or avoid moving into the lane that takes us five miles out of our way, then the sign has done its job. Leisurely examination of the typefaces used in America and throughout Europe would reveal only unremarkable sans serifs, usually in upper and lower case letters – functionality carried to the point of absolute anonymity.

But in Britain, at the end of the 1950s, the question of road sign typography became a matter of heated debate – a celebrated designer, typographer and stonecutter on one side; on the other, the full force of ministerial intransigence.

On 2 December 1958 the British press announced the imminent opening of a new section of road, the Preston bypass in Lancashire in northern England. The Prime Minister himself, Harold Macmillan, would be there in three days' time to perform the official ceremony.

In terms of Britain's transport system this was a significant event. The Preston bypass was the forerunner of the nation's new motorway system, of which the London to Birmingham highway (later to be called the M1), scheduled to open the following year, would be the first component. The Preston bypass would be a guinea pig for the new system, upon which any teething problems could be resolved. The second innovation announced that day was the unveiling of the new road signage. Like the motorway system itself, in typographic terms these signs were a dramatic departure from what currently existed in 1950s Britain.

The incumbent style of road signs had been introduced in 1933. Place names were in black sans serif

capitals, enclosed in white panels with heavy black directional arrows on an overall background of white, yellow or pale blue. The lettering was not particularly large, but at the time of their introduction this wasn't an issue. Road usage was comparatively light, and there were few major routes. In the 1940s, with war and petrol rationing, road usage fell even further; fuel restrictions were lifted only in March 1950, almost five years after the end of hostilities in Europe.

Prosperity slowly returned to Britain after the devastation and deprivations of the Second World War, bringing a rise in ownership of consumer goods in the second half of the 1950s — televisions, washing machines, fridges and, of course, cars. In 1938, the British motor industry had produced just under 445,000 vehicles; in 1959, the year of the opening of the M1, that figure had more than tripled. It was clearly time to develop and overhaul Britain's road network. For cars travelling at higher speeds on uninterrupted stretches of tarmac, the over-complex and typographically unassertive signs currently in use would be hopelessly inadequate. The question was, what should replace them?

The Ministry of Transport and Civil Aviation turned to Richard 'Jock' Kinneir (1917–94). After training and teaching at Chelsea College of Art in west London, he had worked in the Design Research Unit of the Central Office of Information, and had been involved with the 1951 Festival of Britain. In partnership with one of his former students, the South African Margaret Calvert (born 1936), Kinneir had designed the signage for London's Gatwick Airport in the mid-fifties, and together they went on to create the typeface for British Rail in 1965. They were the logical choice to take on this new task.

The *Daily Telegraph and Morning Post* of December 1958 informed its readers that the signs had been designed after studying developments and research in American and European signs, and their legibility had been tested at night on Hendon airfield in north London by Lord Waleran of the Advisory Committee on Traffic Signs for Motorways, driving at speed along the runways.

The lettering used was sans serif, white on a bright blue background. It was also in upper and lower case characters, a departure from the previous all-capitals. The

70 David Kindersley at work, the MOT serif in the background.

signs, as the *Telegraph* conceded, were much larger than any previous road signs.

Even before Macmillan had a chance to open the new bypass, *The Times* newspaper received and published a letter by David Kindersley, Eric Gill's former apprentice and now an eminent letter cutter and designer in his own right.

Kindersley was appalled by the new signs. In his letter he warned that the 12-inch height requirement for a letter to be readable at a distance of 600 feet meant that with the adoption of upper and lower case the height of the capitals would be even greater, which in turn meant larger signs. He argued that the eye recognized the more varied 'word shapes' of lower case (all capitals creating uniform block shapes) only if the word pattern was already familiar, which with place names was not likely.

He also believed that the lettering should be serifed. At a distance, the serifs would help reinforce the characters at the points where there would be loss of definition. And he pointed out that earlier in the decade it had been possible for some all-capitals street name lettering he had designed for the MOT to be 12 per cent smaller than the existing sign letters because of the serifs.

Kindersley was stunned that these lessons had not been applied to the new motorway signs. In a letter to the Minister of Transport and Civil Aviation, Sir Gilmour Jenkins, he pleaded: 'How can you be persuaded and the country saved from mistakes which I am sure we would

all be regretting but finding irremediable within a genera-
tion?'[1] Of Noel Carrington, a member of the advisory
committee, he asked why, if lower case was so superior,
were car number plates all in capitals? 'Of course a shaped
letter with serifs is very much more legible than a mono-
line sans serif. I cannot really believe there is any doubt
either that it is pleasanter to the eye. Did you have all
these points before you and properly supported when
you were deliberating? If so, I cannot imagine by what
process of thinking you reached the conclusion you did.
May the New Year bring some light to you all!'[2]

This wasn't a tone likely to endear Kindersley to the
committee. So far, only his friend Brooke Crutchley, the
University Printer at the Cambridge University Press,
was supporting his campaign; attempts to get the BBC to
produce a programme on the subject, or *Design* magazine
to run a feature, were proving fruitless. But early in the
new year, the ministry replied, conceding cautiously that
the new signs were at present only experimental. Fired
by this, Kindersley decided to design his own alphabet
to offer as an alternative.

In defence of their decisions, the ministry cited the
findings of American and German research. The latter
was to prove elusive, if not mythical, but the American
work had been carried out by the California Division of
Highways and the University of California Institute of
Transportation and Traffic Engineering and published in
1950.[3] They had declared in favour of upper and lower
case sans serif, although their results had been less clear
cut for user recognition of unknown place names, and
there had been no testing of serif lettering. Kindersley
pointed out to *The Times* that the research had also found
that capitals only needed to be 9 per cent larger than the
lower case x-height to compete in readability, whereas
the capitals used in an upper and lower case configura-
tion would actually be larger than this. Furthermore, he
stated, the American letters were poorly designed – not
a good basis for research.

The other significant American research on legibil-
ity had been carried out by Miles Tinker and Donald
Patterson at the University of Minnesota in 1945, an
investigation into the effectiveness of newspaper head-
lines. Their guinea pigs, a group of students, were ranged
in rows, and headlines were exposed to them for a period

1 Letter to Sir Gilmour
Jenkins, 18 December 1958.

2 Letter, 30 December 1958.

3 T. W. Forbes, Institute of
Transportation and Traffic Engi-
neering, Karl Moscowitz, Trans-
port Department, and Glen
Morgan, Materials and Research
Department, California Division
of Highways, 1950.

of one second only. The results recorded for the front rows were conclusive enough for Tinker and Patterson to call for the complete abandonment of upper case usage for headlines. However, the findings also revealed that, for the students sitting in the back rows, recognition of single words in capitals was easier in upper case. This result clearly held implications for road signs, where generally the driver is reading place names of only one or two words. In the resulting article, Tinker and Patterson, while coming down firmly on the side of upper and lower case, concluded: 'For reading at unusually great distances, such as in billboard advertising, the writers would insist that lower case is also to be preferred. In this special situation a larger point size of lower case than the upper case would have to be specified.'[4]

This was further vindication of Kindersley's argument. With capitals only, the signs could be smaller. This was surely desirable, if only in terms of the visual effect upon the environment. Kindersley was later to pursue this line by enlisting the support of rural protection groups in an attempt to stop the spread of the signs nationwide. As he later wrote to the Minister of Transport: 'the present boards mar the landscape and their huge backsides are extremely ugly'.[5]

> I very much fear we have lost the battle over the Motorway signs. I have now had a letter from a new Permanent Secretary of the Ministry of Transport who has apparently been going into the subject himself and discussing our points 'with those concerned with these matters here'. The position remains that 'we are not satisfied that a change would be desirable' and anyway it is too late so far as the London–Birmingham motorway is concerned.
>
> He does, however, say that the Road Research Laboratory are carrying on further experiments. The Ministry has lately been rapped over the knuckles by the Select Committee on Accounts because it has not given sufficient attention to research ...[6]

4 'Readability of Newspaper Headings Printed in Capitals and Lower Case', *Journal of Applied Psychology*, 1946.

5 Letter to Ernest Marples, 4 April 1961.

6 Brooke Crutchley, letter to David Kindersley, 20 July 1959.

Crutchley was right; David Kindersley had made some headway with the Road Research Laboratory. He had been in correspondence with R. L. Moore, the head of the Lighting and Road User Section, who, in October 1959, commissioned Kindersley to produce some road

IJLTFYCP
SVZEXGA
UKORBH
DQNMW

71 MOT serif, quirky, original, each letter a distinct individual, yet part of a team.

signs to his own design, with a view to testing their effectiveness. Kindersley, in line with his arguments, designed an alphabet that was all capitals, and serifed. He also produced dummy signs to show how it would look in practice. Because we are now so accustomed to the Kinneir–Calvert lettering they look strange, but a closer examination actually reinforces rather than diminishes this initial impression.

Few of the letters are consistent with each other in the places where you would expect them to be. The top crossbar on the F ends with an upper serif and a slightly flared lower edge, whereas the corresponding section of the E has a double serif. The middle cross-stroke of the F ends in a double serif; on the E it is flared. The crossbar of the T is slightly flared, but has no serifs. The angled strokes of the Y are fatter, then taper, whereas the strokes of the V are of consistent width. The top angle of the N has a small serif; those of the M have none. The bottom of the vertical stroke of the R has one small serif on the left edge, nothing on the right, whereas on the P there is a small serif on the left edge and a large one on the right.

Kindersley had designed the alphabet this way to create maximum distinctiveness between the characters; he wanted there to be no confusion between them when viewed from a distance. Although looked at coldly the resulting alphabet is something of an oddball, objectively it's a work of no little genius. Kindersley was able to 'think outside the box', jumping beyond the normal

conventions governing type aesthetics – how the letters relate to and echo each other's forms – and create a face tailor made for one very specific purpose, but which still retained its own internal sense of visual unity. And for that one particular purpose, Kindersley believed it to be superior to its rival.

Towards the end of 1960 the Road Research Laboratory put the signs to the test. A group of volunteers was assembled from the Royal Air Force base at Benson in Oxfordshire. Seated on a raised platform, each was armed with a push button. A series of signs in four different type configurations was mounted on the roof of a Vauxhall Wyvern, which was driven towards them at 30 miles per hour. Forewarned of the place names on the signs (which would be in keeping with the foreknowledge of a driver as to what name they were looking for), as soon as each observer could read the names they pressed their button. This activated a marker on a moving paper chart, which gave a reading of the distance of the car at the point when the button was pressed.

The four type styles, all in white letters on a khaki background, were:

1. sans serif capitals;
2. David Kindersley's serif capitals;
3, 4. The Kinneir–Calvert upper and lower case face in two versions: the first closely letterspaced, the second with the wider spacing that was used on the motorway signs.

In all 6,336 reading distances were taken, 1,584 for each version.

On 4 April 1961, David Kindersley wrote: 'the Road Research Labs have completed their testing of lower case letters v CAPS, and, I am glad to say, my own alphabet has proved to be the most legible.'[7]

The average reading distance for Kindersley's MOT serif was 247 feet (75.3 m). For the more tightly spaced Kinneir lettering it was 240 feet (73.2 m) and for sans serif capitals it was 239 feet (72.9 m). The upper and lower case widely spaced 'motorway style' lettering lagged far behind at 212 feet (64.7 m). So it was victory to Kindersley by an average of 7 feet, more than 2 metres, and over the 'motorway style' lettering by a resounding 35 feet, over 10 metres.

7 Letter to John Betjeman.

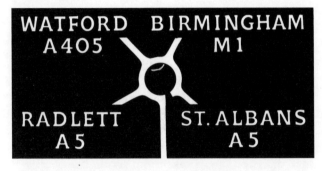

72 No thoroughfare: how it
might have looked – one of
David Kindersley's mock-up
signs for MOT serif.

Kindersley underlined this margin of success by pointing out that the x-height of the tested motorway style lettering was 2 inches (50.5 mm). On a motorway sign this would be five times larger, so the true distance between the two scores would be 175 feet, over 53 metres. Although this straightforward multiplication may not apply precisely in practice, it is none the less a substantial margin.

He felt vindicated; on the same day he sent a letter to Ernest Marples, the Minister of Transport, urging him to make use of the Road Research Laboratory's findings. 'I hope it is not too late to make a fresh start,' he wrote.

But it was. Brooke Crutchley received a letter from the Ministry of Transport, the message being in effect that though their preferred signs might be larger with lots of empty space, that was the way the ministry liked them. The admirable R. L. Moore, trying to keep everyone happy, asked Kindersley whether he would be willing to devise a spacing system for Kinneir's lettering – Kindersley agreed, but Moore, probably then realizing that this could become a political hot potato, did not pursue the idea. Despite further letters by Kindersley to the national press, the issue finally died a quiet death, leaving Jock Kinneir and Margaret Calvert's upper and lower case lettering in possession of the field.

Why was David Kindersley's lettering not adopted, in view of such an affirmation of his ideas and arguments? A closer examination of the test conditions reveals inequalities between the presentation of the four type styles. What *was* equal was the area of all the signs. But the average cap height for the sans serif capitals was 3.1 inches (78.5 mm), for David Kindersley's 3 inches (76 mm), and for Kinneir–Calvert a 2.4 inch x-height (60.5 mm) for the closely spaced version, and 2 inches

(50.5 mm) for the more widely spaced. The ratio of cap height to x-height in Kinneir's face is about 1:1.4, so that would make the respective cap heights about 3.36 inches (85 mm) and 2.8 inches (71 mm) – one larger than Kindersley's, one smaller.

But in upper and lower case words only the first letter and those with ascenders will reach this height – it's not a constant measurement along the length of the word. Although there is the extra dimension of possible descenders to be taken into account, they are not crucial to legibility. Clearly it's hard to precisely compare like with like.

Although the lettering on the other three versions virtually filled their signs, the 'motorway style' had a wider margin of space around it. Consequently the letter size had to be smaller for an equivalent area of sign. When Kinneir's face was brought up to a roughly equivalent size to the all-capitals versions, it fared considerably better. The report concluded: 'The most remarkable feature of the results for the three closely-spaced scripts is that the reading distances are so nearly equal. Although the statistical tests show that the observed difference between the reading distance for the serifed upper-case script and those for the other two scripts is probably a real one, the difference is so small that caution is necessary in interpreting its meaning.'[8]

Although true, this ignores the fact that in the 'motorway style' the ministry proposed to use the signs would have to be much larger than a Kindersley sign with equivalent-size lettering. In Moore and Alex Christie's 1963 report, 'Research on Traffic Signs', they stated:

> It was found that there was practically no difference between good lower-case sans-serif lettering, unserifed upper-case and upper-case with serifs. If anything, the upper case with serifs had a small (about 3%) advantage in legibility distance. In the absence of any marked superiority in the legibility of type of letter used the choice is, therefore, chiefly a matter which aesthetics or fashion may be allowed to decide.

Here Moore and Christie had put their finger on the nub of the matter. Christie and Rutley, in their earlier report, had touched on the question of aesthetics: 'aesthetic questions may be at the root of the controversy. For exam-

8 'Relative effectiveness of some letter types designed for use on road traffic signs', A. W. Christie and K. S. Rutley, August 1961.

ple, Sir Cyril Burt found that in his tests on lettering for books, subjects were inclined to "confuse intrinsic legibility with their private aesthetic preferences".[9]

Aesthetics were indeed the crux. The Kinneir–Calvert face was adopted because that was the look the Ministry wanted – large signs with space around the lettering. The underlying factor, on two counts, was timing. The process of installing the new signs was already under way; after publicly unveiling a solution that, following lengthy consideration, they had decided was the right one, the Ministry of Transport were unlikely to then swiftly abandon it.

But crucially Kindersley's face, though brilliantly designed, didn't *look* as the ministry wanted their lettering to look. At the beginning of the fifties it would probably have been hailed as a practical, British solution. The slab serif lettering used for the Festival of Britain had been chosen on the grounds that it was a perceived *British* lettering style. In a nation still badly bruised from its latest encounter with mainland Europe, there was a desire to turn away from its influences. Here's George Orwell again, pondering the essence of Englishness: 'When you come back to England from any foreign country, you have immediately the sensation of breathing a different air ... the beer is bitterer, the coins are heavier, the grass is greener ... It is a culture ... bound up with solid breakfasts and gloomy Sundays, smoky towns and winding roads, green fields and red pillar boxes.'[9]

But however much, at the start of the fifties, the British government may have cherished this difference – indeed, it was a way of life that the war had been fought to preserve – events later in the decade were to bring about a change of attitude. The 1956 Suez crisis saw Britain attempt a last flexing of imperial muscles, a venture which, with lack of US support, ended in embarrassing failure.[10] The Prime Minister who presided over the crisis, Anthony Eden, resigned with his health and career in ruins. His successor, Harold Macmillan, despite his appearance – that of a walrus-mustachioed Edwardian grandee – saw himself as a modernizer, revitalizing Britain's infrastructure while at the same time reappraising and redirecting the country's relations with the rest of the world. Macmillan was photographed squeezed into the driving seat of that symbol of fun 1960s motoring, the

9 *England Your England*, 1941.

10 As a result of Western withdrawal of prospective funding for the Aswan Dam project, the Egyptian leader, Colonel Nasser, nationalized the Suez Canal Company, which controlled what was effectively an international waterway, a route heavily used by British shipping, and a company in which Britain was a large shareholder. Anthony Eden, haunted by memories of 1930s appeasement, saw Nasser as a potential Middle Eastern Hitler. Nasser's courting of the Soviet Union and the Eastern Bloc countries for alternative finance spurred Britain, seeing a threat to oil supplies and the balance of power in the Middle East, to launch an invasion of Egypt in tandem with the French. When it became clear that world opinion, and most crucially that of the United States, was opposed to the use of force, and with the ominous arrival of the American fleet in the area and the threat of American oil sanctions, the invasion was abandoned.

Mini, and the new motorways were part of his scheme of refurbishment.

But beyond that, in the wake of Suez, Britain's position in the post-war world could be more realistically assessed. With American friendship looking an unreliable commodity, alignment with Europe now appeared a more attractive option, with entry into the recently formed Common Market, the European Economic Community, the new objective.

In this climate, it was politic to make any modernizing of the nation look more European in spirit, and motorway signage was a part of this. To drivers and visitors from mainland Europe, Britain would look a little less alien, a little more like home.[11] Negotiations for Britain's first bid to join the Common Market were begun in 1961.

David Kindersley's MOT serif fell victim ultimately, then, to timing and political fashion, but it's intriguing to imagine it in place today. It looks unusual, but obviously wouldn't do so if it had been part of the landscape for forty years. The debate about Britain's exact relationship with Europe continues undiminished, with the single currency, and feared loss of national identity, the latest sticking points, an uncertainty exacerbated by the divergence in policy during the 2003 invasion of Iraq.

Perhaps the disappearance of any element of distinctiveness in life is to be regretted, and in David Kindersley's typeface Britain would have had a highly practical yet quirkily British road signage system. The type designer Mathew Carter has said: 'Before the war, if a person had been blindfolded and parachuted into a European country, he would know where he was, based on the typeface around him. Today … the international typographic scene has become homogenized.'[12]

That homogeneity has now spread to many other aspects of life in western Europe. On stretches of highway devoid of distinguishing national features, when that 'If it's Tuesday, this must be Belgium' feeling creeps upon the driver, maybe David Kindersley's MOT serif, regardless of its practical properties, is a small but significant loss.

11 A later part of this process was the change in 1971 to a system of decimal coinage, abandoning the ancient system based on units of twelve and twenty. Britain successfully joined the Community in 1973.

12 Interview, Fonthaus on-line magazine, 2002.

16 | A company man: Herb Lubalin and the International Typeface Corporation

The doorbell rang. Sylvia, still in her nightdress, pulled on a robe and fastened it securely around her. Standing against the wall of the hallway, she opened the door wide, and without looking greeted the figure standing on the step.

'Good morning, Ralph.'

'Oh, er … hi, Sylvia. Is Herb in?'

'Ralph, it's five after seven on a Saturday morning. Of course he's in. In bed.'

The newcomer, although casually dressed, seemed ready for work. In one hand he gripped a briefcase, while on the other arm rested a portfolio fat with sheets of tracing paper. He indicated this with a motion of the head.

'Is it OK if I just … ' His voice trailed off.

Sylvia raised a sardonic eyebrow, enjoying his moment-ary discomfort. There was a note of weariness in her voice.

'Of course it's OK, Ralph. It always is. Go ahead. I'll fix the coffee.'

In June 1981 a page-sized advertisement for the Chicago typesetters Ryder Types featured a picture of some 1950s magazines and asked why they looked dated. It was not so much the pictures or the content, explained the ad copy, but the typography: 'Twenty years ago you could have driven a pica ruler through the letterspacing in the headline … Because it overcame the spacing limitation of metal, phototypography created unheard of type flex-ibility … Twenty years ago, what phototypography can do would probably have been called unreadable. But you're still reading this ad, aren't you?'

The award-winning series of advertisements for the British supermarket Sainsbury's from about the same time reflected this current style. The headline was minus leaded – the descenders of each line hung below the top of the capital letters in the line below. The letterspacing throughout was very close, and the typefaces had large x-heights. That it looked this way was due to the influence

The Côtes du Rhône boasts several Goliaths amongst its red wines. (Can Sainsbury's claim at least one David?)

The vineyards of the Côtes du Rhône stretch from Lyon to Avignon, a distance of 140 miles.

It is not gentle terrain.

The vines are often planted on steep granite cliffs and the summers are hot and long.

The wines of the region reflect the character of the land and are big and full-bodied. Amongst them, Hermitage and Châteauneuf du Pape are the giants, with world-wide reputations.

At their best, they are superb wines and priced accordingly.

It was the popularity of Châteauneuf du Pape that encouraged Sainsbury's to look for a similar wine at a lower price.

In 1973, we found it in a most unexpected place.

Beaumes-de-Venise is a small town just 19 miles from Châteauneuf du Pape.

It had long been famous for its white dessert wine but its red wine was an undiscovered treasure.

It is another big wine produced from a variety of grapes, but predominantly the Grenache, Syrah, Mourvèdre and Cinsault.

The very same varieties that are found in the more celebrated appellations near by.

The wine itself, not surprisingly, is similar in character, but with a special fruity softness. It is undoubtedly good value at just under £2.50 a bottle.

In this country, Beaumes-de-Venise is virtually exclusive to Sainsbury's and has proved to be one of the more popular of our 28 Appellation Contrôlée wines.

We hope you're tempted to try it.

A David it may be but its reputation is already assuming giant proportions.

Good wine costs less at Sainsbury's.

73 Supermarket Sainsbury's ad style from 1982 reveals the pervasive influence of Herb Lubalin and ITC.

of one man. In 1970 a shadow fell across typography which was to lie there for the whole decade, and much of the next, a shadow created by the letters ITC, letters so closely spaced that their serifs overlapped, and few chinks of light could make their way between them. ITC stood for the International Typeface Corporation. The founder members were Herb Lubalin, a New York advertising art director, designer and typographer, Aaron Burns, a sometime colleague of Lubalin's and a designer and lecturer on typography, and, completing the trio on the technical side, Ed Ronthaler, of the typesetting company Photo-Lettering.

Herb Lubalin (1918–81) was born in New York City, one of twin sons of a German mother and a Russian father. There was musical talent on both sides; his mother was a singer, his father a trumpet player in an orchestra. The onset of the 1930s depression made the Lubalins anxious that their children should seek financially secure professions – the law or medicine. But Herb was not academically gifted. Although his brother was accepted into the College of the City of New York, Herb was rejected on account of his extremely low grades. Showing some aptitude for art, he enrolled instead at a free art school and, after a shaky start, success in the calligraphy class gave him a much-needed boost in confidence. By

74 Turn the lights out when you leave: Herb Lubalin where he was happiest, at his drawing board.

the end of the course he was one of the best students, and began his professional career working for small studios and advertising agencies.

The Second World War pushed forward developments in drugs and medicine, and with the end of hostilities the pharmaceutical companies were now hungry to sell these products to a peacetime market. In 1945 Lubalin found himself in the right place at the right time, becoming art director for Sudler and Hennessey, an agency that specialized in advertising these very products.

It was here that he began to forge his reputation as a brilliant, workaholic design supremo, running his growing department as a creative autocrat, rarely leaving his desk, hardly speaking, turning out precise visuals on sheets of tracing paper for his subordinates to faithfully transform into camera-ready artwork for reproduction. The company grew and prospered, and Lubalin's name was added to those of Hennessey and Sudler. In 1964 he left to set up his own company, and occupied a godlike status in this and various partnerships until his death in 1981 from cancer.

Gertrude Snyder and Lubalin's former associate Alan Peckolick, while writing something of a hagiography in the introduction to their 1985 book *Herb Lubalin: Art Director, Graphic Designer and Typographer*, nevertheless

include some telling insights, in particular Lubalin's famed lack of verbal communication skills (unless addressing an appreciative audience from a podium). When illustrators or writers brought their work in, Lubalin would just nod or grunt and tell them to send in their invoice. As a colleague remembered:

> The artists were bewildered constantly. I'd say, 'Herb, why didn't you say something?' He'd say, 'Why can't people be satisfied with doing their work? Why do they always want to be patted on the head?' He felt if you knew what you were doing, and if you did it well, that should be enough. I told him most people needed more. But for himself, he had to have his pat on the head – the approval of his peers, and winning awards.

Another unnamed colleague who drove to work with him over a long period recalled that Lubalin would talk only about business, advertising or cars. Any attempt to shift the conversation on to more personal areas would meet with a dead end. Poignantly, one of his sons claimed that he exchanged only a few hundred words with his father in the whole of his life. The early-morning bedside meetings were just a symptom of his ethos.

By now the Lubalin design style was firmly in place. He knew exactly where everyone had been going wrong, typographically speaking, and with the new flexibility afforded by the arrival of photosetting, he was able to begin putting his ideas into action:

> My clients objected violently to the results, which they claimed were illegible. My response was that what they had been reading since Gutenberg invented it, was illegible, unreadable type.
>
> Five hundred years of no progress whatever in the technology of typesetting is what it amounted to; too much space between letters, too much space between words, too much space between lines; x-heights too small, ascenders and descenders too long. Five hundred years of people becoming so accustomed to this they did not recognise legible type when they saw it.[1]

With metal type, close line and letterspacing had always been constrained by the body of the type, the piece of metal that bore the reversed image on the character. But

1 Obituary by Allen Hurlburt, *Typos* 3, Summer 1981.

with photosetting this restriction was gone. The letters were now photographic negatives, whose images could be set very close together or even overlapped. The same could be done with the line spacing.

Lubalin followed this tight-setting aesthetic in his designs. He would cut and recut the headline letters, shortening ascenders and descenders to pack the words together in compact blocks, echoing the fluid density of the psychedelic and art-nouveau-inspired poster lettering of the late sixties. His critics said it was unreadable.

But text typefaces were still a problem if Lubalin was to fully realize his vision. You couldn't cut and repaste every letter there. A radical design overhaul would be needed, and here was where ITC came in.

The company began following a suggestion by Aaron Burns to Ed Ronthaler. Its basic premise was a good one; Burns believed that designers and potential designers of new typefaces were not being drawn to the discipline because of the poor or non-existent financial returns, owing to the age-old problem of faces being copied, subtly redrawn then renamed. ITC proposed and instituted a system whereby a royalty fee only – and that low enough to make it scarcely worthwhile to produce a thinly disguised pirate version – would be paid by the manufacturers of photosetting machines to ITC for use of their faces, a royalty that would then be split between ITC and the type designer. ITC would have the right to inspect the company's books to check that the face's usage was in line with what was being paid for it, but that was it.

The arrangement worked so successfully that a small company of little more than twenty employees was able to exert an enormous influence on the appearance of typography worldwide. And with Lubalin as vice-president and evangelist for his style, the world soon began to look the way he wanted it. By 1984, ITC had fifty subscribers – almost every major manufacturer of photosetting equipment in the world. ITC introduced new faces; Lubalin's Avant Garde Gothic, and Busorama, L&C Hairline and Machine, designed by Ernie Smith, Tom Carnase and Lubalin, with top type designers like Hermann Zapf, Ed Benguiat and Aldo Novarese also contributing originals. ITC faces were all messengers for the Lubalin view of the correct proportional rela-

defgh
ijklm

75 ITC Cheltenham: a typical reworking of a classic face – big x-height, shorter ascenders and descenders.

tionship between the x-height and the ascenders and descenders.

There was nothing intrinsically wrong with this; despite Lubalin's claim that the Western world had got it wrong until he came along, there was in fact a notable precedent in the private press types; Morris's Golden, Troy and Chaucer, Charles Ricketts's Vale and King's Fount, Lucien Pissarro's Brook and to a lesser degree the Doves Type all have generous x-heights. But ITC took things one step farther. Classic faces like Garamond, Century, Cheltenham and Caslon were revamped and reissued under the ITC banner, all remodelled to conform to the Lubalin aesthetic. ITC faces always looked highly professional, but apart from a few exceptions, like Matthew Carter's Galliard, had all character and personality squeezed out of them; a triumph of slick, empty ad-think.

Sometimes these revivals were taken to extremes. It could be claimed that ITC Garamond Ultra Condensed Italic extended the characteristics and use of Garamond, but the end result bore absolutely no relation to what you would expect Garamond to be, or the typographical job you would wish it to perform.

As with Lubalin's own design work, undeniably highly inventive,[2] there was nevertheless a relentlessness and visual monotony about the whole ITC look, a look that was promoted worldwide by the Lubalin-designed company magazine *U&lc* (Upper and lower case). His output was all very similar in feel; it *looked* like the work of someone extremely intelligent and intensely gifted who never left their desk, who rarely stopped for a breather, stepped back and considered the value and benefits of a change in tone and approach. The magazine was thick, large format, printed on what was basically newspaper stock, usually in just one colour. It was sent out free to subscribers and by 1983 claimed a worldwide readership of 700,000. It carried features about design, illustration and type, and of course promotions for the latest ITC faces. To the twenty-first-century eye, the density of its text setting is positively headache-inducing, the pedagogic editorial tone sitting strangely with the slightly childish look of the typefaces, with their constant fat x-heights and stubby ascenders. So pervasive was ITC's influence, though, that the British trade magazine *Litho*

2 His best-known piece of work was an award-winning logo for *Mother and Child* magazine, which is now in the Museum of Modern Art in New York. The '& Child' was placed inside the O of 'Mother', with the ampersand taking on the suggestion of an embryo inside the womb, represented by the O. It was a very ingenious, beautifully simple yet expressive piece of typography. Ironically, the magazine was never published.

Week spoke in 1985 of 'the closeness of fit, consciously executed to "reduce unnecessary and disturbing gaps between characters" which bestows compactness and economy in setting. Without doubt, the modern idiom and penchant for letters of liberal proportions, tightly packed horizontally to the extent of touching in some character combinations, is attributable more to ITC than any other influence.'[3]

A couple of years later, Neville Brody (see Chapter 18) was brutally outspoken: 'I dislike the ITC cut of typefaces, which has been one response to the problem of printability. Really, I don't know what they think they're doing – in a way, it's an attempt to create an American typographic tradition out of European type.'[4]

ITC was bought by Esselte Letraset in 1986, a logical move: Letraset had also implemented a royalty system for its original designs, and its product had from its inception been a means of tighter letterspacing.

Ryder Types at least were gifted with self-awareness. They concluded their advertisement by saying: 'Tuck this ad away. Then look at it twenty years from now. It'll probably look terrible.' It doesn't look terrible, but it looks a period piece. Once again the wheel of typographical style would turn, and Lubalin and his minus line spacing would be swept into the filing cabinet of history, where it awaits revival and refurbishment by some future typographer.

Although the 1980s were to be viewed by many as a spiritual downturn after the 1970s, for type it was to be the dawn of a new age; saviours were just around the corner.

3 'The ITC effect on modern designs', *Litho Week*, 20 February 1985.

4 Jan Wozencroft, *The Graphic Language of Neville Brody*, Vol. I, London, 1988.

17 | The twenty-six soldiers: fiddling with the format

There are now about as many different varieties of letters as there are different kinds of fools ... And as there are a thousand sorts of fancy lettering so there are many too many different sorts of type for reading in books ... Lettering has had its day. Spelling, and philology, and all such pedantries have no place in our world. The only way to reform modern lettering is to abolish it. (Eric Gill, *But Why Lettering?*, 1931)

'With twenty-five soldiers of lead I have conquered the world,' an unknown seventeenth-century printer memorably boasted, but his remark underlines the fact that the alphabet we use today was not always a fixed entity – the letter w was not a recruit in his army.

The above extract is a typically strongly worded polemic from Eric Gill. His solution was simple; as English spelling was so problematic and nonsensical, ditch the whole system, along with the twenty-six soldiers. Replace them with shorthand notation, either Pitman's or some other method. All that was then needed was an enterprising type founder to commission Gill to turn the symbols into beautiful forms.

This didn't happen. Gill never entered the fray with a radical alternative to the existing alphabet and, a conservative where letters were concerned, never challenged the accepted structures. But sometimes others have, either to deal with the technical limitations of a new technology, or on a deeper level, questioning their very use and their impact.

In 1984, the same year as the launch of the Apple Macintosh personal computer (see Chapter 19) and in the same state, California, two graphic designers would produce the first issue of an experimental magazine that has been described as a typography fanzine.

Rudy Vanderlans came from Holland; frustrated with what he saw as the limitations on the work he could do there, he decided to try his luck in America, in a quest for greater creative freedom. He found it, once he'd

teamed up with Zuzana Licko (pronounced *Litchko*; born 1961), who had come to the United States in 1968 from Czechoslovakia. Together they founded the magazine *Émigré*, the title a comment on Vanderlans's and Licko's own outsider status. The magazine featured interviews and comment from contemporary type designers, and took radical stances towards previously uncontested views on sacred cows of design. Violently challenging many conventional notions of layout and legibility, the content of the magazine was frequently fascinating enough to be able to ride roughshod over these technical considerations. It would also meet the challenges and possibilities of the new technology head on.

Although immediately drawn to the possibilities of the Apple Macintosh as a design tool, Licko rejected many of the early Apple computer faces, seeing them merely as crude imitations of classic faces. At that time the resolution of the available desktop printers was very coarse. Indeed, the only printer originally available for the Mac was a dot matrix printer, which built the characters from a simple grid of dots. The resulting image, although having a graphic style of its own, wasn't accurate enough to effectively reproduce a face like Baskerville Italic.

Licko started by designing fonts that looked as they were supposed to even after they had been through the mill of this early technology; she created bit-mapped characters, where the curves and diagonal straight lines were replaced by right-angled steps. Later, although the printers had improved, computer memory space was very expensive, so she designed a font where the serifs were all 45° diagonals, and all other points required to define the characters were kept to a minimum.

As the technology improved, Licko had the opportunity to design more sophisticated fonts and *Émigré* went on to launch its own digital type foundry; all the fonts used in the magazine were made commercially available. The magazine is still published, although in its present full-colour incarnation it is more sedate in appearance than during its heyday of the early nineties.

In 1966 the Dutch designer Wim Crouwel (born 1928) visited DRUPA, the annual print and paper exhibition in Düsseldorf. There he saw the Digiset, the German company Hell's new electronic typesetting device. 'The quality

76 Oakland, a 1985 design by Zuzana Licko in response to the shortcomings of printer technology. It is a style that has seen recent revival, as cheque-book and ATM interface fonts, seemingly the product of machines rather than humans, have enjoyed a certain vogue.

of type that was produced by this machine was horrible. The digital translation made each font, in my opinion, unacceptable,' recalled Professor Crouwel. Hell were later to recruit another Dutch designer, Gerard Unger, to improve the machine's output, but meanwhile Crouwel was intrigued enough by the new technology to consider the problem from a different direction – to design a typeface that would look good on the Digiset.

As curved lines fared worst under the Digiset, Crouwel decided to make a straight-edged set of letters. It was only ever a spare-time project, but a year later he had completed the New Alphabet with the assistance of his father, who drew the final artwork for the letters. The result was probably the most radical lettering yet devised. Most striking were the m and the w, which were the forms of the n and the v underlined. It was an unprecedented yet entirely logical restyling of the very letter forms themselves.

Although Wim Crouwel intended the alphabet only as a theory for discussion, he was asked by the Italian design magazine *Linea Grafica* to use it on a cover design. It was also used for a conference on computing, and received widespread publicity: 'In professional circles it was discussed. Traditional designers hated it, but young people liked the idea.' But beyond this the New Alphabet was never used by its maker for any commercial work.

In the mid-1980s the New Alphabet reappeared in the type specimen book of the Graphic Unit, a photosetting company based in Clerkenwell, London. The face was offered in three weights, called Crouwel Light, Medium and Bold. It was out of tune with the style of the times, and no royalties were ever forthcoming. But the New

77 Wim Crouwel's New Alphabet. Is it readable?

Alphabet lives on, remaining an intriguing and stimulating proposal for new generations of designers, its forms echoed in many contemporary sans serif designs.

As Professor Crouwel concludes:

> A few years ago the New Alphabet appeared in pop and culture magazines, sometimes badly drawn, but mostly made more readable. It was also published on an American website. The Foundry in London asked if I was interested in a reissue of some of my experimental type designs from the sixties. They have digitized them very carefully, with my assistance. And to my astonishment, they are selling in nice quantities.

One day in 1949 the American designer and art director Bradbury Thompson (1911–95) was helping his young son with a primary reading book. He noticed that the child, although he read one sentence, 'Run, pal', with ease, got stuck on the next sentence, 'See him run'. The repetition of the word 'run', instead of making things easier, confused him. He didn't recognize it as the same word, Thompson realized, because in the first instance it had a capital R, and in the second a small one.

Thompson began to wonder why, with a twenty-six-letter alphabet, we use forty-five different symbols to represent them. For any graphic symbol to work effectively, he reasoned, it should be consistent. Yet only seven letters remained unchanged in design for both upper and lower case. Surely it would make more sense to combine the two styles into one set, which would be used in two sizes to represent what had been capital and lower case usage. Graphically a tidy solution, it would also help children to learn to read more easily.

Thompson called his new configuration Alphabet 26, originally offered in Baskerville as a tribute to an earlier pioneer. Most of the lower case letter forms were dropped, the survivors being a, e, m and n. But intriguing and logical though Alphabet 26 is, the fact that it is essentially an upper case alphabet, with no ascenders, no x-height and only the tail of the Q hanging below the baseline, does raise questions about its ease on the reader's eye over long stretches of text. In the final years of Thompson's life, the type designer Paul Baker began working with him to produce a new version of Alphabet 26, a project cut short by his death in 1995.

"œ dɛɛr! iє'm sœ huŋgry," gretel sed, and brœk off a pɛɛs ov ɪhe barly ʃhωgar windœ.

In 1961 a strange and, to the contemporary mind, arguably insane experiment was carried out in selected primary schools. It was a radical attempt to address the perennial problem that the English-speaking world faces when learning to read; the non-phonetic spelling system.

With few hard and fast rules, English spelling can at times defy analysis. George Bernard Shaw once pointed out that the word 'fish' might just as feasibly be spelt 'ghoti'; 'gh' pronounced as 'f', as in 'enough', 'o' pronounced as 'i' as in 'women', and 'ti' pronounced as 'sh' as in 'nation'. In comparison with German or Italian children, whose languages follow a strict phonetic spelling system, English-speaking children can experience great difficulties mastering reading and writing. The experiment to overcome this was ita, the Initial Teaching Alphabet.[1] And with the system came a startling new phonetical alphabet, comprising not twenty-six letters but forty-four letters, ligatures and symbols.

Ita is regarded as a typical, 'anything goes' 1960s experiment, indicative of that decade's, and the incumbent Labour government's, perceived poor track record in education. But the decision to implement it actually saw the light of day in the 1950s, and it was put into practice during the final years of the Conservative administration.

In 1953 a Private Member's Spelling Reform Bill was narrowly carried in the House of Commons. Without government support it got no farther, but the bill's minor success prompted the Secretary of State for Education to agree to an investigation into whether traditional spelling slowed children's progress compared to a simplified spelling system.

The ita system, first called Augmented Roman, had been designed by Sir James Pitman, famous for his shorthand speed-writing system for secretaries. He had based it on his grandfather Sir Isaac Pitman's Fonotypy, tried out in the United States in the 1850s with some encouraging results.

1 'ita' was always rendered in lower case to distinguish it from the Independent Television Authority.

The philosophy behind ita was to get children started. If you could help even the slow learners, the ones who might get stuck on Book 1 with traditional spelling, to progress more rapidly with ita, then confidence would grow, and with confidence all learning would become easier. There would be fewer vicious circles of failure, branding some children as non-achievers from an early age, usually a self-fulfilling prophecy.

When the time came to change over to traditional spelling, initial difficulties would soon be overcome, as the children would be armed with a greater sense of their own abilities, a facility for recognizing symbols on a page and confidence in turning them into sounds.

Ita's ease lay in the fact that there were only forty-four symbols to learn as opposed to over 400 letter/sound relationships in the English language.

The British experiment was begun in 1961, and rolled out more extensively by the middle of the decade. Early progress analysis suggested that it was working. Children using ita moved more quickly through their version of the *Janet and John* series of first reading books, on average being on Book 5 while their traditionally taught counterparts were still on Book 2.

A 1967 survey recorded mostly positive reactions from forty participating schools and concluded: 'whether in Infant or Junior Schools, therefore, there is much to be said for the introduction of ita. It is not a wonder-drug … but when properly used it is a very promising and serviceable tool for education.'[2]

So what went wrong? Posing the question to teachers of an age to have encountered ita, the response was one of uniform dismay: 'It was the changeover. That was the problem. The children took to it really easily, but the switch to traditional spelling caused massive problems for a lot of pupils, as you could easily have predicted,' said one. 'My brother blames it for having ruined his reading and spelling for life. He admits he would have had difficulties in any case, but after ita he really had no chance at all,' said another. 'Of course, it came along in that period in the late fifties and early sixties when people were starting to look at a lot of things and say why do it the way we've always done it? Is there a better way? The problem with ita was that it broke a cardinal rule: never teach children anything they have to *unlearn* later on.'

æ	a as in angel
ɶ	e as in even
ie	i as in pie
œ	o as in only
ue	u as in useful,
ʒ	z as in houses
wh	w as in which, not went★
ch	ch as in chicken
th	th as in thin
th	th as in this
ʃh	sh as in shin
ʒ	z as in television
ŋ	ng as in along
ɼ	r as in urgent, not rat
ɑ	a as in father, not hat
au	aw as in awful
ω	oo as in put
ω	oo as in tattoo
ou	ow as in allow
oi	oi as in annoy

★ now an outmoded distinction

78 ita's new characters and what they meant …

2 John Skeats, *ita and the Teaching of Literacy*, London, 1967.

hansel and gretel wer fast asleep. but when ʃhæ herd ʃhe ʃhoutiŋ, ʃhæ crept ontω ʃhe stærs and lisend.

79 A traditional tale radically retold; 'Hansel and Gretel' as a 1964 ita publication.

A 2001 article in the *Daily Telegraph* took the view that the decision to undertake the experiment was incomprehensible, and worse, had been foisted on children with no parental consultation.[3] But in the 1960s virtually nothing in the educational system was undertaken in consultation with parents, so it hardly constituted part of a sinister plot. There are instances of ita surviving in some schools into the 1970s, perpetuated by those teachers who believed it fostered a more favourable attitude to learning, and who managed to engineer the changeover with minimal damage. Indeed, not everyone found it a problem. As one of the first wave of guinea pigs at an Essex primary school in 1964 recalled: 'I can remember finding reading very easy and was aware that my older sister and I were learning by different methods. I learnt quickly and cannot remember the transition to normal reading, so it must have been smooth. I may be blowing my own trumpet here, but my spelling was always brilliant, even if nothing else was! I still am a big reader.'[4]

Those who would have learned easily under either system weren't hindered and may even have been helped

3 Rachel Johnson, 'A cleer case of educashunal lunacie', *Daily Telegraph*, June 2001.

4. E-mail to the author, 2002.

by ita, but some of the strugglers were permanently handicapped by it. Ita died unlamented, and although there is still a website devoted to it, linked to the Simplified Spelling Society, it is now discredited and forgotten in wider educational circles.

18 | New gods: Neville Brody and the designer decade

The claim that the 1980s made for itself, of being the 'style' or 'designer' decade, may look extravagant now in the light of what was to follow. After a perfunctory, recession-induced stab at being the 'Caring Nineties', the next decade threw itself back into consumer hedonism with a vigour which, although far less ostentatious, dwarfed the material aspirations of its predecessor. Now that the 1980s have slipped far enough into history, some of the music has been repackaged and re-released, a reference point for a new generation of musicians, or used as an advertising lure. At the time of writing, even eighties fashions are responding to the twenty-year nostalgia cycle, returning with a new spin for the contemporary market.

But in the 1990s, the idea of eighties style was a joke – the shoulder pads, the terrible 'mullet' hairstyles and proliferation of 'big hair', the mobile phones the size of a house brick. But it is certainly a claim that bears examination in terms of graphic design.

For a student on an art foundation course in the late 1970s, graphics was regarded as a rather pedestrian choice among the disciplines on offer; fashion and fine art appeared more glamorous options, and the dry, restrained personalities who ran my degree course did little to alter this impression. But things were beginning to change, slowly gathering momentum until the trickle became a torrent; by the end of the decade graphic design would be 'sexy' in a way that would have been unbelievable ten years before, and was teetering on the point of an inevitable backlash, in which the tag 'designer' would become a derogatory one.

The graphics that most engaged my student attention were those on the covers of the music I bought. The vinyl disc still ruled, so consequently the packaging was larger, the visuals more striking. Jamie Reid's sleeve for the Sex Pistols' *God Save the Queen* was one of the earliest and most remarkable designs in a mushrooming design format, the seven-inch single picture sleeve. Its 'blackmail' lettering, characters taken from a variety of

faces and sources to produce the effect of an anonymous ransom note message, and the image of Queen Elizabeth II with eyes and mouth torn out, would still be shocking today if we were seeing them for the first time. (And if it were allowed. Buckingham Palace would surely exercise greater restrictions on the use of the monarch's image in today's more media-aware environment.) In 1978 the designer Malcolm Garrett began producing a highly attractive series of single and album sleeves for the Manchester-based band the Buzzcocks, creating a logo and applying it to a striking backdrop of simple but effective designs; it was a 'corporate identity' treatment he was to carry out for other bands during the following decade.

My design college had recommended ITC's *U&lc* as an educational must, and a whole group of students, myself included, had photocopied a free subscription form and mailed it to America. I was one of the few who actually received some copies back, but I stared in gloomy bewilderment at the Lubalin-driven typography and layouts. There was little or nothing in the design of the magazine that I could identify with, or would have wished to emulate. But in 1980 Peter Saville began designing classically elegant record covers, most notably for Manchester's Factory Records, with restrained serif typography, and fearless use of white space. It may have looked a simple trick, but these covers opened my eyes to the beauty and potential of typography in a way that three years on a design course had not.

It is always dangerous to say of any decade that it has one particular characteristic; human life is too diverse and the flow of events too messy to make such black-and-white statements tenable. But in comparison with the two previous decades, the 1980s were an era of conservatism. Many of Western society's ills were considered to have stemmed from the misguided liberalism and social experiments of the 1960s, and the governments of both Britain and America constantly invoked the supposedly more solid, self-reliant values of an earlier time. The cadaverous British Home Secretary Norman Tebbit garnered either profound approval or shouts of derision with his recollection of his unemployed father, who, in the 1930s, rather than rely on state handouts, had climbed 'on his bike' to look for work. In the United

States Ronald Reagan, the most popular President since Dwight Eisenhower, held office from 1981 to 1989. His very existence, as a former Hollywood star from the 1940s, evoked a previous age, and his major contribution to US foreign policy was to revive the dormant 1950s cold war confrontation with the Soviet Union.

In Britain, the Prime Minister, Margaret Thatcher, was the twentieth century's longest serving, and held the reins from 1979 to 1990. In reality her government was the most radical the United Kingdom had seen for decades, laying waste large sections of underperforming British industry while driving up unemployment to previously unthinkable levels. At the same time she succeeded in moving the mental goalposts of the British electorate with a direct appeal to self-interest at the expense of wider social responsibility, a legacy that any subsequent government still has to wrestle with. Mrs Thatcher famously stated, 'There is no such thing as society,' and sang the praises of 'Victorian values'. She was also given the opportunity to strike a Churchillian stance as a war leader as Britain embarked on its last imperial venture, to recapture the Falkland Islands from an Argentinian invasion.

In design terms it was the start of a period of ironic or affectionate retrospection, and unashamed lifting of previously created elements and illustrations from the fifties and sixties, now popular culture's perceived golden age. Peter Saville dug farther back and began producing designs closely modelled on pre-war Italian Futurist graphics. The writer and social commentator Jon Savage pointed out this growing trend in record cover design, tracing the source of much of Saville's typography to Jan Tschichold; not 'Neue Typographie'-era Tschichold, but his later work.[1] Interestingly, the example reproduced with Savage's feature, with considered, centred serif type, was a cover for a Valium brochure for the pharmaceutical company F. Hoffman-La Roche. Tschichold had worked for them on his return to Switzerland from England in the 1950s, when, according to Hans Schmoller, Tschichold 'squandered [his experience] on brochures and leaflets for tranquillisers and other ephemera for a doctor's wastepaper basket'.[2] For Peter Saville it was a case of unconsidered trifles.

Despite whatever artistic pilfering was going on, the

1 'The Age of Plunder', *The Face*, January 1983.
2 Hans Schmoller, *Two Titans: Mardersteig and Tschichold, a Study in Contrasts*, New York, 1990.

1980s had its own contribution to make. At the begin-
ning of the decade a small nightclub and music scene
had sprung up, strongest in London and, oddly, in the
recession-hit northern industrial town of Sheffield. Those
of its members who had read a little art history called
themselves Futurists; others suggested 'The Cult with
No Name'. But the press weren't going to let them get
off that lightly; the tag New Romantics was coined,
and stuck. Much of the music the New Romantics
produced was poor, a lame fusion of 1970s glam rock
and German electronics, saddled with pretentiousness
and a fatal lack of humour. But there was an emphasis
on clothes and dressing up – again, much of it derisory
– which nevertheless made a contrast with what had
gone immediately before, the charity-shop anti-style of
the punk/new wave years. How you looked mattered
as much if not more than the music you listened to,
a change in emphasis that spawned new magazines to
document and cater for it – *Viz* (a fashion magazine,
not the comic spoof of the late eighties), *Blitz*, *ID*, *New
Sounds New Styles*, and *The Face*.

The Face had begun life in 1980, subtitled 'Rock's Final
Frontier', an independent venture by ex-*New Musical
Express* journalist Nick Logan. At first, beyond the logo,
the design of the magazine was unremarkable. It looked
stylish compared to the newsprint music papers because
it had staples to hold it together, some colour printing,
better paper and a strong cover image. But visually that
was as far as it went. The first issue carried a small feature
on ex-Sex Pistol Glen Matlock's latest band, written by
Neville Brody. In 1981 his name started appearing on the
staff list, but as a member of the design team. Under his
influence and direction the typography gradually became
more considered, more playful and adventurous, until
by the middle of the decade Brody was designing his
own typefaces for use in the magazine. With an edit-
orial content that was now weighted towards fashion as
much as music, and with photography as striking as the
typography, *The Face* began to be tagged a 'style bible'.
And Neville Brody was the person who set that style.

By luck or good judgement, Brody (born 1957) found
himself in a designer's playground, the perfect medium
for the expression of his graphic ideas. Although *The
Face* was never visually inaccessible, Brody was allowed

80 Ghosts of princes in tower blocks: student days for Neville Brody (left), photographed in the subways outside the London College of Printing with course mate Julian Balme.

to have fun with his lettering in a way that would not have been tolerated on other publications. Words would start at the outer edge of one page and continue on to the next, necessitating a turn of page to read the entirety. In a sequence running over several issues, the letters of the contents page heading metamorphosed until they became purely abstract forms.

This flouting of the accepted rules on magazine typography was possible because *The Face*'s readership was perceived to be at the leading edge of those interested in music, fashion and design. The editor was unlikely to complain: 'But the readers won't understand that.' The subliminal message to the readers was, 'If you don't understand, then you're just not hip enough.' And who wants to admit that?

Neville Brody became the first, and so far only, typographical star in Britain – gauged not just by the quality of his work, but by the fact that his name was known to

81 Where type is king: Neville Brody layouts for *The Face*, 1984 and 1985, striking and profoundly influential in their dominant, custom-designed headlines, and playful, inventive section headings.

people outside the design disciplines. When the first book on his work was published in 1988, it merited prominent display in bookshop windows – this for a book about graphics and type design. Eric Gill may have experienced fame, but his public profile came from his sculpture, not his typefaces. Brody's came because he was inextricably linked with a magazine that had a high media profile, and which looked very different to other 'youth culture' publications. A newsprint music paper such as the *New Musical Express*, highly popular in the late 1970s and early 1980s, looked by comparison as though it were designed and laid out by the printers.

Brody's work was studied and imitated – he was to have a massive impact on the way people looked at typography, and design in general, and arguably kick-started the 'designer decade' almost single handed. It didn't hurt that he was highly quotable, with strong opinions

about typefaces and design, frequently uncomplimentary: 'I hated type … I thought typography was a boring field to work in, overladen with tradition that would repel change … The traditions of typography are not fun: communication should be entertaining.'[3]

This was the typical self-deprecatory talk of the era. In today's culture, the plan is to have established a life goal while still in primary school and then single-mindedly gone all out to realize it. But it was customary in the 1970s and 1980s for a successful person to nonchalantly claim that they had arrived in their field only by accident, and that really they had wanted to do something else entirely. It didn't do to look as though you were trying too hard. But in a period of extreme polarity of political opinion in Britain, where the right wing now held an overwhelming ascendancy with near-blanket support from the national press, where the dictates of the marketplace were deemed the only ones worth considering, Brody also had things to say about the responsibility and the effect of graphics and advertising that made arresting copy:

> The Midland Bank in Oxford Street is the new church of the new design for the new religion. It's the perfect mix of signified design with money: 'We share your language'. But Midland Bank is going to have to redesign within the next four or five years.[4]
>
> I think the way major design groups tackle the 'problem' is by coming up with something that signifies 'this is a big job'. Contemporary design is no more than a cover-up job.[5]

Brody's sympathies were decidedly left leaning; he carried out redesigns for *New Socialist* magazine, Red Wedge, an ill-fated musicians-for-socialism initiative, and *City Limits*, a London culture and entertainment listings magazine which had broken away from the market leader *Time Out* after the latter's abandonment of its 1968 equal-pay-for-all structure. In a period when the left in British politics looked a complete lame duck, swept aside by Margaret Thatcher's strident single-mindedness and her appeal to the most selfish instincts of the British electorate, Brody was at least trying to give alternative political messages some visual credibility.

Although Brody's opinions were liberally offered, he came across as a somewhat humourless individual, given

3 Neville Brody, *The Graphic Language of Neville Brody*, Vol. 1, London, 1988.

4 This particular branch was a style flagship for new-look banking; no classical pillars or reassuringly solid architecture. It was very postmodern, with graphics, bright colours and marbled effects. The Midland itself was redesigned in the 1990s, absorbed by the Hong Kong and Shanghai Banking Corporation.

5 Interview, *Blueprint*, April 1988.

to making gnomic pronouncements on the nature of content, style and communication that laid him open to accusations of pretentiousness. In Britain this sort of stuff has to be leavened with a dash of levity if the message is to be effectively delivered. I wondered what he had been like in his formative design years, and whether his potential was obvious when he was at college. He had studied design at the London College of Printing, a dour tower block in the Elephant and Castle, an area of south London high on traffic and underground walkways, and extremely low on visual charm. Fellow student Julian Balme, himself subsequently a successful graphic designer and journalist, recalled: 'It was 1976, the end of that hot summer. Neville had arrived with a friend from his foundation course at Hornsey, and they lived for a while in one of the prefabs[6] behind the LCP. But after the first term the other guy dropped out, and then Neville and I gradually became something of a double act. He had long hair at first, *really* long. When he had it cut, no one recognized at first who it was!'

Personality-wise they were opposites; Julian outgoing, entertaining, Brody always the quiet one. Their arrival at the LCP had coincided with the explosion of punk rock on to the London music scene, and Brody and Julian began collaborating on self-written and designed fanzines: 'I just saw it as an excuse to approach record companies and get free records! For me the music was the important thing, but for Neville it was always the graphics.'

Brody subsequently made much in print about his disaffection with the LCP course. This is fairly standard student stuff, but was the course really so bad?

It was real Swiss corporate typography – it would actually be very popular today, but back then we were saying, 'I don't want this! I want blackmail lettering!' I used to enjoy confrontation, arguing with the tutors, but Neville would just withdraw – if they didn't like what he was doing, they just didn't understand, that kind of attitude. But for all that stuff about him not being understood at the college, we made damn sure that Neville got to do the poster for the final degree show. His work was really good, though, all the way through. And he knew his art and design history too, which the rest of us had little time for.

6 'Prefab' was short for prefabricated housing – temporary, one-storey structures built after the war as an immediate solution to the shortage of housing caused by bombing. They were supposed to last only five years, but some were still in existence fifty years later.

223

Through the fanzine, Julian and Brody had met Barney Bubbles, the designer of the record covers for the independent label Stiff, and later Radar Records. Both were to work for Stiff after leaving college in 1979:

> For a while Neville lived in a squat in Long Acre in Covent Garden. It's hard to believe now, but before they redeveloped it, Covent Garden was little better than the slum it had been in the nineteenth century. In the evenings, when everyone else just wanted to go out and have a good time, Neville would be drawing, painting, designing. It was simply what he liked doing best. When people employed Neville, they knew they'd got their money's worth. He would have done three, four, five possibilities for a design. He was constantly reappraising his work, trying to see how he could improve it. He wasn't the kind of person you'd go out and get rolling drunk with, although he did have a nice, self-deprecatory sense of humour.

Julian was soon to pick up well-paid major label record company work, but Brody was designing for small labels and then on the fledgling *Face*:

> He could hardly have been making any money at all. But where Neville was canny is that he always picked people to work for who didn't have the budget to argue with him. He had great talent, and they needed him. We saw the first issue of *The Face* and said, 'What's he working on this for? It'll last three issues, and Logan can't be paying him anything!' It struck me, on looking at his first book [*The Graphic Language of Neville Brody*, vol. 1], that he'd done extremely well on basically small-budget work. *The Face* later became highly successful, but it started as a shoestring operation, and remained so for quite a while.

The early Brody lettering was angular, heavy san serif; he was to claim that this was a 1930s influence that was itself a comment on and a response to the political climate of the 1980s. Equally, though, for someone who professed himself unable to draw a face such as Baskerville, and when the only tools he would have had to create his letters would have been a pen and brush, this geometric style, while being extremely effective for bold magazine spreads, would also have been much easier to execute.

As Julian Balme recollected, Brody was always aware of what had gone before, and Joost Schmidt's masthead lettering for the Bauhaus journal, designed in 1929, could easily be a Brody design. But Brody was never a plagiarist. It is perfectly acceptable to be influenced by someone else's work – the trick is to take what you like from it and make it your own. When Brody and Julian once visited Barney Bubbles's studio, Bubbles said, 'Wait a minute!' and scurried around concealing things. When asked what he was doing, he replied, 'No one gets to see *my* library books!'

Often a Brody face would start life simply as the letters required for a magazine headline, and be later developed into a full set, starkly titled Alphabet no. 1, Alphabet no. 2 and so on. As his typographic skills developed further, he created one of his most attractive faces, Arcadia, the condensed modern-style serif lettering he designed for *Arena* magazine – a truly beautiful, striking and timeless piece of work.

In 1988, at the tender age of thirty-one, Brody was honoured by a retrospective exhibition at London's V&A Museum, and the publication of a book, *The Graphic Language of Neville Brody*, later to be followed by a second volume. Yet as the decade neared its end, it seemed that disillusionment had set in. Nick Logan's new launch, *Arena*, was the first men's magazine (of the non-pornographic variety) in Britain for two decades, an area of publishing long considered commercial suicide. With the economy now on the upturn following the recession at the start of the decade, consumer spending was on the increase. With its pages of clothes, accessories and 'designer' objects, *Arena* prospered, but Brody abandoned much of his previous typographical style:

> [The advertising agencies] wanted the so-called 'youth culture' look, and advertising appeared very old-fashioned … the only way they could match it was by trying to be ahead of, or lift ideas from, the editorial. Advertising always kidnaps modes of language to use as its own … The wider public probably saw no difference. With the struggle to look ever more modern, an air of desperation set in. So when it came to *Arena*, I said, 'Stop, sit down, see what's happened'. In fact I went back to ranged-left Helvetica, the norm when I was at college.[7]

82 Arcadia, Brody's striking lettering for the first issue of *Arena*, 1986.

7 *Blueprint*, op. cit.

THE LEADING MAGAZINE OF ARCHITECTURE AND DESIGN/APRIL 1988/NUMBER 46/£2

BLUEPRINT

ESPRIT IN LONDON/THE CUCKOO CLOCK AS ARCHITECTURE

SPECIAL ISSUE
BRITISH GRAPHICS
THE VISUAL LANGUAGE
OF NEVILLE BRODY
THE GUARDIAN
FROM COMMERCIAL ART
TO PLAIN COMMERCIAL

PHOTOGRAPH OF NEVILLE BRODY BY NICK KNIGHT

83 High-water mark: Brody featured on the cover of *Blueprint* magazine in 1988, the year of the V&A exhibition and his first book.

The materialism of *Arena*, a 'lifestyle' magazine, sat ever more uncomfortably with Brody's principles. In 1986 he left, but illogically only to join *The Tatler*, a 'toffs and titled folk having fun' magazine which gained a new lease of life in the 1980s amid the growing atmosphere of conspicuous consumption. It was a pointless appointment. Brody, frustrated at not being allowed to design things the way he wanted, quit in the middle of his second issue. His only front cover was memorable for having (apart from the magazine title, the price and a facetious dateline) no type on it at all. Again, called in by Condé Nast in America to redesign *Mademoiselle*, Brody fell out with the worldwide editorial director. For whatever reasons – money, the seduction of his own celebrity or an attempt to subvert the Establishment from within – it was clear that Brody's relations with the mainstream would always be problematic. Yet he had liberated typography from the

moneyed hand of the 'Madison Mafia', the soulless grip of ITC, and proved it was possible for anyone, given the necessary ability, to create their own typefaces, providing the inspiration through his work.

The V&A exhibition and Brody's high media profile proved a double-edged sword. His own work became over-exposed, and many potential clients, rather than commissioning him, would seek the cheaper route of Brody pastiches – *hommages* would be too complimentary a term. Every design group and advertising agency in possession of his book now had the opportunity to study the Brody approach in close detail, and turn out their own 'knock-off' versions.

The immediate aftermath of the exhibition saw a dearth of new commissions for the Brody studio. Fortunately, the show had travelled abroad, where new clients were eventually to be found. Since then, the majority of Neville Brody's work has been for non-British clients, from America, Japan, Holland and Germany. Internationally, he remains a successful designer, but he seems largely forgotten in his homeland. A temporary critical backlash after his period of intense popularity and ubiquity was to be expected; a Brody design had such a strong persona it was always apparent who had designed it, and people will always eventually tire of a style and want something different. But his career trajectory does seem symptomatic of the British inability to take a living practitioner of the visual arts seriously for their work alone. If, like Damien Hirst or Tracey Emin, they can provide good copy, then fine as long as that lasts. But there seems little desire for any widespread and lasting intelligent analysis of their work and its implications. Britain loves its 'national treasures', but it is doubtful whether an artist or designer would ever reach this status in the public affections. Neville Brody's work has developed and evolved, but his subsequent neglect in Britain is not as mystifying as it may first appear.

84 Industria, a commercially available Brody font.

19 | Revolution again: liberating the letter

William Morris has predicted that type will cease to exist during the next century, and he may be right in his forecast. I see it threatened by the camera, the etching fluid, and by the (at present) harmless and inoffensive 'typewriter', in the keyboard of which lies the germ of something much greater in the future. ('Concerning fashion and taste', R. Coupland Harding, *The Inland Printer*, August 1895)

… people were going to learn more about fonts and typography using the Macintosh than they had since Gutenberg first got his hands inky. (Steven Levy, *Insanely Great, the life and times of Macintosh, the computer that changed everything*, 1994)

Sorting through a stack of old magazines which I'd kept for reasons now only vaguely apparent, I found a Sunday newspaper supplement of November 1982, which contained a page-sized ad for the Apple II and III personal computers. The Apple II cost around £2,500, and the ad claimed: 'Over 400,000 businessmen throughout the world have found how an Apple can put the enjoyment back into their work … you can handle amazing feats of calculation, like financial projections, as well as storing, organising and retrieving information the way you need it.'

Although Apple is a company whose products have in the intervening years come to be closely associated with the design professions, there is significantly no mention of them here. Closer inspection of the machines featured in the ad would tell you why. The screens had a black background with either yellow or green words on them, and there was no mouse.

The year 1984 came loaded with cultural significance. Since 1949, *Nineteen Eighty-four* had been the title of a novel by George Orwell. The book visualized a nightmarish future society in which everyone was under constant surveillance by a supposedly benign presence called Big Brother, in reality an ultra-repressive government intent on stamping out any free thought or action.

At the start of the year an advertising campaign ran on television in which a Big Brother-like face on a giant screen intoned monotonously to a downtrodden grey-clad audience. Suddenly a woman rushed in from outside, brandishing a sledgehammer which she hurled at the screen. It shattered, and the spell over the audience was broken. This was an ad for Apple, announcing the birth of the Macintosh, with the final shout line 'And you'll see why 1984 won't be like *1984*'.

Apple the company had been around since 1976, and the Apple II, the machine featured in the magazine, was still a very successful product for the company. But in 1979, as part of a deal in which Xerox, the photocopier giant, would get to buy shares in Apple, a small delegation from the latter company were allowed to visit Xerox's Palo Alto Research Center (PARC) in California. There they saw a personal computer called the Alto, which Xerox had developed earlier in the decade. It had never been marketed, possibly because it would have been too expensive, and wouldn't have succeeded without a crucial software application that offered something that other computers couldn't.

The Alto had bit-mapped graphics – far superior in quality and possibilities to what could currently be seen on a computer screen – windows and a mouse. This was WYSIWYG, 'What you see is what you get'. The printed image on paper was how your document looked on screen, and trial users found the mouse extremely easy to use – no typing in codes, just point and click. A small number of Altos were given to the White House, and were enthusiastically received. Clearly this was the user-friendly future of personal computing. Astounded that Xerox had developed this technology but failed to see or exploit its potential, the Apple team went away and set about creating it themselves.

Great care was taken with the whole look of what appeared on the Macintosh screen: the white background, like a sheet of paper – demanding in terms of computer memory, but crucial to the WYSIWYG concept – the icons, the round-edged buttons, the borders of the windows and the look of the dialogue boxes. But just as important were the fonts. The Macintosh was the first personal computer where the typefaces mattered. There was a choice of seven, pastiches of existing faces,

designed by Apple themselves to avoid any licensing costs, and named after cities – New York, Geneva and Chicago. And there would be the capability to italicize, bolden and apply outlines and drop shadows.

But although Macintosh was the future of computing, potential customers in the here-and-now proved difficult to convince. Initial sales were extremely disappointing. The memory the Macintosh needed to keep its image on screen was expensive to produce, and left little capacity for actually working on the machine. In comparison with its rivals, the Mac was costly, and had few applications to run on it. It looked different, and although easy and even fun to use, this didn't necessarily tell in its favour. To many, it didn't look serious enough to be a business machine – it was just a toy.

The future through 1984 and 1985 looked black. Because the Macintosh survived, it was able to define the way all computer screens would look and how people would interact with them, and by extension make possible the success of the Internet. What saved the machine was typography; in the end it all came down to type.

What the Mac lacked, as the Alto had, was that essential software application which would enable the user to do something revolutionary which couldn't be done on any other computer. Its designers had always said that they couldn't predict the changes that the Macintosh would set in motion, and probably few would have guessed what the essential application was going to be – desktop publishing.

At the start of 1984 a former newspaper editor called Paul Brainerd (born 1947) had been working for a company that made large computer workstations for newspaper and magazine production. They were expensive, complex machines, but Brainerd was convinced that the functions they performed could be done by small, personal computers. When his company was bought by Kodak, Brainerd was made redundant. Turning this setback to his advantage, he formed his own outfit to develop publishing software for use on a personal computer. As the Macintosh was the only machine on the market that offered WYSIWYG, it was the obvious choice, a choice that was doubly clear when Brainerd found that Apple had developed a printer, the LaserWriter, which, although twice the price of the actual computer, used

a new language called Postscript, developed by former
employees at Xerox's PARC who had left to form a
new company, Adobe.

Postscript's great innovation was in the printing of
letter forms. The fonts were stored as mathematical
formulae instead of bit maps. The letter form became
an outline, described mathematically to the computer
as a set of lines and curves, with guidelines for which
parts were to be filled with tone or colour and which
were counters, to be left white or take the background
colour. Unlike bit mapping, this freed the letter from
dependence on resolution, the number of pixels per
inch or centimetre, for its image quality. With a digital
scan of a photograph, if the picture is then scaled on
the page to a larger size than its resolution will toler-
ate, it will start to pixillate – break down into squares
of colour or tone.

But with Postscript the letter could be increased in
size to the limit allowed by the software application, and
its edges would remain smooth, with none of the bit-
mapped jaggedness that had previously typified computer
output. It could also then be printed in as fine an image as
the printer was capable of producing. Apple now licensed
existing typefaces like Helvetica and Times Roman for
use in every LaserWriter, while Adobe were producing
and selling other faces in digital format. Postscript could
also be read by other, larger printers, the kind that maga-
zines and newspapers were using to run out the film for
printing plate-making.

Brainerd named his company Aldus, after Aldus
Manutius, a fitting role model given that the Italian had
infinitely widened the commercial horizons of the book
with his inexpensive pocket-size editions. As a means of
achieving this he had created the italic letter, a capability
that the Macintosh could also offer the computer user.

Aldus's new software was called PageMaker. With it
text could be run on to a page, arranged into columns,
headlines resized with a click and pull of the mouse, text
run around pictures. And if you didn't like what you had
designed, the whole layout could be radically rejigged in
a matter of minutes. For a designer coming to the Macin-
tosh after years of sticking down paper page layouts as
guides for repro houses to re-create for film-making, it
was a revelation, it was liberation. Get over your techno-

fear and within days you would be amazed at what you could do – the Macintosh was that simple to use.

On the first magazine I worked on using a Macintosh, the owner, still unconvinced by the technology he had just bought, was won over when a requested total redesign of an eight-page section was back on his desk within the hour. Under the old technology it would have been a next-day job.

Macintosh finally had its winning software; PageMaker was released in July 1985. Demonstrations to cynical company buyers quickly won converts. The Macintosh was no longer a toy, but a powerful business machine. PageMaker saved the Macintosh and type saved the Macintosh, because what the software offered was the ability to make typography a fluid entity. Now truly free from its metal past, it could be pushed around on-screen, made to do what *you* wanted, rather than making the user its servant.

Of course, for a time there was a dip in quality. What could be produced and cheaply printed out using a Macintosh looked so much better than what could previously have been created in-house that many companies were initally fooled into thinking that, as anyone could do it, a lot of design chores could be taken on by secretarial staff. Your copy was too long to fit the available space? Don't bother cutting it, just squeeze the font to get it in. You would see, and occasionally still do see, some horrible condensing of headlines too, the letter forms squashed into ugly travesties by untrained eyes trying to fit too many words into too little space.

But once the realization seeped in that a designer's eye and an understanding of and sensitivity to typography were still needed if your publication was to look better than the amateurish efforts of your competitor, quality began to take an upward turn, in overall terms eventually far exceeding what had been produced with the old technology.

The typographic digital age had truly arrived, and was to bring with it an explosion in typeface design, a creative flowering unparalleled in all of type's previous five-hundred-year history. It was a revolution that in terms of technological innovation and in its implications and possibilities matched Gutenberg's. In 1994 Paul Brainerd was awarded the Gutenberg Prize by the city of Mainz.

Detour | Inside the micro-foundry: twenty-first-century type

The giants and their roaring machinery have gone. The modern digital type company is an altogether quieter and more compact affair, more likely to be contained in one room than in a two-storey building in a suburban industrial estate, what Joe Graham of typeface company Fontworks has described as a 'micro-foundry'. One of these, Acme Fonts, is based in what used to be called London's Tin Pan Alley, Denmark Street, two floors up above a guitar shop.

It was a surprise to find that the person who essentially is Acme was actually a native of Oberhausen, in Germany's Ruhr region. Christian Küsters was always attracted by type: 'I remember my grandmother asking me to letter a name plate for her house, and I really liked finding a type book and drawing out the characters in black letter.' Dissatisfied with the current state of the art in Germany, Christian had been inspired by English graphic design and applied to Neville Brody's old college, the London School of Printing, in 1990. 'In the first year of the course you created letters entirely by hand. They didn't even let you touch a computer until the second year,' he recalls.

After graduating from the LCP, he was on the move again, taking an MA at Yale University in America, and becoming teaching assistant there to Matthew Carter, the founder of the Bitstream digital type company. Christian's first type design, Retrospectiva, was a deconstruction, with Carter's full approval, of his celebrated Galliard face.

Life immediately post-college was difficult; work was hard to come by and irregular. Christian filled the frequent downtime by furiously designing fonts. 'It drove my girlfriend absolutely crazy,' he admits, 'although she did end up marrying me, despite it all.' Initial approaches to established companies were met with rejection. 'I realized eventually that the amount of administration required for them to take on a small designer just wasn't worth their while. That's when I decided to set up Acme.'

Christian had picked the name not just because of its

85 Christian Küsters, head of his own type 'family'.

jokey Warner Brothers cartoon associations, but because the brand name was actually in common usage by American companies. 'I liked that commercial aspect of the word, but also the fact that its original Greek meaning is "highest point", perfection. It was a nice duality.'

Along with his own designs, Christian looked around student degree shows for promising talent, and when he'd amassed about twenty fonts he approached Fontworks with a view to them marketing the work. In this way a designer needed only one font family to their name but, under the Acme banner, could be part of a 'type family' large enough to be marketed by others.

Fontworks brought the Neville Brody connection full circle. The company had been formed at the end of the 1980s, the brainchild of Brody in conjunction with the German type designer Eric Spiekermann and his wife Joan. Christian's approach was the right one, as Fontworks marketing manager Joe Graham explains:

> If it's just a solitary face you're offering then it's helpful from our point of view if it has some kind of story or notoriety attached to it. Maybe it's already been used in a magazine or somewhere else with a high profile. But generally we're looking for a designer with a well-established body of faces to offer, rather than just an individual face. Not just one family, but several families. You need to come up with a brand for yourself, or have the depth in your work that we can do it for you. That way we've got something we can market.

This Christian was able to do; Acme already looked a solid, credible entity, and had the x-factor, striking but saleable typefaces. Christian explained how the relationship with Fontworks operates: 'I design the promotional material, but Fontworks print and distribute it, do all the PR and admin. I don't want to get involved in that side of things – it's a job in itself. I've no interest in doing the selling. I run my own design company here as well; Acme isn't a profit-making venture for me. I see Acme essentially as a creative project, a means of getting interesting designs into the marketplace.'

This corresponds with Joe Graham's opinion of the financial side of type designing: 'For the most part, the designers we promote have other lines of income, working as graphic designers, lecturing, teaching. I think type design is very much a personal pleasure or passion that you can convert into a subsidiary source of income – but as your whole living, I'd say no.'

That may not seem a great incentive to design a typeface, but there is more, beyond the creative challenge and enjoyment, which in itself is surely enough reward. Christian receives speculative calls from designers; one of these was from Dirk Wachowiak, whose AF Generation font was later to win an award from the Type Directors Club in New York and be licensed to the German state of Baden-Württemberg. Although Dirk's work has received international recognition, he pinpointed as one of his motivations type's wider potential: 'It's the chance to have influence beyond the area where you personally are designing. When do you otherwise have the possibility of extending your work into other areas? Through your typeface you can have your own design element used in brochures, books or other graphic material all over the world.'

In an industry that is highly service oriented, and whose output is often of short-term use, the typeface can represent permanence for its designer, an expression of ideas and thought processes that stand free from purely answering someone else's brief. It is a piece of intellectual property. If designers solve other people's problems while artists solve their own, then a typeface can place its creator solidly in the realm of the latter.

86 Some fonts from the Acme stable: Henrik Kubel's Battersea and Klampenborg, Simon Piehl's Spin and Dirk Wachowiak's AF Generation are striking but practical modern sans serifs. Paul Renner's lower case g Futura experiment is put to good use. Paul Wilson's Screen takes the essence of the traditional letter form and pushes it to extremes.

The digital era has been called the third age of history. In part it was ushered in by the demands of having to deal with type, that child of the second age, and the attraction of the new capability of controlling and manipulating it without recourse to outside specialists. For the designer of a magazine or newpaper this meant no more long, tedious days or evenings sitting in type-setters' premises as press deadlines loomed, making final corrections to the pages. Any last-minute changes or adjustments could be carried out without leaving the office. Everyone outside the design profession could be his or her own typographer.

This third age was also to bring with it a typographical flowering of a magnitude never before witnessed. In the 1930s, American Type Founders produced on average about five new typefaces a year. A recent single catalogue, the Garage Fonts Collection from Atomic Type, contained 200 families of alphabets, symbols and decorations, most of them probably designed in the past year or so.

Font design software has made the whole process much easier, and also much cheaper. To produce a typeface for letterpress was a lengthy and costly business, and therefore, from a business point of view, to be approached cautiously. Now there is little financial risk involved in designing and marketing a new typeface; what costs exist are incurred through promotion rather than production.

These changes mean that the impetus for new designs now comes from designers themselves. In the past much of type design was reactive. Morris Benton's design department tried to analyse the often ill-formed or half-expressed desires of their market of printers and advertising agencies, using this word-of-mouth research to inform their design decisions. Stanley Morison commissioned Gill to design his sans serif as a reaction to developments in Germany; he himself was commissioned by *The Times* to develop their typeface in response to Morison's own criticisms of the paper's typography. Helvetica initially came about as a proposed replacement for

an established best-seller. But today a designer can develop an alphabet purely for his or her creative amusement. If they find someone to market it for them, they may hit lucky, who knows?

And now they're even giving them away. You can build a massive digital library downloading free fonts from dedicated websites. With most things in life, you get pretty much what you pay for. In this instance you get more, but not substantially so. Many of these free fonts serve well enough for the occasional word or two, but when the letters are fitted together into words and sentences, their shortcomings become quickly apparent – characters of uncertain legibility, lack of harmony between the letters. It then becomes clear how much skill and feeling is required to design a *really good* typeface.

The digital revolution has ushered in a typographical golden age; there is more choice than ever before – sometimes bewilderingly wide – and better, more varied typeface designs. The reverse side of the coin is a general loosening of typographic standards. There has of course always been good and indifferent typography under any system. But it is very common now, even on big-budget work like Hollywood film posters, to see the design of the film title break that cardinal rule – the word spacing must not appear wider than the line spacing. If this is ignored, in large amounts of body text 'rivers' are created, visual streams of white space trickling vertically through the block of text. In headlines of more than one line, visually the words group not horizontally, line by line, but vertically. Aesthetically, and for the sense of the words, this is wrong, but if no one notices or cares, and legibility is not affected, in the end, does it matter? Only from the point of view of craft. And if the rules are incessantly disregarded, then the new approach eventually becomes the norm, and a new aesthetic is created. After all, readability, as we have already seen, is largely about familiarity, not intrinsic design.

The third age has been midwife to the most creative era of type design. But as the focus of communication moves away from printed media and on to the computer screen, it will also bring with it the ultimate death of typography in the sense of an aesthetic beyond its purest function as the carrier of legible information.

The Internet has exploded as a communication and information medium. Every company has its own Web presence, now almost every television programme. Doubts are expressed as to the validity of information posted on websites, but printed information in books and newspapers has no intrinsic guarantee of accuracy. Many sites created by individuals and enthusiasts seem to be motivated by nothing more than a genuine desire to share and inform, for little or no discernible profit.

Type on the Web comes under certain technical restrictions and pressures. Screen resolution makes finely serifed faces unsatisfactory. Weightier serifs work fine, but, like most bold versions of classic faces, aren't visually very appealing. Sans serifs work best, and it is partly owing to their ascendancy in cyberspace that they have become dominant in printed media as well. Print now imitates Web design in its typographical feel, seeing the new medium as a more immediate, up-to-date form of communication, and wishing to absorb some of that vibrancy by proxy. This is a factor in the shrinking in headline sizes over the last few years; there is virtually no large, banner typography in websites. Type aesthetics on a site are far less important than navigation, and easy, logical, speedy access of information.

It has been said of the typeface Bembo that it looked its best in letterpress printing; its qualities were never quite the same under subsequent technologies. Perhaps typefaces in general work best when they have been specifically designed for the medium in which they are used. Classic faces like Garamond can look attractive on websites, but also slightly quaint, a little out of place, as if they've wandered in from somewhere else. Which they have.

With the arrival of the personal computer, some raised the question of whether the bit-mapped image was now the true form for all lettering – a development like Postscript essentially took something that existed in a computer-generated form and turned its visual appearance into something that was palatable, but inextricably linked to older means of production. 'Technology and means of production should determine the form and use of type and image. It is no longer relevant to have serif types in an age of desk-top publishing and electronic laser setting. We must find a vocabulary of expression

that has meaning today. Statements about where we are and where we want to be, not meaningless nostalgic garbage."[1]

If a media player of the magnitude and influence of Rupert Murdoch states that the investment of News International will increasingly be directed into non-print media, then the future looks fairly certain – the writing is on the wall. Except that's just where it won't be. The thinking now runs that nowadays people read printed media only when they have no easy alternative to passing the time or entertaining themselves. A captive audience, waiting for a train, sitting on a bus or aeroplane – these are the occasions when print comes into its own. At home, with access to a television, videos, PlayStation, CD player or the Internet, most people won't choose to sit down and read a book.

The Internet is a development that 'the man in the street' would not have predicted fifteen years ago. It's a dramatic innovation, but maybe the great change to be brought by the digital age is yet to happen. My feeling is that the much-derided supporters of ita phonetics weren't barking entirely up the wrong tree. Nor was Eric Gill, with his advocacy of shorthand. It's entirely feasible that within the next century written English will begin to disintegrate. The rules of spelling and punctuation will soften, blur and eventually disappear altogether. The possessive apostrophe is already an endangered species – different spellings for homophones such as 'there' and 'their' will be the next to go.

The phenomenal rise in teenage mobile phone ownership in the final years of the twentieth century has seen a parallel growth in text messaging, a cheap, silent form of communication that can be carried out with a low risk of detection in the classroom environment. A written shorthand quickly developed to speed the exchange of messages, using abbreviations and numbers to simulate words and parts of words. Initially derided by adults, the argot has been featured in mainstream advertising, always desperate to reflect the latest societal developments, and most people are now aware of the phenomenon and the concept, even if having no first-hand experience. It has now achieved an accepted cultural status, a position from which it is just a short step for some of these written configurations, or subsequent developments, to

1. Malcolm Garrett, 'A dearth of typography', *Baseline* 13, 1990.

239

find their way into general usage over the next couple of decades. Younger generations, increasingly less familiar with physically writing their own language, will use the forms, a kind of visual slang, with which they are most comfortable. In the breakdown of traditional written English, 'txt' could be a surprising contributor.

It won't stop there. Within the next hundred years it is entirely feasible that the written language will be replaced by a system of symbols, ideograms – dingbats essentially – to be used for any graphic commands needed on whatever form of computers are in use in the future. This will become the lingua franca for all necessary unspoken communication. These same symbols will represent the equivalent meanings in each spoken language, so that a written instruction could be read by anyone, regardless of their mother tongue, a kind of single currency of language. Look at the power and significance of that little symbol @ , for so long a very minor player on the keyboard, but now ubiquitous. Could not this process be extended for a whole range of on-screen commands and information?

Digital type as we know it today will disappear. But maybe type and the existing written tradition will be kept alive by the descendants of the typecasting enthusiasts of today. Rather as in the future society of H. G. Wells's *The Time Machine*, but without any of the moral implications, there will be a split between those tending the clanking machinery and those living a life of diminishing physical activity in front of their visual display. The typophiles will continue to print limited-edition runs for a select clientele, paper once again a rare and expensive resource. When their machinery, those old Monotype and ATF casters, finally reaches the end of its working life, they will have custom-built modern replacements. But the principle of the technology will remain unchanged – lead, antimony and tin filling the matrices. Because that is what the typophiles love – the smell, the sound and the sheer physicality of these old methods, as much as the quality of the print. And through them the heritage of Baskerville, Caslon, Gutenberg and everyone else we've encountered in these pages will survive.

Preposterous?

Illustration credits

5 by permission of the British Library

6 by kind permission of Theo Rehak and the Dale Guild Type Foundry

7 by kind permission of the Statsbibliotheek Haarlem

9 and 10 by kind permission of the Type Museum

11 and 13 by permission of St Bride Printing Library

15 by permission of Birmingham Museums and Art Gallery

17 by kind permission of the City Archives, Birmingham Libraries

18 by kind permission of Agfa Monotype

19 photograph by Christine Lalla

20 by permission of St Bride Printing Library

29 and 30 by permission of St Bride Printing Library

31 by permission of the National Portrait Gallery

33 by permission of St Bride Printing Library

40 by kind permission of Andrew Johnston and the Ditchling Museum

41 and 43 photographs by Christine Lalla

44 by kind permission of John Miles

45 by kind permission of Agfa Monotype

46 and 47 by permission of St Bride Printing Library

56 by kind permission of the Cardozo Kindersley Workshop

66 and 67 by kind permission of the Cardozo Kindersley Workshop

68 by kind permission of Agfa Monotype

70, 71 and 72 by kind permission of the Cardozo Kindersley Workshop

77 by kind permission of Wim Crouwel

79 by kind permission of Susan Nottingham

80 by kind permission of Julian Balme

81 by kind permission of *The Face*

82 by kind permission of *Arena*

83 by kind permission of *Blueprint*

85 by kind permission of Christian Küsters

While the publishers have made every effort to trace the owners of copyright material used in this book, they will be happy to rectify any errors or omissions in further editions.

Bibliography

Aside from magazines and periodicals quoted in the text, the following proved invaluable sources of reference:

General

Carter, Sebastian, *Twentieth Century Type Designers*, London, 1987.

Dreyfus, John, *Into Print, Selected Writings on Printing History, Typography and Book Production*, London, 1950, 1994.

Eason, Ron, and Sarah Rookledge, *Rookledge's International Handbook of Type Designers*, Carshalton Beeches, 1991.

Haley, Allan, *ABCs of Type, a guide to contemporary typefaces*, New York, 1990.

Heller, Steven, and Philip B. Meggs (eds), *Texts on Type, Critical Writings on Typography*, New York, 2001.

Meynell, Francis, *English Printed Books*, London, 1946.

Tracy, Walter, *Letters of Credit, a View of Type Design*, London, 1986.

Wood, James Playsted, *The Story of Advertising*, New York, 1958.

1

Fuhrmann, Otto, *Gutenberg and the Strasbourg Documents of 1439*, New York, 1940

Hellinga–Querido, Lotte, and Clemens Wolf, *Laurens Janszoon Coster was zijn naam*, Haarlem, 1988.

Hessels, J. H., *Haarlem, the Birth-place of Printing, not Mainz*, London, 1887.

Kapr, Albert, *Johann Gutenberg, the Man and His Invention*, Aldershot, 1996.

Scholderer, Victor, *Johann Gutenberg*, London, 1963.

Steinberg, S. H., *Five Hundred Years of Printing*, London, 1955.

Van der Linde, A., *The Haarlem Legend of the Invention of Printing by Lourens Janszoon Coster, Critically Examined, translated from the Dutch and with an introduction and a classified list of Costerian incunabula by J. H. Hessels*, London, 1871.

2

Ball, Johnson, *William Caslon: Master of Letters*, Kineton, 1973.

Howes, Justin, and Nigel Roche, *Founders London A–Z*, London, 1998.

Mosley, James, *The Nymph and the Grot*, London, 1999.

Reed, Talbot Baines, *A History of the Old English Letter Foundries*, London, 1952.

3

Williamson, Hugh, 'Jean Jannon of Sedan', *Printing Historical Society*, London, 1987–88.

4

Jay, Leonard (ed.), *Letters of the famous 18th Century printer John Baskerville of Birmingham together with a bibliography of works printed by him at Birmingham*, Birmingham, 1932.

Pardoe, F. E., *John Baskerville of Birmingham: Letter founder and printer*, London, 1975.

Straus, Ralph, and Robert K. Dent, *John Baskerville: a memoir*, London, 1907.

Walker, Benjamin, *The Resting Places of the Remains of John Baskerville, the Thrice-buried Printer*, Birmingham, 1944.

6

Cost, Patricia, A., 'Linn Boyd Benton, Morris Fuller Benton and Typemaking at ATF', *Printing History*, Vol. XVI, no. 1/2, 1994.

Walters, Gregory Jackson, *The Auction of the Century, August 24, 1993*, New Jersey, 1994.

7

Avis, F. C., *Edward Philip Prince, Type Punchcutter*, London, 1967.

Cobden-Sanderson, T. J., *The Diaries of T. J. Cobden-Sanderson*, New York, 1969.

Franklin, Colin, *The Private Presses*, London, 1969.

— *Emery Walker: some light on his theories of printing and on his relations with T. J. Cobden-Sanderson*, Cambridge, 1973.

Harrop, Dorothy A., *Sir Emery Walker 1851–1933*, London, 1986.

Zaczek, Iain, *Essential William Morris*, Bath, 1999.

8

Bielenson, Peter, *The Story of Frederic W. Goudy*, Mt Vernon, 1939 and 1965.

Bruckner, D. J. R., *Frederic Goudy*, New York, 1990.

9

Banks, Colin, *London's Handwriting; the development of Edward Johnston's Underground Railway Block-Letter*, London, 1994.

Howes, Justin, *Johnston's Underground Type*, London, 2000.

Johnston, Priscilla, *Edward Johnston*, London, 1959.

Moran, James, *The Double Crown Club: a history of fifty years*, London, 1974.

10

Barker, Nicolas, *Stanley Morison*, London, 1972.

Barker, Nicolas, and Douglas Cleverdon, *Stanley Morison, 1889–1967*, radio portrait, Ipswich, 1969.

Moran, James, *Stanley Morison: his typographic achievement*, London, 1971.

Morison, Stanley, and D. B. Updike, *Selected Correspondence* (ed. David McKitterick), London, 1980.

11

Burke, Christopher, *Paul Renner, the Art of Typography*, London, 1998.

Mouron, Henri, *Cassandre*, London, 1985.

Schmoller, Hans, *Two Titans, Mardersteig and Tschichold, a study in contrasts*, New York, 1990.

12

Gill, Eric, *Autobiography*, 1940.

— *Lettering, an essay on Typography*, London, 1931.

Kindersley, David, *Mr Eric Gill; Further Thoughts by an Apprentice*, Cambridge, 1982.

MacCarthy, Fiona, *Eric Gill*, London, 1989.

Detour

Cardozo Kindersley, Lida Lopes, *The Cardozo Kindersley Workshop, a Guide to Commissioning Work*, Cambridge, 1999.

Lloyd-Jones, Emma, and Lida Lopes Cardozo Kindersley, *Letters for the Millennium, why we cut letters in stone*, Cambridge, 1999.

Shaw, Montague, *David Kindersley, His Work and Workshop*, Cambridge, 1989.

14

Chudley, John A., *Letraset: A Lesson in Growth*, London, 1974.

16

Peckolick, Alan, and Gertrude Snyder, *Herb Lubalin, Art Director, Graphic Designer and Typographer*, New York, 1985.

17

Skeats, John, *ita and the Teaching of Literacy*, London, 1967.

18

Wozencroft, Jan, *The Graphic Language of Neville Brody*, vol. 1, London, 1988.

— *The Graphic Language of Neville Brody*, vol. 2, London, 1994.

19

Cringely, Robert X., *Accidental Empires*, Boston, MA, 1992, 1996.

Levy, Steven, *Insanely Great, the Life and Times of Macintosh, the Computer that Changed Everything*, New York, 1994, 2000.

General Index

Illustrations are in *italics*; fn = footnote reference

Typeface index

The designers' names are in brackets